Artwash

Big Oil and the Arts

Mel Evans

PlutoPress
www.plutobooks.com

First published 2015 by Pluto Press
345 Archway Road, London N6 5AA

www.plutobooks.com

British Library Cataloguing in Publication Data
A catalogue record for this book is available from the British Library

ISBN 978 0 7453 3589 6 Hardback
ISBN 978 0 7453 3588 9 Paperback
ISBN 978 1 7837 1332 5 PDF eBook
ISBN 978 1 7837 1334 9 Kindle eBook
ISBN 978 1 7837 1333 2 EPUB eBook

This book is printed on paper suitable for recycling and made from
fully managed and sustained forest sources. Logging, pulping and
manufacturing processes are expected to conform to the environmental
standards of the country of origin.

10 9 8 7 6 5 4 3 2 1

Typeset by Stanford DTP Services, Northampton, England
Text design by Melanie Patrick
Simultaneously printed by CPI Antony Rowe, Chippenham, UK
and Edwards Bros in the United States of America

For Rachel Singer, my mum, who taught me change is a process, not an event; and for her mother and grandmother, Mickey and Beth, who, in their purchasing, kept an arm's-length relationship with any company that invested heavily in advertising.

Contents

List of Illustrations and Tables

Tables

List of Acronyms

A&B – Arts and Business (lobby group)

ACE – Arts Council England

APOC/AIOC/BP – Anglo-Persian Oil Company, later Anglo- Iranian Oil Company, later British Petroleum, now BP

Ash – Action on Smoking and Health

CAPP – Canadian Association of Petroleum Producers

CEMA – Committee for the Encouragement of Music and the Arts

CSR – Corporate Social Responsibility

DCMS – Department of Culture, Media and Sport

GDP – gross domestic product

G.U.L.F. – Global Ultra Luxury Faction

MoMA – Museum of Modern Art (usually, New York)

MOSOP – Movement for the Survival of the Ogoni People

NGO – non-governmental organisation

NDPB – non-departmental public body

PR – public relations

ppm – parts per million (usually of carbon dioxide in the earth's atmosphere)

SLO – Social Licence to Operate

List of Characters

Leeora Black – founder and Managing Director, Australian Centre for Corporate Social Responsibility

Iwona Blazwick – Director, Whitechapel Gallery, London, 2001–

Pierre Bourdieu – cultural theorist

George Brandis – Arts Minister, Australia, 2013–

John Browne – chairperson, Tate Board of Trustees 2007–; CEO of BP 1998–2007

Anna Cutler – Director of Learning, Tate, 2010–

Andrea Fraser – performance artist and theorist

Christopher Frayling – chairperson, Arts Council England, 2005–2009

Viv Golding – senior lecturer in Museum Studies, University of Leicester, UK

Hans Haacke – artist and theorist

Tom Henderson – Director for External Affairs, Shell Plc.

Jude Kelly – Artistic Director, Southbank Centre, London, 2005–

Jennie Lee – Minister for the Arts, UK, 1964–1970

Peter Mather – Honorary Director, Royal Opera House; BP Group Regional Vice President for Europe, 2010–

Emma Mahony – lecturer in Visual Culture, National College of Art and Design, Dublin, Éire

Maria Miller – Culture Secretary, UK, 2012–2014

Grayson Perry – artist

Nicholas Serota – Director, Tate, 1988–

Margaret Thatcher – British prime minister, 1979–1990

Colin Tweedy – Chief Executive, Arts & Business, 1983–2012

John Williams – co-founder, Fishburn Hedges (public relations firm)

Chin-tao Wu – assistant Research Fellow, Academia Sinica, Taipei, Taiwan

Acknowledgements

Artwash was born in 2012 when I attended a course at Tate led by curator Michaela Ross titled 'Inside Today's Museum'. I wanted to look into the reasons Tate was reluctant to drop BP from the perspective of each and every department. So I approach oil sponsorship both from the inside and the outside: as a visitor, a Tate member, as an artist and maker of performance interventions, and also as part of a community of objectors that includes staff, members, artists, academics and activists from around the world; and as a curious, critical outsider. I also attended a course led by curator Martine Rouleau at Tate, 'What's in a space?', and thank her for all the thinking that inspired. Many thanks to curator and academic Emma Mahony at the Dublin National College of Art and Design, whose writing and presentations on Liberate Tate have been enormously instructive.

I draw significantly on the work of the academic Chin-tao Wu, who also approaches the art museum from both within and without, as both a researcher and emigrant. A research fellow at the Academia Sinica in Taiwan, Wu's influential text *Privatising Culture* – which has been translated into Turkish, Portuguese and Spanish – started life as a doctoral dissertation at University College London and her research grew out of journeys between galleries in the USA and the UK. Wu describes her investigative interest as founded in an appreciation, then concern, for public access to the arts as she saw it increasingly under threat during her time living in London over two decades from the late 1980s. Therefore, I ground my questions in the very thing that is important to critics and supporters alike: the arts, and the valuable role of the arts in society. From that shared starting point I will consider what is at stake for the arts when oil sponsorship enters the scene. My concerns around oil sponsorship of the arts share a similar duality: I have worked in the arts for over a decade, starting in theatre,

and have been involved in environmental activism for the same period in parallel.

Artwash was nurtured into fruition by the arts, activism and the education organisation Platform, where I spent six years researching, writing and developing creative projects on oil, finance and arts sponsorship. I am forever thankful for the ambitious and dedicated world of Platform: Ben Amunwa, Anna Galkina, Tanya Hawkes, Emma Hughes, Farzana Khan, Sarah Legge, Adam Ma'anit, James Marriott, Mika Minio-Paluello, Greg Muttitt, Mark Roberts, Kevin Smith, Sarah Shoraka and Jane Trowell, among others in various eras; and trustees Rosa Curling, Glen Fendley, Charlie Kronick, Diana Morant and Charlotte Leonard. And thanks to the endlessly creative people of Liberate Tate – both past and present. Both groups embody many of the wonderful qualities I hope to find in all creative collaborations for social change. And, thanks to all the others in the Art Not Oil network: at BP Out of Opera, Reclaim Shakespeare Company, Rising Tide London, Science Unstained, UK Tar Sands Network and Shell Out Sounds. A few people deserve extra special mention: Kevin Smith, who I have had the sheer luxury to collaborate with so closely for a good number of years and hopefully a long time yet, and Hannah Davey and Hayley Newman, whose creative minds I admire and wavelengths I share. And the third organisation that of course bore *Artwash* into being is Pluto: thank you to you all for giving the project life and constructive feedback, especially David Castle, my editor, and Alison Alexanian, Emily Orford, Thérèse Wassily Saba, David Shulman and Robert Webb.

The best place to write in is the next one. Thank you to all those who gave this project space physically, whose homes or presence I have benefitted from as spaces to write in: Sophie Allain and Simon Lewis, Kheya Bag and Blair Ogden, Franziska Grobke, Will McCallum, Rachel Singer and Brian Evans, Kevin Smith and Nacho Romero, Kristina Weaver and Eze Amos, Tate Reading Rooms, Hackney Central Library, Walthamstow Central Library, William Morris Gallery and the heavenly Blue Mountain Centre and all its people – Zohar Gitliss, Hannah Lee, Luke Nathan, Ben Strader, and my fellow makers Jessica Caldas, Sermin Kardunster, Kristin Kimball, Holly Metz, Liam

Robinson, Jean Rohe, Onnesha Roychoudhuri and all – we gave each other space, perseverance and precious encouragements.

Thank you to all the people who have given me vital feedback on chapters and drafts: David Castle at Pluto, Kevin Smith, Jane Trowell and James Marriott at Platform, Sarah Keenan, Emma Mahony, Hayley Newman, Onnesha Roychoudhuri, Rachel Singer, David Singer and Kristina Weaver – all gave considerable time and careful thought for which I am deeply grateful. Thank you to all who have given vital encouragement and inspiration in all things art, activism and writing, including but not limited to: Sophie Allain, Kheya Bag, Hannah Davey, Lou Dear, Suzanne Dhaliwal, Maddy Evans, Sam Evans, Anna Feigenbaum, Grainne Gannon, Beth Hamer, Sarah Keenan, Michele Kirschstein, Poppy Kohner, Hannah Leigh-Mackie, Hayley Newman, Onnesha Roychoudhuri, Kristina Weaver and Beth Whelan.

1
Introduction

In June 2010 the British cultural institution Tate held its annual Summer Party. It was a prestigious affair. Guests were greeted and tickets were inspected at the main entrance. Notables on the guest list included the art historian Wendy Baron, the Duran Duran keyboardist Nick Rhodes, the artist, author and Marquess of Bath Alexander Thynn, and the Conservative party faithfuls Virginia and Peter Bottomley. Smiles and nods from smartly dressed staff directed them up the stairs into Tate Britain's impressive and expansive Duveen Galleries, where silver service staff standing in a perfect 'V' were holding shiny trays and offering each new arrival a flute of champagne.

The party hosted a cast of characters crucial to the story of *Artwash*. Nicholas Serota, Tate Director, and John Browne, ex-CEO of BP and Tate Chair of Trustees, were both holding court. Penelope Curtis was centre stage; as director of Tate Britain she curated the exhibition of Fiona Banner's artwork that formed the party's centrepiece. Nearby: Iwona Blazwick, once Head of Exhibitions and Displays at Tate and now Director of the Whitechapel Gallery in London – the position Serota held before stepping up the cultural professional's ladder – and Anna Cutler, the newly appointed Head of Learning. Around them party goers surveyed Banner's *Harrier and Jaguar*, decommissioned fighter jets suspended through the 100 metre-long gallery, and accepted offers of sausages on sticks.

It was an opportunity to rub shoulders or take 'selfies' with some prominent individuals. Christopher Frayling, a previous director of Arts Council England, and Colin Tweedy, a lobbyist for corporate sponsorship of the arts, each would have made an appearance, as would the artistic directors from other BP- and Shell-sponsored galleries,

1

such as Jude Kelly of the Southbank Centre and Sandy Nairne of the National Portrait Gallery. There was a light accompaniment of live music heard underneath the buzz of chattering guests.

Tate holds the party annually but on that particular occasion Tate directors elected to use the event to mark 20 years of BP sponsorship of Tate's group of four art galleries spread around the UK. And meanwhile, across the Atlantic Ocean, BP's Gulf of Mexico oil spill that had begun on 20 April 2010 was still splurging from the seabed as party guests gathered at Tate Britain on the River Thames in London. Outside of the party, the world's eyes were fixed on BP's gigantic spill as it spun out of control. It would take 87 days to cork the blowout but on 28 June, the night of Tate's party, no one knew how long the ruinous spill might last.

Unbeknown to the party planners beforehand, a number of unlisted guests were making their way to Tate Britain that evening, and not merely to gatecrash in pursuit of Pimm's and nibbles. Entering the building stage right at 7.15pm: Anna Feigenbaum and me, both part of the freshly formed Liberate Tate. We arrived ready to make a spill performance we created with climate activists Danni Paffard and Beth Whelan – Beth, Anna and I shared intertwined histories experimenting in art and activism, which for Anna was in parallel with a media studies lectureship and authoring the book *Protest Camps*, and for Beth and me this was our chosen path concurrent to our contemporaries' entry on to the Glasgow and London theatre scenes. Anna and I, naming ourselves Toni (Hayward) and Bobbi (Dudley) after the outgoing and incoming BP CEOs – we are also one English and one American performer – entered the party just like the other guests, with heads turning at our large floral vintage bouffant dresses. Invisible to the casual passer-by, we were carrying ten litres of oil-like molasses into the gallery under our skirts, held in easily rippable rubble sacks attached to our hips with remarkably transferable strap-on harnesses. When we reached the entrance to the 'V' of the champagne reception, we spilled our precious cargo across the polished stone floor of the gallery. Across the Atlantic BP was attempting to plug the dire spill, and here at Tate we replicated their messy clean-up mission. We donned the BP ponchos hidden in our handbags and attempted to contain our spill

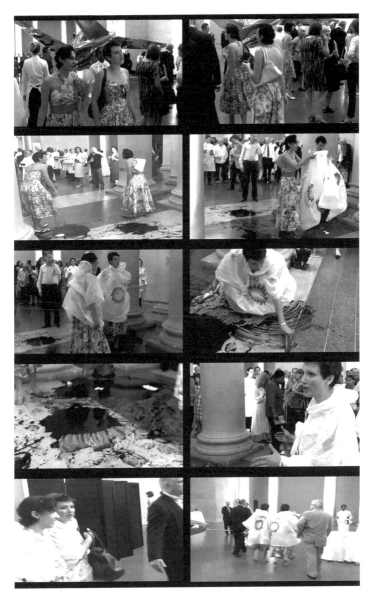

Figure 1.1: *Toni & Bobbi*, Liberate Tate, June 2010, Tate Britain. Film stills. Video credit: Gavin Grindon, 2010.

with our nail-polished hands and classy party shoes, as we described the mess to our gathered audience as 'tiny in comparison to the size of the whole gallery', echoing Tony Hayward's widely criticised initial defence of the BP disaster. Gavin Grindon, who lectures in art history at the University of Essex and curated Disobedient Objects at the V&A, joined us inside as videographer of our spill performance.

Then, at 7.25pm a group of twelve performers in black clothing, with black veils reminiscent of Catholic widows in mourning covering their faces, poured more oil-like molasses from BP canisters at the main entrance to Tate Britain, as the guests continued to arrive. The spill seeped down the steps and across the entranceway, silent itself but eliciting gasps from the gathered crowd. In the group were Isa Fremeaux and John Jordan from the ever-inspiring art and activism collective the Laboratory of Insurrectionary Imagination, who were key to the catalysing of Liberate Tate; artists Hannah Davey, Tim Ratcliffe and Darren Sutton who with several more artists and activists went on to form the core of the Liberate Tate art collective and create many more interventions in the space and the discourse; and other performers who founded new groups such as Shell Out Sounds and the Reclaim Shakespeare Company to call out oil sponsorship in different museums and galleries. The twelve figures upon emptying their barrels turned and calmly walked away, a steady procession of graceful objection. These acts, among others by the group, brought the distant spill into greater physical and discursive proximity to the BP logos at Tate.

Remaining at the scene were over fifty people, who were part of a wider movement opposing oil sponsorship of the arts – Art Not Oil. A group of artists and activists held hand-crafted placards declaring 'Artists are angry' and interpreted the spill performances for guests: in the bunch was Matthew Todd, the editor of *Attitude* magazine, the performance artist Hayley Newman who later joined the hub of Liberate Tate, and the artist and educator Jane Trowell from Platform, an organisation that is a long-standing critic and creative provocateur of oil and its cultures. Platform's press officer Kevin Smith ferried himself between soundbites and interviews, and videographer Tom Costello captured every splash. Many of the artists who had gathered had signed

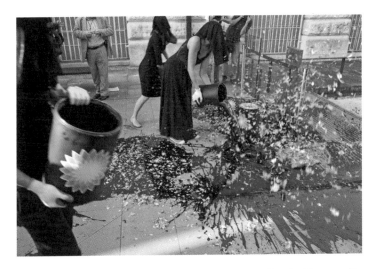

Figure 1.2: *Licence to Spill*, Liberate Tate, June 2010, Tate Britain. Photo credit: Immo Klink, 2010.

a letter in *The Guardian* that day, calling for an end to BP sponsorship of Tate. Signatories to the letter included the playwright Caryl Churchill and the artists Sonia Boyce, Hans Haacke and Suzanne Lacy.

A chorus of voices critical of alliances between art and oil in the city has since risen up, and oil sponsorship of the arts is becoming increasingly controversial in the UK and around the world. Soon after novelist Margaret Atwood expressed concerns about Shell sponsorship of the Southbank Centre in a presentation of her work revolving around art and climate change, the Southbank Centre's five-year-long sponsorship deal with Shell came to a close. *Artwash* will visit art museums around the world where Big Oil – the multinational power glut of petroleum conglomerates – has made an appearance. Of the galleries in London that accept oil sponsorship, it is Tate with which I am most intimately engaged. The changing exhibitions always bring something new to my attention with clarity and depth. Tate's vast collection of surrealist work is a real treasure and the Beuys exhibits remain a favourite. The buildings themselves are part of the delight: Tate Britain on Millbank, London; Tate Modern at Bankside, London; Tate Liverpool on the docks, Liverpool; and Tate St. Ives, on the sea

shore in Cornwall. Each one is distinct, but the four share a certain spacious, sacred – yet somehow not overly pretentious – core. The first time I visited Tate Britain the BP logos remained at the margins of my perception, but once the corporate message registered, my visiting experience changed. I'm glad of this – I want to be clear about how often visits to Tate incur regular, delicate imprints in my mind of a green and yellow 'helios'. This is the reason I set out to examine here the impact of oil branding in the art museum, with reflection on the various galleries around the world that accept oil sponsorship. I do this from a position connected to Liberate Tate, Platform and Art Not Oil, without wishing to speak for all involved in this movement but rather aiming to reflect some questions back at the picture we are collaboratively painting.

From the Thames, via the Atlantic, to the Gulf, the tides connected the two sites of Tate's party and BP's catastrophic spill. The link was both fluid, via the oceans, and solid, in BP share value, because BP's relationship with Tate was fundamental to the company's survival of the disaster. There is a cynical PR strategy central to every oil sponsorship deal, and the companies themselves do not deny this: sponsorship consultant Wendy Stephenson, who delivered many of BP and Shell's arts sponsorship contracts in London, says that 'they milk the sponsorship for what its worth.'[1] Oil companies' desire to associate themselves with prestigious arts institutions is a survival strategy of an industry that itself feels increasingly precarious, both upstream and downstream. In the theatre of the global public relations and brand management industry, arts sponsorship becomes a way for the global, transnational corporation to present and benefit from a nationally specific brand identity; it offers a pretence of corporate responsibility for the callous profiteer; and becomes an illusionary act of cultural relevance for outmoded industries. Many risks accompany the presence of Big Oil in major cultural institutions across the world: the political influence allowed to the oil lobby, stymying efforts to tackle climate change; the uncomfortable disjuncture between the oil sponsor branded on the entrance of the gallery and the artworks, learning programmes and curatorial intentions of specific exhibitions;

and the restraints put on our imaginations through Big Oil's co-optation of these spaces meant for creativity and reflection.

A visit to a gallery opens doors to moments in history when the present is made. It can bring the ideas of artists – who, walking the earth centuries apart, never would have crossed paths – into conversation with each other. The dialogue between visitor and artwork is varied and open-ended. I want to ask, where does Big Oil fit into that conversation? While a visitor to the Turner Prize final selection in 2012 stood seemingly engrossed in Paul Noble's *Homeland*, their mind might also have been filled with Spartacus Chetwynd, and those other things they saw: the map of the gallery, the names, the phrase 'sponsored by BP'. If the sign had no impact whatsoever, it simply wouldn't be worth putting it up: the fact of its very existence warrants critical discussion over the impact of those few words, 'sponsored by BP', 'supported by Shell', 'in association with Chevron'. However discreet, however small, these words have purpose and they have effects. What does the presence of an oil company *do* to the galleries they sponsor? What are the material and aesthetic impacts? How does the curatorial control of the gallery differently extend to staff, artists, visitors, members and corporate sponsors?

In the context of cuts in state funding for the arts, corporate sponsorship looms as an inevitable route – but these debates are riddled with ideological strategies and misleading narratives. This situation should not restrict anyone concerned with ethics and the arts from taking a critical stance on the arguments made by Tate staff and British civil servants under the all-consuming dictum of 'Austerity Britain'. Oil sponsorship is one small, replaceable thread in the multi-coloured cloth of the organisational incomes of large galleries in the UK, North America and Europe. Anyone working in the arts will have had first-hand experience of shifting funding terrains that require constant renegotiation. Power over these decisions is tangled: members and gallery-goers hold a stake in these spaces, but stand at a remove as audiences, while artists and staff share potential influence and precariousness since they are both essential and vulnerable to the institution. Crucially however, galleries can and do change. Shifts take

place when voices within and around coalesce in harmony to shape the institution as they see fit.

The question of oil sponsorship is sometimes submerged into the many considerations that arise with all corporate arts sponsorships. Although associations with certain companies, such as banks or car manufacturers, bring up related ethical questions, the singular impacts of oil make a narrow focus on oil sponsorship both necessary and urgent. The oil industry is responsible for some of the most devastating social and environmental disasters in history. At every stage of the industrial process from extraction to transport and refinery, the sector has created countless catastrophes. Eleven people died in the explosion on the BP Macondo rig in the Deepwater Horizon field, Gulf of Mexico, and sixteen were injured: these terrible risks are more often associated with joining the armed forces, not extracting oil. Drilling rigs like the Macondo have exploded numerous times, killing the workers on board. In 2012, 154 people died on the Chevron KS Endeavour exploration rig in the Funiwa field, Nigeria. Oil tankers at sea are another source of nightmares for the industry and feature in a heavy catalogue of oil's most apocalyptic moments. The counter climbs to over 9,500 tanker spills to date, depositing thousands upon thousands of oil into the oceans to be washed up along the shores. Oil pipelines, the arteries of the industry, are notorious for causing immediate community disruption and frequent accidental disaster. In Nigeria, up to 2,500 people have been killed in oil pipeline explosions between 1998 and 2008. In 2013 an ExxonMobil pipeline bearing tar sands oil from Canada burst in Arkansas and spewed out 1,000 tonnes worth of its contents. The spill basin included twenty-two homes, and forced residents to evacuate. And potential for accident awaits crude oil upon reaching its destination: refinery explosions around the world have wrought devastating losses of life. However shocking they may be in cause and consequence, these incidents are far too frequent to seem surprising.

Further to catastrophic events, oil extraction produces daily social and ecological harm. Despite its illegality since 1984, some oil companies in Nigeria continue to flare, or burn off, unwanted natural gas as a routine practice of oil extraction by crafting ways to

circumvent the law. Toxic chemicals released during gas flaring have been linked with chronic illnesses including respiratory problems and skin conditions. Shell pledged to phase out the activity by 2008, but has since postponed its commitment year on year, unfazed by condemnation from local and international civil society groups. In 2010 Shell burnt 22 billion cubic metres of gas, which was equivalent to 30 per cent of North Sea gas production in the same period. In Canada, numerous First Nations groups have joined together to oppose tar sands expansion because it denies communities access to indigenous lands and livelihoods; the extractive method has also been linked to increasing cancer rates and decreasing deer populations. Resistance to oil pipelines is global: communities in Azerbaijan, Georgia, Turkey, Egypt, Ireland, Ghana, Nigeria, Chad, Cameroon, Canada and the USA are all engaged in ongoing campaigns against the pipelines built and proposed to be built in their respective regions because of the disruption to land use and risks associated with living in the proximity of a monstrous and foreboding oil pipeline.

From UN report findings to scrawled peace protest placards, the capacity of oil to exacerbate war and conflict has been noted on every continent. The influence of oil companies in the decision of the US and UK governments to attack Iraq in 2003 is summed up in the minutes from a meeting between BP and the British Foreign Office, which state: 'BP is desperate to get in there and anxious that political deals should not deny them the opportunity.'[2] Smaller oil companies Tullow and Heritage raised capital to drill exploration wells on the border between Uganda and the Democratic Republic of Congo, in the same month that 30,000 people fled North Kivu during two weeks of fighting in the region. With reference to British Foreign Office emails and US diplomatic cables Platform and Corporate Watch accused Heritage Oil, founded by former private mercenary Tony Buckingham, of bearing responsibility for the death of six Congolese civilians near an oil exploration site in 2007,[3] and a Platform source found Heritage had equipped the DRC military with boats and jeeps in 2010.[4] In Nigeria, Shell is alleged 'to have transferred over $159,000 to a group credibly linked to militia violence.'[5]

These examples of the relationship between oil and conflict also demonstrate an uncomfortable pattern of the industry to re-inscribe colonial geographies. BP, Shell, Chevron, ExxonMobil and Total's operations in Iraq, Iran, Nigeria, Uganda, Madagascar, D.R.C. and Angola trace the shape of nineteenth-century British, French and Portuguese colonialism. BP originated as the Anglo-Persian Oil Company (APOC) to drill for oil in Iran in 1909 with the objective of fuelling Royal Navy warships, and in the following decades it formed subsidiaries to drill in Mesopotamia (now Iraq) and Kuwait. When Iranian Prime Minister Mohammad Mosaddegh announced the nationalisation of the Iranian oil industry and said that AIOC should 'return its property to the rightful owners',[6] the British government co-ordinated an international boycott of Iranian oil. British Prime Minister Winston Churchill recruited the US president Dwight Eisenhower to deliver a *coup d'état* and remove Mosaddegh from power. Mosaddegh was overthrown in August 1953; he was held in prison for three years and then kept under house arrest until his death in 1967; the state ordered his burial to be held in his home for fear of a public outcry. BP began life intertwined with British military activity; it survived thanks only to British imperialism, and at the start of the twenty-first century it again sought British government intervention to secure access to oil in the Middle East.

After over a century of quests for oil and disputes over access, Big Oil companies have begun to escalate environmental risk-taking, since the remaining or available sources of oil are more remote and increasingly difficult to seize. Oil rigs that once populated shorelines creep further out to sea into deeper waters that bring an unknowable host of new safety challenges. Drilling methods compete with millennia-old geologies to crack oil and gas shale rock in vast swathes of land and below the seabed, as part of a highly controversial drilling process known as hydraulic fracturing or fracking. Canadian tar sands are potentially unprofitable when the global oil price dips due to the high cost and increased carbon emissions involved in the production of synthetic crude. The continuation of the practice illustrates another facet of the scramble to procure oil: the devastation of precious landscapes. In Canada tar sands strip mining decimates the ancient

boreal forest to below ground level and leaves the land contaminated with a toxic sludge industrial waste product which is laid to rest in tailing ponds the size of large lakes. Further towards the polar north, companies try their hand at grasping oil reserves deep beneath the icy Arctic waters, nonchalant in the face of the extreme risks of a spill in isolated locations and sub-zero temperatures.

At a time when extreme weather events are increasing and scientists agree that climate change is one of the biggest threats we face, oil companies are not only directly responsible for a significant amount of global carbon emissions – since 1854 almost two-thirds of industrial carbon pollution emitted into the earth's atmosphere can be traced to fossil fuel companies and extractive industries – but certain companies have been exposed as silent funders of climate science denialists. In 2009 *The Guardian* newspaper revealed ExxonMobil had continued support for groups that promote climate science denial despite a public pledge to withdraw funding. In 2010 the Brussels-based NGO Corporate Europe Observatory disclosed BP's admittance that it provided funds to the Institute for Economic Affairs even though the company was fully aware of the organisation's denial of climate science.

The unethical singularity of oil company arts sponsorship reeks of the industry's spills, tailing ponds and contaminated rivers. Yet oil sponsorship is commonly regarded as unchangeable, just as petrol is considered to be a fixed facet of modern life. The perceived immutability of oil is used as evidence that no change can take place. And yet the question of oil is answered daily by British government civil servants writing foreign policy documents for North Africa and the Middle East, by fumbling diplomats in powerful cliques at unwieldy global climate policy summits, by power company executives as they bask in multiplying profits: these are not predestined outcomes, but decisions taken and enacted. Critics of the oil industry regularly meet the objection that anyone who has used oil or its products is in no position to challenge the industrial practices of Big Oil. This support for oil is short-sighted; if there is a power profiting from the infrastructure that makes up – and concurrently risks – our entire lives, we must interrogate it. When the widespread harm of the oil industry is pushed

aside in this way as merely a collateral damage of a necessary act, a war mentality demanding collective amnesia in pursuit of a greater goal dangerously pervades our daily existence.

The tides are hesitating however – aching to ebb. Investment bankers raise eyebrows as many join the chorus warning that oil stocks are approaching their sell-by dates. A societal shift from oil is a broader question, but it is crucially linked to that of sponsorship.

The petrol station scene is a familiar one, in film and in art. The car pulls in and the viewer knows the ritual instantly and intimately, whether the setting is a dusty North American desert or a beating European metropolis. But growing oil consumption in post-industrialised countries is not inevitable. Alternative sources of heat, transport and power both exist and evolve. Despite its mundane regularity, oil is historically peculiar and not essential to human life on earth. Oil dependence is a social standard constructed daily by those who benefit from the vast profits made possible by extreme risk and exploitation of land, homes and habitats. In the global casino that is the international oil industry, arts sponsorships play a vital role in securing access to power and acceptability in the eyes of consuming publics. Through the arts the oil industry embeds itself in cultures, as the creator of our lives, a disguise to mask its shadowy presence as a threat and force of destruction. The ending to the story is as yet untold however, and the script remains open to edit. The use of oil can be questioned, and so too can oil sponsorship of the arts.

Naomi Klein, author of *No Logo* and *This Changes Everything*, succinctly points out in response to the climate challenge, that: 'Humans have changed before and can change again.'[7] Art galleries house a visual history of cultural shifts, turns and re-awakenings. In every difference from one generation and school of thought to the next, the museums suggest change is a core part of what societies are, and that culture itself is a process of change. As cultural shifts take place, the arts play a role in shaping, articulating, understanding and embedding those changes. Galleries and museums are important cultural sites in which we understand our lives and society – and in which we imagine the future.

Art and performance are therefore both the subject and object of *Artwash*. The arts are the location and the method to be examined: the performative manoeuvres of oil companies on site at the art museums are under examination. Associations with high art are sought by oil companies in their mission to perform a role of Corporate Citizen. Therefore to 'artwash' is to perform, to pretend, to disguise. As a verb it resembles several other laundering processes: 'whitewash', to cover up, or 'greenwash', to make polluting appear environmentally friendly. BP are familiar with greenwashing: their advertising campaign for a new millennium, 'BP: Beyond Petroleum', presented the oil company as undergoing a transition to producing renewable energy instead of fossil fuels, despite a minimal investment in renewables that was cut from the company portfolio altogether shortly after the brand revamp. Also in cultural parlance is 'pinkwash', a publicity campaign for governments to appear liberal by way of promoting policies around LGBT (lesbian, gay, bisexual, and transgender) issues, for example the Conservative/Liberal Democrat coalition's support for gay marriage during social spending cuts. Like all these various washes, to artwash is to do one thing in order to distract from another.

But it is more than this too. The wash is made possible in the act, the performative moment in which companies take on a thoughtful, refined, cultured persona deigned for an audience of special publics – opinion-formers occupying influential positions in the media and politics. Not only does art cover up the negative attributes, but the company re-performs its brand in a new disguise. Tina Mermiri, previously a researcher with the corporate sponsorship lobby group Arts & Business, coined the term artwash as a caution to indiscreet sponsors, when she said: 'Businesses that simply try to art wash themselves in order to restore trust, will not always succeed.'[8]

Performance is a core part of communications. This rule applies from public relations to protest. To artwash is therefore part public relations and part theatre. Well before Erving Goffman, Shakespeare's *As You Like It* described the aspects of performance in everyday life in Jaques' famous soliloquy:

All the world's a stage
And the men and women merely players.[9]

Stemming from Goffman, Judith Butler and others' analysis of social performance, performance studies looks at human existence in the world as a large-scale piece of theatre. Oil companies' practice of artwashing places its characters on the stages of art museums around the world to play out a persona that can bring material effects. The performance of Corporate Citizen is a necessary act to maintain a guise of social acceptability.

And yet the visual image of oil company logos in gallery spaces jars nonetheless. Imagine any Tate gallery littered with British American Tobacco logos. The picture alerts suspicion. Where oil companies seek to polish brands in the gallery, Big Oil in fact sets up a dialectic between art, environment, ecological destruction and ethics. While sponsorship serves to artwash oil companies, it concurrently evokes negative reactions to the industry. The stage is set with multiple players who shape the drama in opposing directions.

Both inside and outside the international art museum, arts funding is a hot topic. Oil sponsorship arrives in a story already thick with characters and sub-plots that shape how artwash works for the oil industry. Chapter 2, 'Big Oil's artwash epidemic', paints a picture of oil sponsorship around the globe, and considers previous incarnations of debates on ethical funding in the arts by looking at tobacco and arms sponsorship.

Across Europe, corporate sponsorships have been framed as a perfect plug to fill the gap left by government arts spending cuts, despite counting for relatively little of many large organisations' income. Chapter 3, 'Capital and Culture', dissects narratives that present corporate funding as vital in the current economic climate, or acceptable in light of government agreements and galleries' ethical policies.

Oil company spokespeople often claim to be fans of the arts. Their claimed calling to sponsorship is however belied by senior figures in public relations and high-level corporate staff themselves. Despite making appearances at opening nights and private views, comments recorded at annual general meetings and business sector events unsettle the still façade. Chapter 4, 'Discrete logos, big spills', sheds

light on the PR strategy that evolved to manage public perception of the oil company brand, in lieu of actually altering operational standards.

Chapter 5, 'The impact of BP on Tate', uses Tate's mission to increase the public's 'understanding and appreciation of British and contemporary art'[10] as a frame to investigate the impact of oil sponsorships on galleries around the world. Many of the art museums that oil sponsors select are public galleries, which as such hold a special place in the national imagination. The juxtaposition of specific galleries and exhibitions with Big Oil catalyses an uncomfortable tension for audiences, disrupting and inhibiting the real work of the gallery.

Chapter 6, 'Opposition to oil sponsorship', looks at performance protest, critical museology and institutional critique to consider artist strategies to affect change in galleries. Corporate – including oil – cultural sponsorships have previously been subject to artists' scrutiny across the world over several decades. A genealogy of creative disobedience in gallery spaces has cross-fertilised to challenge corporate power and gallery ethics. This global beehive of creative intervention shares some stamps of parallel practices. Where the art has been used in an act of dissembling, performances of public rejection of oil expose the disguise for what it really is. The potential efficacy of these groups gives rise to the unravelling of artwash.

The role of art in society is a hotly contested territory, from debates about censorship to concern around instrumentalism, but the playing out of a corporate agenda within the territory of arts and culture is an important dimension to this debate. The case against oil sponsorship is part of broader resistance to corporate power in public spaces and over public and political life. All the main characters in this story are interested in art, what it is and what it can be. As artists strive to express their ideas, and community arts workers around the world seek to use the arts to enable others to find fulfilment in their lives, the insidious co-optation of the arts by Big Oil looms as an ugly stain on our cultures.

In late 2013 John Keeling's graph of rising carbon dioxide levels in the earth's atmosphere marked the point many had wished it would never reach. Carbon dioxide reached 400 parts per million (ppm). The safe level was back at 350 ppm, and climate scientists warn 400

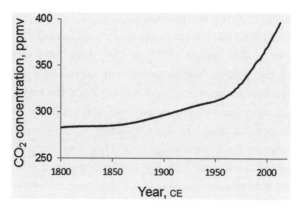

Figure 1.3: *Carbon Dioxide Concentration* ©Simon Lewis, 2014.

Carbon dioxide in the atmosphere, measured in parts per million by volume, 1800–2013. Data from 1959 onwards is the Keeling Curve, of direct measurements of atmospheric CO2. Data: annual measurements of CO2 in the atmosphere from 1959, from Mauna Loa, Hawaii, and from 1800 to 1955 from air bubbles trapped in ice, from the Law Dome ice core from East Antarctica (version with seventy-five-year smoothing).

ppm risks irreversible and dangerous changes. The Keeling Curve is an artwork in itself: historical projections followed by painstaking measurements plotted conscientiously over a fifty-year-and-counting duration, each dot signifying a new set of possible challenges. The shape of the curve in its full eight million year mapping is swift and unforgiving, the upward route in recent times looking skyward, questioning the gods. Many galleries profess their concern about global warming and publicly announce their carbon dioxide reduction schema. But do influential actors like Nicholas Serota and Lord John Browne begin to consider the detrimental impact on climate action embodied by oil sponsorship of the arts? If we are to dream, to sketch and to create ways of living that reduce human impact on the planet's ecosystems, we cannot allow our imaginations to be filtered by Big Oil. Galleries' associations with oil companies are not financially inevitable or otherwise beyond challenge. It is a choice that must remain open to question, and therefore to change.

At Tate's Summer Party 2010, at around 7.45pm security staff were ready to conduct Anna and me out of the building. Two burly

men brought over large black screens to surround us and our messy molasses spill: we thanked them for helping with the clean-up and cover-up operation. Upon being calmly ejected from the building, we could see the artists' protest continuing and Tate cleaning staff beginning to reckon with the twelve oil barrels' spill – some of whom were Colombian emigrants and said they understood fully why people might object to BP. The events continued inside, but the morning's newspapers told the spill story first, and pictures from Liberate Tate's performances appeared in print and on websites around the globe.

It was Tate's party, it was BP's – but it was ours too. We were all there at that moment: the naysayers, the stunt-makers, the corporate lackeys, the undecided and the stuck-in-the-mud, the hard-working staff and the ones who call the shots. We've been crossing paths and debating the issues ever since.

2
Big Oil's Artwash Epidemic

Whenever arts sponsorship enters the conversation, someone is sure to pipe up, given a downbeat, with the history of arts patronage and the Borgia dynasty: when monies made by mafia-like factions in the upper echelons of fifteenth-century European society shaped Renaissance artists' endeavours. Although a popular television drama in the USA, Rodrigo Borgia's influence over artists in the fifteenth-century papal fiefdoms that make up modern-day Italy is probably not the best social standard to measure gallery practices by today. Rodrigo, as Pope, was only answerable to himself for his morals; now, five hundred years on, ethics are debated publicly.

Most galleries around the world now inscribe appreciation for donors – from foundations and individuals to corporate sponsors – on the walls of their foyers and entrances. Before marching into line for a ticket, dropping off coats, hitting the shop or nipping for coffee, stop off at these monuments to funders and bask in the display of elite graffiti yelling: I was here. Mark the difference between donors who choose to remain anonymous and those that prefer to be singled out as primary sponsors. Note the surprise candidates, the sharp guttural reactions, and the warm fuzzy feelings in response. These revered tags at the gates of cultural institutions become a seed of hope not to be forgotten in the history books.

The array of names has shifted between different sectors over decades. Various industries have experienced successive urges to seek peace with a critical public. While family endowments and legacies continue, company sponsorships shift and swap with the changing weather of public opinion. But positions on the list are not to be taken for granted by corporations: an offering ultimately invites rejection.

Tobacco and arms manufacturers: ethics and sponsorship

The story of ethical dilemmas around corporate sponsorships has been played out before – with a different cast, but on similar stages. In place of BP and Chevron were Imperial Tobacco and British American Tobacco, antagonists in the tobacco-advertising saga that spanned the second half of the twentieth century. Challenges to oil sponsorship resonate with questions of ethics in the arts raised by people around the world in a bid to end tobacco and arms sponsorship of cultural institutions and events.

Tobacco sponsorship saw the final loss of social licence when, following decades of limitations on advertising, sponsorship of arts and sports events was banned in several countries including the UK, Canada and Australia. With a new millennium came a bounty of legislative ambition. Government passed the UK Tobacco Advertising and Promotion Act in 2002, comprehensively banning the advertising of tobacco products and commencing a phase-out of brand promotion through cultural and sports sponsorships by 2005. The European Parliament and Council swiftly followed with a directive in 2003 to regulate tobacco sponsorship across member states. That same year, a Canadian policy passed in 1997 came into effect prohibiting the display of tobacco sponsors' branding at arts or sports events. Australia legislators orchestrated the full eradication of tobacco sponsorships by 1996.

Policy follows the people in moments of cultural change. These laws did not presuppose public anxiety around the association of tobacco with major cultural events, but were shaped by a tidal shift in public opinion that pushed tobacco sponsorship to the margins of social acceptability. A cultural artefact that was once background noise became a screaming anathema over the course of a twenty-year period of intense debate and criticism. When proponents of oil sponsorship claim the arts-oil deals are merely lawful, end of story, they sidestep an essential part of the democratic process that guides social policy change: public opinion.

Cultural institutions often manifest public opinion. The National Portrait Gallery amplified the sea change in public feeling towards

tobacco sponsorships in the UK when in 1992 it cut its ties with Imperial Tobacco. The company had sponsored what was first known as the Imperial Tobacco Award, which it later retitled as the John Player Portrait Award to promote a new brand of cigarettes. As a parting gesture the National Portrait Gallery held an exhibition commemorating the sponsorship entitled 'The Portrait Award 1980–1989: Ten Years of the John Player Portrait Award', marking a certain finality to the relationship. The academic Chin-tao Wu's meticulous documentation of two decades of corporate sponsorship in the USA and the UK, *Privatising Culture*, offers insights into gallery strategy, political influence and corporate involvement in the arts on both sides of the Atlantic. Wu infers the subtext in the director's decision to delegate the word of thanks to the sponsor in the exhibition brochure to an outside critic: 'The director's silence eloquently articulated the fact that the heyday of tobacco arts sponsorship was now over.'[1] BP succeeded Imperial Tobacco as the sponsor of the Portrait Award in 1989.

In other frames of public life, campaign groups nudged the tides to turn. Action on Smoking and Health (Ash) offered government a health warning, that the 2002 Act would save 3,000 lives a year.[2] Ash countered ministers' fears that sports events might struggle to replace tobacco sponsors, arguing that sponsorships would necessarily find substitutes due to the existing market value of the original deals. By the very attractiveness of associations for the tobacco industry, it was certain fellow corporate 'malefactors' would snap up tickets to the sports sponsorship party. When the laws were finally passed, the government gave companies and cultural events alike a five-year notice period – in motion from 1997 – to bring sponsorship arrangements to a close. Ash argued that this allowed sufficient warning for both sponsors and arts or sports organisations to amend their contracts and build relationships with alternative donors. They questioned government proposals to offer state-aid for large sponsorship deals, arguing that the size of certain contracts only served to demonstrate the value of the association to the tobacco company in question, and signalled the appeal of the arrangement for other potential sponsors. In all the countries that took up the ban, another chorus line was waiting in

the wings. Corporate sports sponsorship actually increased following the tobacco bans, with multiple sectors dashing to grab the valuable asset the tobacco industry desperately sought to retain. The higher the price of the ticket, the better the seat at the table of access, influence and brand-promotion. The withdrawal of tobacco sponsorship did not leave arts and sports events wanting.

In 2003 Ash supported an artist who forced British American Tobacco (BAT) out of sponsoring an exhibition at the Old Warehouse, London.[3] As part of an exhibition of new work by contemporary artists in association with the London Open House annual weekend event, titled 'We love to kill what we love' – bearing immediately painful implications when juxtaposed with tobacco sponsorship – Simon Tyszko inserted anti-tobacco messages into his video installation to alert audiences to BAT's presence, following which BAT withdrew its sponsorship. It was a low profile exhibition, enjoying the dirty glamour of a temporary gallery space. BAT's choice to sponsor the event reveals a keen eye for the opportunity of association with young emerging artists, the kind who must surely smoke socially, and who could tie the sponsorship arrangement up in neat smoke rings at the private view. The new branding strategy post-advertising ban – before the introduction of laws around sponsorships – backfired for BAT.

Large sports events became symbolic of the wider issue. What took place on the grand stages of global sporting arenas would shape changes across the board. For Ash, specific companies' influence on sports events hindered the organisers' aims:

> We believe there is not a single Formula One team that could not replace its tobacco sponsorships by 2004. In fact, it would probably benefit the sport by breaking the stranglehold of Marlboro/Ferrari/ Schumacher partnership, which has turned the Grand Prix into a tedious spectacle.[4]

Beyond characterising sponsorship as simply replaceable income for sports organisations, Ash called out sponsors' potential to stifle the event atmosphere. Formula One had announced in 1998 that it could replace tobacco sponsorship within four years, bolstering the case for

phasing out the deals, which ultimately ended due to an EU ban in 2007.[5] Nonetheless, Ferrari continues to accept funds from Phillip Morris – Marlboro's parent company – having signed a contract that extended to 2015.

As tobacco sponsorships came to a close, Ferrari began a partnership with Shell. Having started in 1995, the promotion was significantly ramped up in 2004 with the end of tobacco deals and the launch of Shell's 'V-Power' fuel. Like the move from Imperial Tobacco to BP at the National Portrait Gallery, Formula One's seemingly natural step from tobacco to oil sponsorship demonstrates the similar value of such associations for Big Oil as was for tobacco: both are operating at the margins of social acceptability. A person smoking a cigarette in an advert from 1975 now looks dated and uncomfortable, just as billboards advertising car manufacturers that once bore slogans selling high speeds and roaring engines now claim fuel efficiency and ever-improved emissions standards.

The health impacts of tobacco which shaped public perception of the product have been widely documented from the 1960s onwards. Oil occupies a somewhat different role in the daily life of industrialised societies, but due to the harm to human health of car emissions, power pollution and smog, petrol-related sectors have faced policy restrictions in the EU and North America since the 1990s. The ecological damage of oil is significantly worse than tobacco, and Big Oil's associations with human rights abuses further singles out the industry for concern.

Tobacco is not the only sector to have been cast out: arms sponsorship has been deemed an inappropriate arts funding source in the UK by numerous institutions including Tate and the National Gallery. Like tobacco, discussions around ethics and sponsorship have found fault with any allegiance between art and armaments. Again, the logic flows like water now – of course arts institutions would draw the line at associations with industries that profit from death and destruction, and such sectors are unfit for the opportunity to mop up their sullied image in the stately galleries of the capital city.

Tate withdrew from a deal with arms manufacturer United Technologies in 1986 after artists objected to the arrangement.[6] Tate followed up this move with a statement drawing a clear line at arms –

and tobacco – as sources of corporate sponsorship it would not revisit: 'It [Tate] does not accept sponsorship from tobacco companies or companies dealing in armaments.'[7]

By making this statement over fifteen years before tobacco sponsorship was outlawed, Tate played a role in the growing cultural shift away from arms and tobacco sponsorship, influencing public policy rather than adhering to laws only once in effect. The social stigmatisation of arms sponsorship continues. Member-funded civil society organisation Campaign Against Arms Trade, among others, accelerates the ethical journey of institutions that hold arms sponsorship deals, which includes the London Transport Museum and the Imperial War Museum, in a project they call 'Disarming the Gallery'.

Faced with this kind of opposition, the Italian arms manufacturer Finmeccanica withdrew sponsorship from the National Gallery in London. Criticism from the writer Will Self and the artist Peter Kennard sparked the break. Self and Kennard joined other artists calling for an end to the deal because they felt there was a conflict between art and arms:

> How can an institution which celebrates the creative spirit of humanity open its door to those dealing with products designed to kill and destroy?[8]

Kennard's work in particular reflects the sentiment expressed in the artists' objection. Tate holds fifteen of Kennard's artworks, including *Haywain with Cruise Missiles*, an early work from 1980, which exemplifies the artist's style and focus. The serene pastoral landscape of John Constable's *Haywain*, painted in 1820–21, is rudely interrupted by Kennard's positioning of missiles on the delicate horse-drawn cart paused crossing a ford in the centre of the painting. The first *Haywain* revelled in the beauty of a tiny village in East Anglia; in the second, Kennard critiqued the arrival of a US military base in that same location. The dissonance between the military and the agricultural mirrors the disjuncture between arms manufacturers and the National Gallery. As part of the widespread reaction to arms sponsorship at the National Gallery, in BBC 3's *The Revolution Will Be Televised* the actors Heydon

Prowse and Jolyon Rubinstein installed a *Haywain with Cruise Missile* print on one of the gallery's walls.

The three-year deal was terminated in 2012 after running for two years only. The contract contained a cancellation clause making it possible to end the arrangement part-way through the intended time period. This is significant for oil sponsorship: even if a deal is made in the long term, either party can break it off under the ordinary terms regarding return of unspent funds or waiver of obligations in *force majeure* cases – extreme weather events, strikes, protests and so on. According to standard sponsorship contracts, if the sponsor cancels the contract it would usually be expected to maintain payments during the current financial year, conversely if the sponsored organisation drops the deal, further years' funding is forfeited. Finmeccanica brought the arrangement to a premature end weeks before the end of year two of the contract, which may have allowed them to avoid obligations to pay the final annual sum.

Connections between the two industries run deeper than sponsorship contract terms. Oil and arms have a history, from the origins of BP and Shell to current security demands of oil extraction, transport and processing. The escalation of conflict in oil-rich regions is one facet of what is now widely referred to as 'the resource curse'. In another connected industry, oil and chemicals transport company Trafigura faced intense criticism amid revelations of its toxic waste dumping in Côte d'Ivoire – and objection spread to the Trafigura Arts Prize. In 2009 the Cynthia Corbett Gallery in London dropped the sponsor in response to public concern about the company and the competition, which ramped up at the announcement of the 'Alternative Trafigura Arts Prize' in direct opposition to Trafigura sponsorship. Another arts competition faced criticism from entrants in 2011: the TS Eliot Prize was revealed to include prize money from the hedge fund manager Aurum, to which high-profile poets Alice Oswald and John Kinsella objected and duly boycotted the competition – Oswald having commented: 'Poetry should be questioning not condoning such institutions.'[9]

Artists and cultural workers in London and Sydney have questioned sponsorship of the arts by the multinational migrant detention centre contractors Transfield and Serco. In both cases political protest in

reaction to the tightening immigration policies and terrible living conditions inside detention centres drew attention to the companies' attempts to artwash. Criticism of sponsorship and government policy in both countries intensified when the detainees rioted in an offshore Australian detention centre on Manus Island, Papua New Guinea (which Transfield was in the process of taking over, alongside another offshore centre on Nauru Island), in the same month as protests were held at the Home Office in the UK to highlight the treatment of female detainees in the Serco-operated Yarl's Wood detention centre in Bedfordshire, England. Cultural sponsorships were the next port of call for objections: artists boycotted the Sydney Biennale because of Transfield's sponsorship, and activists criticised Serco's sponsorship of the London Transport Museum's Prize for Illustration.

In both cases the discord between creative freedoms and incarceration is as sharp as smashed glass in a picture frame. Liberate Tate's statement of support for the Australian artists' boycott echoes the sentiments resounding around the Finmeccanica deal:

> Thinking of the many refugee artists who have been able to practice and make work only by finding asylum and continuing to work in exile – Lucien Freud, Paul Klee, Wassily Kandinsky, Max Ernst, Marc Chagall, Anish Kapoor, Mona Hatoum, the list goes on – is it not a disrespect to their memory, story and experience for the Sydney Biennale to accept funds from a sponsor currently engaged in the incarceration of exiled people?[10]

Freedom of movement and freedom of expression are intertwined questions which arts sponsorship by a detention centre operator bludgeons through destructively. The weight of this contradiction was felt by those connected to the Biennale in all respects, from staff, volunteers, artists and curators, and the directors ended the Transfield sponsorship within weeks of the boycott.

As organisations that carefully reflect on politics and social practice, and that share a commitment to the public, evidently arts institutions of all shapes and sizes see a need to draw a line at what constitutes ethical sponsorship. Patrick Steel, part of the Museums Association (MA) in

the UK, recommends a cautious approach to sponsorship: 'Commercial sponsors have an agenda to promote and are answerable to private interests. The first responsibility of museums is to the public.'[11]

The oldest organisation of its kind, the MA was set up in 1889 and remains entirely member-funded. Conversations around sponsorship concerns are part of the water-cooler improvisational script for staff working in the cultural sector. A boundary tape has been pulled around various issues by different organisations at numerous moments in history making the process a familiar one: it can and will happen again.

Oil sponsorship of the arts around the world

Imagine a globe garnished with silky black ribbons, each tying a connection between oil companies' headquarters, the many locations of their drilling apparatus, and the numerous cultural institutions the companies sponsor. A pattern emerges threading regional arts centres with local sites of extraction in some parts, and knitting together blockbuster museums with financial and political hubs on other shores. Big Oil's allegiance with the arts is now a global phenomenon.

In Europe, oil companies sponsor the arts in Italy, France, Germany, Norway, Sweden, Ireland, the UK and Russia. The French company Total forms allegiances in the persona of its subsidiary the Total Foundation. The trust funds exhibitions at several Parisian museums including the Louvre and supports the work of the Fondation du Patrimoine (Cultural Heritage Foundation), which operates across France. It has a special programme titled 'Sharing the world's cultures' through which Total brands exhibitions of art from the various regions of the world in which it also holds stakes in oil fields. Numerous oil companies follow this trend to collect art or sponsor exhibitions in the places the company extracts oil.

Italian oil company Eni has sponsored exhibitions at the Louvre, as well as other international art museum heavyweights including the Metropolitan Museum of Art in New York and theatre events at the Barbican, London. Eni is associated with a wide range of arts and classical music sponsorship deals in Rome, Milan and Bologna. So far

Eni and Total sponsorship deals have evaded criticism and protest. Russian, Norwegian and Swedish oil companies have not been so lucky. Gazprom (the Russian oil major that gained unwanted notoriety after Russian authorities arrested Greenpeace activists aboard its rig in the Arctic in 2013) sponsors a number of arts and sports events in Russia, China and across Europe. The member-funded global direct action organisation Greenpeace has targeted Gazprom at several of the European Champions League football games at which the brand appears.[12]

The Norwegian oil company Statoil sets up sponsorships that, it says, 'build our brand'; this includes a number of arts and music sponsorships, especially focusing on projects involving young people. Statoil is also an art-buyer, and uses its offices to hold regular exhibitions in the oil capitals of Oslo, London, Calgary, Baku and Houston. Alongside this, the company sponsors exhibitions at the Oslo Gallery for Contemporary Art and, akin to the twenty other arts festivals in Norway that receive oil sponsorship from various companies, Statoil stamps its name on the Festspillene i Nord-Norge (the Festival of North Norway) and the Bergen International Festival.

The latter event drew significant negative attention for the oil company in the national press.[13] The drama of the debate mounted when the opening act at Festspillene i Nord-Norge, Amund Sjølie Sveen, asked the audience to vote on whether Statoil sponsorship should continue.[14] More was to follow: a singer from Norwegian pop band Team Me, Synne Øverland Knudsen, joined the throng and argued:

> Experience shows that it is possible to survive as a festival without oil sponsorship. It is a shame that these arrangements put both volunteers and the public in a moral dilemma. With all we know now, there are nothing but valid reasons to have a discussion about the choices Statoil and other oil companies are making today.[15]

Statoil's six-year deal with rock and pop festival By:Larm ended in the wake of critical statements from the artist group Stopp Oljesponsing av Norsk Kulturliv (Stop Oil Sponsorship of Norwegian Cultural Life).[16] Led by the musician Maja Ratkje and the artist Ragnhild Freng Dale,

the group encourages critical evaluation of any link between oil and the arts, lifting their gaze beyond Statoil. A similarly cold reaction met the Swedish oil company Lundin when it began a sponsorship deal with the Astrup Fearnley Museum in Oslo. The editor of arts magazine Kunstkritikk called for a boycott of the closing reception of the Norway Cultural Council's conference, held at the museum, in defiance of the deal.[17] As perspectives coalesce from myriad artistic fields, the climate around oil sponsorship in Norway has shifted. For a nation so closely aligned historically with the evolution of the oil industry, the rising temperature of public thinking on the issue is a sign of considerable change.

Lundin is not the only neighbouring national oil company to sponsor the arts in Norway. The largest German oil company Wintershall sponsored an exhibition of German artist Emil Nolde at Norway's National Gallery. Lundin and Wintershall each operate Norwegian oil licence blocks in the North Sea, therefore social capital in Norway is important. Wintershall similarly sponsors arts and music events in Russia to solidify its important relationship with Gazprom. In Germany, Wintershall has sponsored the Kulturzelt Kassel for twenty years.

Back on home turf in Sweden criticism also greeted Lundin when the subsidiary Bukowskis art auctioneer struck a deal with the Tensta Konsthall in Stockholm. At a gallery event which was focused on arts funding,[18] dissenting voices expressed concern around human rights abuses associated with Lundin's extraction projects in Sudan.[19] Controversy surrounding the oil company follows swiftly in the wake of their positioning on museum signage.

The technique of sponsoring cultural events in the vicinity of extraction projects at first aims to secure brokerage of deals, but all too often it becomes an attempt to rebuild trust following an accident or opposition. Shell sponsors the folk festivals Féile Iorrais and Geesala in rural Ireland. There has been an unshakable campaign against Shell's Corrib gas pipeline at Rossport in County Mayo for over a decade.[20] The Rossport Five were jailed for ninety-four days in 2005 following activities interfering with Shell's attempts to lay the pipeline through land which the five men own and have lived on, variously, for around fifty years. Protests across Ireland disputed the group's imprisonment,

and eventually Shell withdrew the injunction on which their conviction was based. Since that time, Shell has attempted to set up cultural sponsorships – and in the process has come under further public scrutiny. Academic staff at the Dublin Institute of Technology raised concerns when the Shell Corrib Community Gain Investment Fund offered money for an academic course.[21] The organisers of Fleadh Cheoil, a major Irish music festival in Sligo, elected to return Shell sponsorship money and end a pre-existing deal just days before their 2014 gathering, citing their wish to remain 'an inclusive, community driven and family focused event'.[22]

In Canada local and global companies vie for entry into the tar sands, using sponsorships to build cultural capital as part of their endeavour. The licencing season sees state oil companies from Norway and China launch courtships of civil servants in parallel. Statoil sponsors the Calgary Stampede (a festival celebrating nineteenth-century settler colonial lifestyles), and the Chinese National Offshore Oil Company (CNOOC) has set up several sponsorship deals. CNOOC supports the University of Alberta Museum, holds the position of title sponsor in Calgary Central Library's planned redevelopment, and sponsored a special exhibition 'The Forbidden City' to bring exhibits that had never left the Beijing Palace Museum (as The Forbidden City was officially renamed in 1925) to the Vancouver Art Gallery.

First Nations groups and environmentalists have built legal and protest campaigns against tar sands extraction and associated industrial projects in Canada, following which the Canadian Association of Petroleum Producers commenced a multifaceted public relations campaign that included sponsorships of the Canadian Museum of Civilization in Gatineau and the Canada Science and Technology Museum in Ottawa. Politicians, artists and activists alike criticised the move. Elsewhere in Canada the musicians from the Godspeed You! Black Emperor band, after winning the prestigious Polaris Prize, released a statement querying the composition of the award ceremony:

Asking the Toyota Motor Company to help cover the tab for [this] gala, during a summer when the melting northern ice caps are

live-streaming on the internet, *IS FUCKING INSANE,* and comes across as tone-deaf to the current horrifying malaise.[23]

As a part of the oil economy, the reaction to Toyota amplifies the concurrent criticism of oil sponsorships at Canada's largest museums.

Oil sponsorship of the arts is by definition closely comparable to the cultural associations of other corporations operating in the extractive industries, and the similarities are most notable in oil's sibling fossil fuel: coal. The carbon cousins are jointly responsible for the majority of rising levels of carbon dioxide in the atmosphere. Coal has historically played a fundamental role in the economies of Australia and Brazil. In both countries national companies mingle with global ones in arts deals that see oil, gas, coal and mineral sponsors sitting side by side.

In Brazil, the national oil company Petrobras sponsors a range of arts, music and theatre, while mining company Vale has a close association with photographer Sebastião Salgado. Vale and Petrobras both sponsor the Museu Casa do Pontal in Rio de Janeiro, and their connections to the Museu de Arte Moderna ignited criticism from local artists. The Australian picture is an assemblage of several mining conglomerates. Rio Tinto and Chevron both sponsor Black Swan State Theatre Company. QGC sponsors the Queensland Ballet, and BHP Billiton sponsors the Bangarra Dance Theatre. Oil companies also feature: Chevron sponsors the West Australian Symphony Orchestra, alongside ConocoPhillips and Shell. The front row of the theatres must be frequently populated with corporate staffers competing for recognition.

The photographic endeavours of John Gollings in Australia (2010) and Sebastião Salgado in Brazil (1986) revealed the vulnerability of human workers in the face of their own society's vast devastation of the landscape. Cultural workers, artists and academics in Australia have widely criticised mining sponsors and *Artlink* magazine ran a special edition on the issue. *Mining: Gouging the Country*[24] features Charmaine Green, an Aboriginal artist whose article, 'Breaking my country's heart', illustrates the lamentable harm caused by mining sponsors of Aboriginal arts events. Sponsorship of an Aboriginal Australian art exhibition in Perth, titled 'Good Heart', from Oakajee Port and Rail (OPR) mining consortium purports to demonstrate Aboriginal support

for mining projects, but Green points out that the funding deals are in fact evidence of just how little acceptance of the mines exists. In the negotiating process companies divide communities as they damage the land. With 'Breaking my country's he<u>art</u>', Green explains the deep inter-connections between land and culture for her as a Yamaji Aboriginal Australian, and the risk posed by arts sponsorship of Aboriginal artists' work by mining companies:

> One of the strongest cultural values instilled into my family is the importance of 'country' to Yamaji. It is because of this that I understand and value the importance of 'country' to our spiritual, emotional and social wellbeing ... A social licence to operate would ensure 'country' was once again stolen, with minimal fuss from traditional owners and no costly delays to the resource sector. There is hypocrisy in this because on the one hand OPR gives artists the opportunity to paint about 'country' and on the other hand they will destroy that same country. This access to temporary monies will never compensate for the ongoing and future destruction of country.[25]

Green's specific analysis resonates with art galleries around the world housing centuries of landscape paintings. The internal contradiction of bearing the name of a mining company – be it coal, oil or minerals – beside a celebration of the careful craft of finding visual languages for sacred and splendid landscapes is unfortunately widespread.

Controversies around cultural sponsorships are not limited to those occurring in regions where the extraction takes place, but also reach the financial centres of the country. Public outcry over mining for coal seam gas in Australia has also ignited criticism of arts sponsorship deals. The art-activist group Generation Alpha created several performance interventions in the Gallery of Modern Art, Brisbane, in protest of the gallery sponsor Santos and that company's use of hydraulic fracturing or 'fracking', a mining process which some scientists say risks water contamination with toxic chemicals.[26]

The USA is a considerably different arts funding environment compared with Canada and most Asian, European and Latin American

countries. Corporate philanthropy by way of private endowments forms the basis of arts funding and sponsorships naming specific companies are much more frequent. This is largely a consequence of the nation having been founded on settler colonial wealth and of a political ideology that valorised individual freedoms over state influence, but it is also a product of a careful process initiated by Standard Oil's owners the Rockefeller family to fund civil society as an attempt to embed the company within the fabric of society and suppress the power of labour unions in the early twentieth century.[27] Oil sponsorship in the USA therefore occurs within different conditions to similar practices in Canada, Australia, Europe and Brazil.

Texan oil wealth supplied Houston with patrons that gave to the arts in the early twentieth century; now Chevron funds the Houston Grand Opera programmes. Shell also sponsors culture in the oil state, at the Museum of Fine Arts, Houston, where Saudi Aramco and ExxonMobil have together sponsored exhibitions. In 2013 ExxonMobil set up a donation-matching programme to raise funds for Houston-area cultural institutions such as the Alley Theatre, the Houston Ballet and the Houston Symphony. In Louisiana, which is not only an important market but also a point of extraction (in offshore deep-water oil licence blocks), cultural sponsorships seek to repair relationships with communities harmed by oil: even before the BP catastrophe in 2010 the region suffered ecological damage to the wetlands caused by the numerous oil industry giants operating in the coastal state. When the Gulf Restoration Network protested against Shell's sponsorship of Jazz Fest in New Orleans by flying a banner reading 'Fix the coast you broke' in 2009, the jazz musician Dr. John spoke out against the oil sponsor – although he later retracted his words following pressure from unnamed sources.[28] In later years, Greenpeace has joined in the creative protests that accompany the festival atmosphere at which Shell's shadow looms.

Meanwhile in the political centre Washington DC, US-based and international oil companies mark their status by sponsoring galleries. As well as sponsoring the Smithsonian in DC, the Shakespeare Theatre and the Washington National Opera,[29] ExxonMobil is working alongside Russia's largest oil company Rosneft (part-owned by the Russian state and partly by BP), who together sponsor the National Gallery of Art –

where Chevron, BP and Shell have all also made deals.[30] In California as in Louisiana, oil sponsorship has not found casual acceptance. When BP announced sponsorship of the Los Angeles County Museum of Art (LACMA), a journalist for the *Los Angeles Times* commented: 'Putting an oil company's name on LACMA's doorway brings an unusually high potential for controversy.'[31]

Similarly in New York, where BP and Eni have sponsored exhibitions at the Metropolitan Museum of Art, artists and activists have objected to the museum's connections to the oil industry: three members of the artist group The Illuminator were arrested during a protest at the Met's opening of the David H. Koch Plaza, in honour of funders of climate science denial, the Koch brothers.

In the UK, Shell and BP dominate the oil sponsorship of the arts landscape, as the next section will explore. There is some intermingling by BP with their partners in business and patronage Rosneft: together the two closely connected companies sponsored the UK–Russian Year of Culture 2014 at events in the UK. The method here – akin to ExxonMobil's co-promotions with Saudi Aramco and Rosneft – is to offer a display of working together in harmony and secure a venue for opposite staff from both companies to familiarise themselves ready for a switch from competition to collaboration. In the UK, almost every single one of BP and Shell's sponsorship arrangements has received critical attention.

In some countries, these deals appear to be a recent trend, but in others the relationships have been built over the course of twenty or thirty years. During this time, however the social and environmental political landscape has shifted. Local, regional and sometimes international resistance has increasingly greeted oil extraction and transportation projects in all parts of the world, and concurrently public attention in many cases has encompassed the arts organisations in receipt of funds from oil corporations. Any association with oil has started to gain attention and lose acceptability.

If in the 1980s, when some deals began, the conditions mixed by Margaret Thatcher and Ronald Reagan felt warm and comfortable for a high profile business partnership, the atmosphere is somewhat altered after a decade of World Trade Organization protests, the surge

of the Occupy movement following the financial crises of 2008 and 2009, and the associated public questioning of multinational corporate activities. As the reaction to oil sponsors in many of the cases mentioned demonstrates, the arts territory for Big Oil may not be as solid a ground as it once appeared. Attitudes and expectations evolve over time, and oil sponsorship will soon find itself to be a relic of a bygone era.

The international oil economy and the BP Ensemble in London

Oil is a truly transcontinental business operation. Hundreds of oil companies operate on land and at sea; the smaller ones – the 'minnows' – explore and test, and then pass over the lucrative fields to their bigger siblings to swing into full production. Enrico Mattei coined the title 'Seven Sisters' in the 1950s to describe the absolute power of the largest international oil companies that dominated ownership of licence blocks and market share of sales at the time. Of the original seven, only four large companies remain influential – Chevron, ExxonMobil, BP and Shell – and now the industry has defined a new line-up, including Saudi Aramco, Gazprom, Petrobras and Petronas. All these companies hold reserves of oil across the globe, and it is this access that secures their share value. Each day a machine of international finance deals, legal arrangements, political lobbying, transportation (from tankers to pipelines), sales, marketing and public relations whirs into action to keep the companies operational and profitable. Platform's patient disentangling of this 'Carbon Web' over a twenty-year period has resulted in numerous publications diligently dissecting this highly advanced game of Risk.[32]

In this global business in which companies have offices and subsidiaries scattered around the globe – for reasons of both gaining proximity to oil fields and making nuanced tax arrangements – several cities are of supreme strategic importance. Currently the business district of Calgary, Canada, is viscous with oil companies' presence, all seeking a stake in the tar sands. Since it opened its doors to oil majors in 1995, Baku, Azerbaijan, has welcomed regular arrivals of oil companies eager to gain access to new fields. Houston, Texas, in the USA is another

centre of commerce for petroleum. Cities close to production have a certain value, but so also do the financial and political centres. London, unlike its financial counterpart in the USA, New York, mixes access to financial, political and cultural power in one place. Whereas in the US oil majors manoeuvre between finance in New York and politics in Washington DC, London offers the full spread of business meetings in one city.

London's strategic importance as a centre of the oil economy may have been bolstered by the discovery of oil in the North Sea in the 1970s, but its position of power in global economies of exploitation stretches back further. The trade in human lives that began in the sixteenth century was started in London and fuelled the city's growth. More than that: profits made in the Transatlantic Slave Trade and the exploitation of slave labour in the colonies built the banks and monuments; paved the streets of the city; and created industries, railways and trading centres across the UK. London established itself as a global financial centre in the founding of insurance companies, such as Lloyd's of London, that insured the ships on which people were abducted – the Middle Passage during which an estimated nine million people died. London's political power is similarly connected to old empire: the invasion of the English language, the connections of the 'Commonwealth' – wealth stolen and protected for the few – the legal and political structures that mirror its own by the force of imperial settlement. The arts and culture have a history intertwined with politics and economics. The buildings, collections, content and discourses of art galleries and museums all relate to the colonial empire, whether by theft or by theme.

In *World City* social geographer Doreen Massey considers the specificity of London's cultural and political infrastructure, and reveals the singularities of this global city despite the similarities between rapidly growing and increasingly economically divided cities around the world. A series of post-World War Two governments from Harold Wilson to Margaret Thatcher to Tony Blair have promulgated a neoliberal political agenda in the city that has national and global impacts.[33] For international oil companies the amalgamated access to financial, political and cultural capital is unparalleled. So although BP and Shell are undoubtedly global companies with roots in many

corners of the world's oil economy, the strategic importance of London, and of securing adequate cultural capital in the city, should not be understated. Both companies rely on the political support of successive British governments to assist in securing licences and contracts from Canada to Russia to Iraq. Although Shell, or Royal Dutch Shell to give the company its full name, was 40 per cent British-owned and 60 per cent Dutch-owned from inception in 1907 until the final complete merger in 2005, it has always had headquarters in London as well as in Amsterdam – when it opened in 1963 the Shell Centre was the tallest multi-storeyed building in the city, a title BP would steal four years later. And while BP's immersion in North American finance, markets and oil reserves means it relies heavily on the US political administration, the influence of the British government in this relationship is vital. The specific allure of British cultural institutions – the largest and most internationally influential of which are found in London – to both BP and Shell, is the connections to political, financial and consumer market power that the city provides.

Nationally, neither company has sponsored the arts – except BP's association with Tate as a national group of galleries and its brief sponsorship of the Royal Shakespeare Company, based in Stratford-upon-Avon, but regularly performing in London. The focus on the arts is absolutely on the capital. In the past decade Shell has sponsored the Southbank Centre, the National Theatre, the National Gallery, the Science Museum, the Royal Opera House, the Victoria and Albert Museum (V&A) and the Natural History Museum. BP briefly sponsored Almeida Theatre, but has held longer attachments to the Science Museum, the National Maritime Museum, Tate, the British Museum, the Royal Opera House and the National Portrait Gallery. The latter four are of especial interest to the analysis of the impact of Big Oil on the arts here due to both their presentation of national identity and the particular way in which spokespeople from these four institutions have bolstered BP.

A press conference was held in late 2011 to announce the renewal of BP sponsorship deals at British Museum, Tate, Royal Opera House and the National Portrait Gallery. It was an unprecedented move. Previous deals had been signed without the sing-song. This was to be a more

ceremonial occasion however: only select journalists were invited to the confidential, embargoed announcement. It was held at the British Museum and invitees arrived for a business breakfast accompanied by the London Sinfonietta. My heart aches that no one in the press team thought to invite Liberate Tate, who might have responded creatively to the spectacle.

The arrangement was exalted by the four institutions, despite many of them having received sums of money from BP for over twenty years. They were presenting a united front: during the previous eighteen months criticism of BP arts sponsorship had gained international media attention, and the corporate sponsorship lobby had rallied supportive voices in the national press to defend the company's association with the arts. Despite accounting for a minimal slice of each of their annual budgets, the deal was made to seem bigger than it really was. In the press release the figure was put at £10 million, however in fact each organisation would only receive around £500,000 per year – much less impressive. The press conference manifested precisely what BP's slim contribution buys the company: support, approval and solidarity.

BP's choice to strike a deal with these four institutions out of the wider group it sponsors was carefully stage-managed. In 2004, BP spent over £136 million developing and rebuilding the brand of its new logo, the 'helios'.[34] Their previous coat of arms logo spoke a little too strongly of old boys' networks and empire, of nineteenth- and twentieth-century ideas of Britain. BP changed its logo in 2000 in preparation for its first centenary celebrations. It switched from a coat of arms branded BP to a green and yellow shape given its own name, 'Helios', after the sun god of ancient Greece. According to the PR department the new logo represented the 'company's aspirations … beyond petroleum',[35] and was followed by the aforementioned advertising campaign under the same banner. But BP is an oil company, not a solar panel manufacturer. The company sought to reinvent itself for a second century, but its business remained the same. The resonances of old boys' clubs and empire in the previous coat of arms persist in its practices, despite the new look. Perhaps it can lay claim to the twentieth century; the twenty-first century, however, is still up for grabs.

The new logo and the expanding arts sponsorship are part of the same programme of rebranding and finding a place in the new millennium. The 'Britishness' of the cultural institutions offers a positive slant on this part of the company's full title. British Petroleum wants to be intertwined with the *British* Museum – similarly last century but secure in the new; aligned with the prestige of the *Royal* Opera House; connected to ideas of identity of the *National* Portrait Gallery; and intimate with the home of British art Tate – originally the *National* Gallery of British Art – and now including Tate *Britain*.

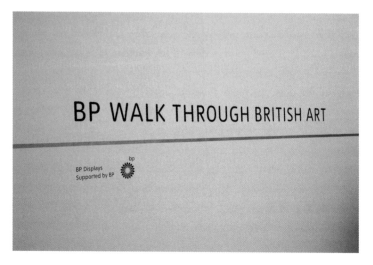

Figure 2.1: 'BP Walk through British Art' – BP sponsorship in Tate Britain. Photo credit: Martin LeSanto-Smith, 2013.

Its intimacy with British art at Tate Britain as the sponsor of the BP Art Displays and BP Walk through British Art is invaluable in this sense – with every regular press release regarding a new exhibition opening, BP's cultural 'Britishness' is further embedded. BP started to sponsor the permanent exhibition as part of its own PR plan for a new millennium at the same time as Tate Gallery at Millbank became Tate Britain in the year 2000, with the opening of Tate Modern. Immediately before that, in 1998 under John Browne's new leadership of the company, BP took an opportunity to influence gallery visitors' perceptions of the sponsor. On Tate's display list of donors the BP logo

appeared neatly beside The Heritage Lottery Fund emblem, and in a special tribute BP described itself:

> BP is one of Britain's leading sponsors of the arts and has supported the work of Tate Gallery since 1990. BP is proud of its close association with this important national collection and has recently extended its sponsorship at the Tate by supporting the creation of the Tate Gallery of British Art at Millbank.[36]

BP continues to chant a similar line in response to all questions on sponsorship to this day. For BP, the 'close association' with British art is a beneficial one.

With the four cultural institutions British Museum, Tate, Royal Opera House and National Portrait Gallery – the BP Ensemble, if you will – BP seeks to achieve a renewed vigour to the British, or brutish, in its name: a clean association for what would otherwise remain a complicated association, to say the least, with imperialism (past). Without these associations, BP is not all that British. Majority-owned by US banks, institutions and individuals, the company that once was nationalised needs to maintain home-grown political support by alternate means. The British government gradually privatised BP between two symbolic events of the era: Margaret Thatcher's inauguration as prime minister in 1979, and BP's purchase of the Rockefeller family's company Standard Oil in 1987. The largest stakeholder is now JPMorgan Chase bank; its offices spread across all continents; and BP has 605 high-secrecy subsidiaries registered in tax havens.[37] BP is global, but like so many transnational corporations its worldwide success is totally dependent on national support. It is useful for the company to retain its historical national identity, and so it seeks to soak up a sense of place in the public consciousness via proximity to the cultural institutions.

Each institution has its own specific benefits of association, but Tate makes an especially interesting case study of the effects of BP sponsorship in motion. Home of 'modern and British art', it brings together the old and the new ideas of Britishness, and presents a politically progressive persona that can soften the edges of BP's threatening corporate demeanour. Furthermore, Tate is hugely

influential on the global modern art scene, and director Nicholas Serota was ranked number one in a top 100 of powerful figures in the art world in 2014. Ethical standards at Tate will be mirrored elsewhere – if oil is safe at Tate, it is secure across continents. When Tate – alongside the Guggenheim, New York – initiated a call for support of Ai Weiwei following his arrest in 2012, art museums round the world took heed and signed up in an unprecedented display of political action from the art world.

Lastly, the former BP CEO Sir John Browne chairs the Tate Board of Trustees. Browne is a key protagonist in this chronicle of art and oil. Before Tate, Browne sat on the British Museum's board from 1995–2005 and, professing a profound love of opera, he regularly attends Royal Opera House performances, where his former close colleague Peter Mather holds court as Honorary Director. Browne undoubtedly maintains connections at all four of the institutions that make up the BP Ensemble. His position of power at Tate during a period of questioning and criticism of oil sponsorship renders an especially clear picture of the inner workings of corporate arts sponsorships.

Where Statoil's sponsorships in Norway and Canada have specific regional goals, BP and Shell's sponsorships in London have global ambitions. These London-based case studies offer examples that reflect the issue more broadly. There are many parallels to be drawn between the patterns at Tate, the BP Ensemble, and the two international oil companies' activities in London with other global examples of oil sponsorship of the arts. Certain chapters in this examination of oil sponsorship of the arts will therefore pay particular attention to these sites and examples in the UK, alongside wider international references, due to the relevance of London to the global oil economy, the tight allegiances within the BP Ensemble, and the influence of Tate on contemporary art museums worldwide. The bigger picture of how oil sponsorship plays out will appear like Russian dolls each with a new verse to the narrative, a series of microcosms contained one within the next. Just as other global deals will terminate, the deal struck in 2011 will at some point lose steam for renewal. The current trend towards oil sponsorship will soon reach the end of the line.

3
Capital and Culture

Discussion of arts funding brings up three important things for young and emerging artists in particular: food, rent and student debt. How can artists who hope to make a living expect to reach for the moral compass every time a gig or a commission lines up? Artists have lived hand-to-mouth for centuries, but today's conditions of freelancing work, self-employed tax status, eye-watering student loans constantly increasing with interest and escalating rents in the biggest cities, which are essential for entry into the visual arts, music and theatre scenes, make for a singular set of challenges for the conscientious visual artist, theatre-maker or musician.

Under these constraints, no one can be expected to maintain ethical purity – if that were ever truly possible. But it remains a harsh predicament to be faced with great opportunities that come tarnished with oil sponsorship accepted by some of the world's largest, most established arts institutions. The artist Richard DeDomenici found the compromise ultimately unpalatable and in 2014 publicly refused a commission from Tate on the grounds that he objected to BP sponsorship. This act of resistance demands answers: why would Tate take this money and ask its artists to silence their better judgement? Does Tate, or the other institutions in the BP Ensemble, even need the money to survive? And is Tate acting in the public interest and according to its own ethical policies when it opens the door to BP?

Art at arm's-length from the state, but ethics under its thumb

Arts institutions are under pressure from all directions to accept any offer of funding. Rejecting one donor could offend another, and no one

in the fund-raising team wants to give the impression that sponsors might be met with a judgemental eye. The relationships between high-level staff, trustees and sponsors run deep – as most succinctly demonstrated by the position of the former BP CEO John Browne as Tate Chair of Trustees. On top of this, the political pressure to accept private funding comes from myriad, often ideologically driven, sources.

The UK arts funding body, the Arts Council of Great Britain, was founded in 1946 by Clement Attlee's Labour government, a remoulding of the wartime Council for Encouragement of Music and the Arts (CEMA). John Maynard Keynes, the British economist in favour of public spending as part of a sustainable economic model, was the first Chair of the new public body. The Arts Council was a separate body from the state with the purpose of distributing state funds. Its mission was to support the arts across the UK according to the arm's-length principle: the idea that the arts would flourish better without direct meddling from government. Jennie Lee, the first Minister for the Arts – a role established by Harold Wilson's Labour government in 1964 – believed in the arm's-length principle at the same time as wanting to give the value of the arts full recognition in public policy. Lee mobilised the Arts Council's regional support for the arts, catalysed the Southbank Centre project and helped establish what Wilson called the greatest achievement of his government – the Open University. At her ministerial appointment, Lee described her perspective on governing the arts:

> Political control is a shortcut to boring, stagnant art: there must be freedom to experiment, to make mistakes, to fail, to shock – or there can be no new beginnings. It is hard for any government to accept this.[1]

Lee's words resound decades on, naming the risk to the arts of zealous state influence.

There began to be a shift in perspectives on the arts in the 1970s and 1980s however, not least as a consequence of Margaret Thatcher's rise to power. Thatcher's Conservative government published *The Arts are your Business* in 1980 with the aim of stimulating corporate sponsorship

of the arts. In 1983 Thatcher installed a new Secretary-General at the Arts Council of Great Britain in the form of Luke Rittner, whom the academic Chin-tao Wu describes as 'the sponsorship-broker turned secretary-general.'[2] Rittner was director of the Association for Business Sponsorship of the Arts at the time (the lobby group later named Arts & Business, which was formerly headed by the outspoken supporter of oil sponsorship, Colin Tweedy). Rittner's appointment seemed to be a symbolic action by Thatcher to push for private investment in lieu of state funding. Thatcher's government pushed national museums and galleries to start charging admission fees instead of expecting state support, and about half of all the cultural institutions across the UK followed orders – British Museum, Tate and the National Gallery held out, however, and maintained free access throughout this period.

Thatcher and the Conservative minister Norman Tebbit found the regionally autonomous arts funding structure which had been set in motion by Jennie Lee threatening, and feared it encouraged an oppositional political bias.[3] Tebbit was a permanent feature in Thatcher's cabinet, and for a time he was thought to be her most likely successor. Side by side, Thatcher and Tebbit rearranged the terms of the game: they made a 50 per cent cut in the number of funded organisations nationally in 1987. Wu sums up the changes made by Thatcher's government: 'Without changing its structure, the government was able to shape the [Arts] Council, regardless of the notoriously ambiguous principle of "arm's-length".'[4] As well as shaping the funding body, Thatcher was moulding the logic that would inform arts funding debates for decades.

Thatcher's lesson in obeying the hand that feeds did not pass unchallenged. In 1987 the National Theatre director Peter Hall quit the Arts Council in protest. Hall, co-founder of the Royal Shakespeare Company and one of the most prominent British theatre directors of all time, continues to speak out for public subsidies for the arts to this day. Legend has it that Hall delivered his resignation speech atop a meeting table for suitable theatrical effect.

Thatcher's ultimate successor John Major, an anti-climax to her undeniable stage presence, pressed on with the programme of realigning arts funding. In 1992 Major's government sent the major

galleries – including Tate, the National Gallery, British Museum and the National Portrait Gallery – out into the world as incorporated, non-departmental public bodies (NDPBs), each with the mission of balancing income that was, loosely, one-third from the state, one-third self-generated and one-third from private sources. The shift to NDPB status was a mixed blessing: alongside more secure funding came a cap in support proportional to expenditure – however much the incomes grew, the NDPB's could only expect a third of that funding to come from government. It was at this point that government set in stone free public access to the NDPB museums as a condition of the funding they received – the other museums across the country continued to apply to the Arts Council for funding and were encouraged to charge admission.

Although New Labour maintained its election promise to make entry to museums free across the country possible again, which it achieved in 2001, it also continued Thatcher's campaign to shape the arts funding structure according to a neoliberal market logic. In 1997 Tony Blair turned the Culture Ministry into the Department of Culture, Media and Sport and in 1998, as part of its inaugural efforts, DCMS produced its Creative Industries Mapping Document; mapping in the loosest sense of looking for evidence to back up an existing argument rather than a detailed survey of the full picture. The key aim of the paper was to put an economic value on the arts, or under the new dictum, the creative industries. An answer was found to the debates from the 1950s and 1960s around how government related to the arts: put a price on them.

The mapping document used statistics to relate the arts to gross domestic product. DCMS found that:

The cultural industries employed close to 1.4 million persons, which represented five per cent of the total UK workforce at the time; revenues from the cultural industries was in the excess of £60 billion; they contributed £7.5 billion to export earnings (excluding intellectual property); and value added (net of inputs) was £25 billion, which significantly was four per cent of UK GDP, and in excess of any (traditional) manufacturing industry.[5]

Where Thatcher had manipulated the Arts Council and Major had incorporated the museums, Blair embedded the market logic in the broader conception of the value of the arts. Chin-tao Wu describes the new phase:

> For those who waited 18 years for the Tory Party to be defeated, Tony Blair might seem to be a born-again Thatcherite, and the celebrated 'Third Way' he so fervently champions nothing more than the decanting of the old wine of market principles into attractive new bottles, with the added ingredients of moral uplift and big smiles.[6]

The arts were not to be merely symbolic of wider government strategy, but instead were used as another site to embed an economic and political ideology.

The DCMS research was based on then Australian Prime Minister Paul Keating's 'Creative Nation'. Keating called for a new visioning of the Australian economy in which the creative industries were as central as the primary sectors, and ultimately their successors:

> The shift we've made in this country from just being a quarry and a farm to a great manufacturing society, that shift to innovation is a call upon the ideas and the art. The Arts and industry are one, can be one, should be one, because we'll never get pride from a truckload of coal.[7]

The closing sentiment resounds with the Thatcherite imagery on which service sector economies were built – a disdain for primary sectors that held significant union-based power. With the corporatisation of the arts came the casualisation of labour across sectors familiar to those working in the arts: temporary contracts, frequent interning and freelancing.

Tony Blair sold his Mapping Document in similar language to Keating's, pushing the creative industries into the centre spotlight of the UK economy: 'Nurturing creativity and enabling the growth of the creative economy is a crucial element in the UK's economic success in the emerging new knowledge-based economy.'[8] Where the Arts Council and Jennie Lee had sought to separate the arts from politics, Blair and

Keating situated the arts in a purely economic frame. In his writing, the community arts practitioner François Matarasso discusses the arts and in 1997 asked whether their purpose might be *Use or Ornament?*,[9] but Blair and Keating found something less profound: money-making potential. The impact of these policies on arts funding in the UK was that it shaped a new model, moving away from the arm's-length principle to follow a logic different to the top-down management of culture in France, and the hands-off approach in the USA. Instead, let the arts represent the market: like god in human form, the market sculpted on the body of the cultural sector. Jennie Lee's concern around artistic stagnation will be debated, but for arts organisations the message on funding was clear: follow the market logic.

The strategy gave the cultural sector plenty of good press and challenged far right arguments against arts funding based on the arts' lack of economic value. As such New Labour's methods initially seemed designed to use the research findings to consolidate support for state funding of the arts. But concurrently Blair laid the path for the Conservative/Liberal Democrat coalition to slash state arts funding in 2011 – because if all arts organisations can make their own money as well as the West End theatres, then surely they should be left to fend for themselves. As Thatcher initiated, state provision for regional culture and leisure via the Arts Council was minimised over the course of consecutive governments but meanwhile the non-departmental public bodies, who were now directly answerable to the government and therefore within closer control, had their state funding assured – and in many cases it increased rather than decreased over the years. The financial story of these large cultural institutions is not one of reduced state funding as it is for many smaller arts organisations supported by Arts Council England (ACE) who have faced a series of cuts, and for whom it is more difficult to generate other sources of income. When rejection letters descended momentously onto the doormats of the 206 arts organisations for which ACE funding was cut by 100 per cent in 2011, the addressees knew their plight was not shared with the likes of London's gigantic galleries.

The response of Australian arts minister George Brandis to artists' condemnation of the Sydney Biennale sponsor Transfield perfectly

exemplifies the logic that pervades the neoliberal state's relationship with the arts as shaped by Blair and Keating. When the artists' boycott was successful and forced controversial immigration detention centre operator Transfield to withdraw from the sponsorship contract, Brandis called the situation 'shameful' and threatened to force a policy on the Australia Council (equivalent to Arts Council England) that would limit funding to any arts organisation that rejected corporate sponsors in the future. His recommendation was:

> The policy should consider whether all future funding agreements should contain a clause that stipulates that it is a condition of Australia Council funding that the applicant does not unreasonably refuse private sector funding, or does not unreasonably terminate an existing funding agreement with a private partner.[10]

The translation of what might be 'reasonable' or 'unreasonable' seems to fall, worryingly, upon the state, rather than the arts organisations and the public. Where arts organisations in a healthy democracy might make varied ethical decisions, the picture Brandis paints is a pseudo-Elizabethan chain of being where morals are dictated from on high.

Not all politicians kowtow to the mission of multinational corporations however. When the Canadian Association of Petroleum Producers struck a deal with the Canadian Museum of Civilization, MP Marjolaine Boutin-Sweet – who previously worked as a museum guide in Montreal – challenged the parliament: 'Is it now the mission of our museums to promote the oil lobby?'[11] Boutin-Sweet was willing to recognise the desperate need of oil companies operating in the controversial tar sands in Canada to purchase greater access to hearts, minds and key governmental figures. For some politicians, there is an important role to play in clarifying the distinction between acceptable and questionable corporate sponsorship.

The UK culture secretary Maria Miller, who arrived in office 2012 amid queries about her lack of interest in the arts and left in 2014 over her part in the British government's expenses scandal, gave her blessing on Tate's 2014 deal with Hyundai: 'I will do everything I can to make sure businesses see the value of supporting arts organisations

like Tate.'[12] Miller's dedication demonstrates that, similar to Brandis, the ideological narrative she wishes to spin is of greater importance than recognising the real bedrock of these institutions' income, state support, or truthfully acknowledging the minimal role business plays. Nicholas Hytner, director of the National Theatre, criticised Miller's particular take on the arts-austerity debate, arguing that if the culture secretary were to follow the economic argument for the arts made by Blair's government, she would see that government grants nurture wider economic growth and to take away from the arts would undermine this necessary process. Hytner uses the Blair logic to call for public arts funding, but Miller wins out: the economic case for the arts made by Blair and Keating is ultimately used to withdraw state support for the arts.

The Arts Council started recommending corporate sponsorship in the 1980s when Norman Tebbit slashed their income and Luke Rittner took the helm. Arts Council England continues to push corporate funding as a solution to lost state funds with the recent offering of Catalyst Arts. Through the Catalyst Arts scheme organisations receive match funding for any corporate sponsorship deals they manage to strike. North of the border Creative Scotland, the devolved segment of what had been the Arts Council of Great Britain until 2008, offers similar incentives to Scottish arts organisations and businesses. ACE and Creative Scotland's abetting of corporate sponsorship is at odds with their own aims to operate at arm's length from politics – as expressed by Jennie Lee when she said, 'political control is boring art' – because of course corporate sponsorships *are* political. Corporate sponsorships have specific politics relating to the activity or industry of the particular company involved. Furthermore, the process of promoting corporate sponsorship has been a political one that has skewed the arts funding debate and climate.

The lean towards corporate sponsorships by ACE and Creative Scotland demonstrates the success of the Thatcher, New Labour and Conservative/Liberal Democrat governments' ideological shaping of the position of the arts in contemporary Britain. The government and government bodies have been active in cornering arts organisations into taking an economic and political role that upholds neoliberal values. Arts organisations of all sizes are under significant political pressure

to accept any source of private funding, and corporate sponsorship is promoted as a scapegoat for state support despite demonstrably counting for very little of organisations' income.

Where the money really comes from

When asked to comment on artists' objections to the BP–Tate deal, Christopher Frayling, former Chair of Arts Council England, came out ultimately in support of oil sponsorship, saying, 'Now is not the time to be squeamish.'[13] Frayling acknowledged that there are reasons to react to oil sponsorship with some revulsion: the creator of a mini-series on the semiotics of advertising is no stranger to the power of association for the corporate arts sponsor, or the compromise of the sponsored. As part of his career as historian and broadcaster, Frayling is Rector of the Royal College of Art and is the longest-serving trustee of the V&A – a gallery on Museum Street in London at which Shell sponsored an exhibition in 2013. Frayling played the part of the ideological arts bureaucrat and went on to argue: 'The system is utterly dependent on sponsorship from companies and large firms.' It was a bold and hyperbolic statement, and to come from a person who until reasonably recently had held such a significant role in the world of arts funding, Frayling was able to influence the terms of the whole debate. But was it true?

Each of the oil-sponsored institutions in London has evolved over decades of changing expectations around state support for the arts, and Tate makes an interesting example as a gallery – like the British Museum and the National Gallery – which was founded on a private collection, given as a donation to form a public institution. The initial Tate collection was a gift Henry Tate bequeathed to the nation in his final years, made up largely of Victorian artworks. As part of the legacy, Henry Tate had offered to pay for the building of the gallery on the site of Millbank penitentiary on the proviso that government pay for the site and the running costs. The National Gallery of British Art opened to the public in 1897 and switched officially to the name it became popularly known as in reference to its founder, Tate Gallery, in 1932. It housed

an overflow of British art from the National Gallery, which maintained control of Tate until 1954.

Table 3.1: Tate income 1953–2014

Year	Grant-in-Aid	Private foundations	Trading
1953–54	£6,250	£1,000	*
1963–64	£40,000	£18,102	£10,000
1973–74	£310,000	£71,349	*
1983–84	£2,021,000	£31,684	*
1993–94	£16,500,000	£2,506,000	£1,396,000
2003–04	£30,300,000	*	£19,802,000
2013–14	£30,400,000	£59,828,000	£24,886,000

*No data available.
Source: Tate annual reports.

Tate's funding structure has undergone numerous permutations since 1897. The 1938–53 annual report shows that the gallery's entire income was from gifts, legacies and publications or prints sales, until it was given its first state grant – called Grant-in-Aid because it is tax-exempt – of £2000 in 1946. This was 'repeated annually with an abnormal supplement of £1200 in 1950 until 1953 when it was increased incrementally to £6250.'[14] From the first grant of £2000 in 1946 Tate's state funding was given directly by the Treasury. Tate Trustees pushed for a Bill in parliament to increase the organisation's 'Purchase Grant', designated for buying new artworks only, which eventually came in 1959 to the tune of £40,000.

The onslaught of Thatcher's neoliberal policies as part of the wave of 1980s privatisation in parallel with similar political strategies to reduce state responsibility and social welfare in Europe and North America put Tate's government grant at risk. In the wake of Thatcher and Tebbit's confiscation of Arts Council funds, Tate trustees made a renewed push for state funding, arguing in the Foreword to the 1984–86 annual report:

It is our strongly held belief that the Government has an obligation to meet the full cost of running the national museums … in the present economic climate the Tate Gallery … is short of funds.[15]

The director Alan Bowness, who had been at the helm since 1980, held firm in this position when he challenged in the 1986–88 report:

> The arts have become enormously popular … The politicians who provide arts funding seem to be the last to recognise this situation. The country is rich enough, the sums involved are relatively small, why cannot more cash be provided for the arts and the national museums?[16]

These arguments made thirty years ago resonate still with the continued battle for state support for the arts, albeit different in tone. Bowness' plea here might now be scripted with reference to the government's capacity to bail out the banks while at the same time butchering limbs from the NHS, Arts Council and the education sector. The case has been made time and again that institutions fulfilling a public function must receive guaranteed state funds as part of a wider picture of common provision for health, recreation and culture.

Bowness argued the case for increased state support and was reluctant to seek private sources since in his view it was the state's responsibility to maintain public institutions. But the state was not forthcoming in meeting the needs of the expansion plans, and trustees were impatient to make progress. Serota, who was made director of Tate in 1988, was keen to try any avenue to amplify Tate's potential. He had ascended rapidly from the position as director of the Modern Art Oxford gallery in 1973, aged twenty-seven, to director of Whitechapel Gallery, London, in 1976 – in which role he had impressed Tate trustees by renovating the building with cash raised in art auctions and rectifying the Whitechapel Gallery's position on the London art scene with a series of daring and popular exhibitions. Serota also has a certain familiarity with negotiating politics and institutions: his mother Beatrice Serota was a Deputy Speaker of the House of Lords and, in the 1940s, assistant principal in the Ministry of Fuel and Power. When Tate was incorporated as a non-departmental public body alongside other large museums in 1992 (and assured around a third of its funding from the government grant) Serota was willing to look beyond the state support, unlike his predecessor Bowness.

Despite remaining insufficient in Bowness' eyes, the Grant-in-Aid offers substantial sustainability to Tate. Commentators rarely recognise state support as the bulwark of Tate and other cultural institutions' income, and the oil companies misrepresent the true picture. In a promotional video the BP Director of UK Arts and Culture (a carefully chosen title for the person responsible for sponsorship advertising), Des Violaris, declared that 'Here in the UK, museums are free and corporate sponsorship enables them to remain free.'[17] This was untrue. At the 2013 Tate Members' annual general meeting a number of individuals present posed questions about BP sponsorship and Tate funding. Several members resigned over BP sponsorship, and a third of the hundred or so attendees raised their hands to convey their discomfort at the relationship. One member reacted to the outpouring by articulating the tale in which BP saves the day and asked, 'But don't we need BP to have free access to the gallery?' Nicholas Serota found himself stepping in to unravel the fantasy and directly contradict Des Violaris and BP, saying, 'There is no direct connection between any single sponsor and the ability of Tate to maintain free admittance.'[18]

Access for all is enshrined in the Grant-in-Aid agreements. Free entry to the permanent collections of the national museums is a condition of the DCMS grant for British Museum, Tate, the National Gallery and the National Portrait Gallery. Far from a luxury, at risk, desperate for corporate intervention, or even a benefit brought by corporate sponsors, it is central to the terms of the institutions' very existence. Tate has received state support consistently and in increasing amounts, tied to an agreement to offer free public access as a condition of its status as a non-departmental public body.

Misinformation cloaks the issue in a similar fashion in Australia. Australian arts leaders pointed out the major disparity between the story told and the actual evidence. The *Sydney Morning Herald* summed up their comments:

Donors and especially corporate sponsors often wanted their 'name up in lights' even though their funding contributions were often less than what comes from the public purse. 'Government doesn't get enough of an accolade actually.'[19]

In various countries state support is dismissed and corporate sponsorship glorified but for many large institutions like Tate, public funding is secure and substantial.

Bowness' request for increased state funds was led by a desire within Tate to grow and gain capacity as a leading national art museum. From the 1940s to the 1980s the gallery's predicament was consistently framed in annual reports as a series of lost opportunities to buy significant artworks at a lower price due to lack of funds, the gallery paying double a few years later. The conditions of continually chasing an art market that increases in value exponentially has marked each decade of the gallery's existence. Staff would propose a purchase, but by the point of approval, the organisation could no longer afford to buy the artwork.

Tate wanted to increase not only the size of its collections, but also the size of its buildings, the number of them, the number of staff, and indeed the entire scale of its operations as an internationally renowned British and modern art gallery. For Bowness, developing the site at Millbank was not the only reason to increase in size. He personally led the Tate Liverpool project, and sowed the seeds of Tate St. Ives through his connection to the town and its most famous artist Barbara Hepworth – who was also Bowness' mother-in-law.

With the pressure on Bowness to find funding and the handover to Serota who was willing to try anything, Tate had a charged atmosphere on the brink of a moment of chrysalis. To fuel the growth desired by all the key players, Tate looked to other sources of funding and income generation. It was on the hunt for additional – not alternative – sources of funds.

The table of Tate's operating income (Table 3.2), taken from Tate annual reports, shows firstly that from the 1990s Grant-in-Aid increased in real terms, beyond inflation, year on year, rather than decreased as some commentators continue to imply.

The Grant-in-Aid amounted to 87 per cent of Tate's operating income of £15.7m in 1990–91. It was the carbohydrate to a skimpy sauce. But with the push for increased funds the organisation's operating income increased dramatically to £51.8m in 2000–01.

Although the Grant-in-Aid had increased, by 2000–01 it was 48 per cent of operating income, taking up half the plate. From 2002–14 the

Grant-in-Aid has remained fairly stable at an average of 40 per cent of operating income. After a period of growth, organisational funds diversified to bring in 60 per cent self-generated and 40 per cent from government support. State funding increased but Tate grew bigger and faster over the period 1990–2013. Rather than losing an ingredient for its square meal, Tate augmented its menu with a delectable array of funding dishes.

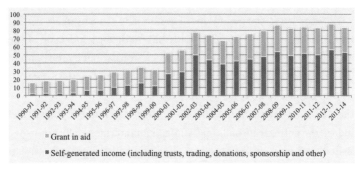

Figure 3.1: Tate operating income year-on-year 1990–2014 (millions)

Tate's current financial make-up has many resemblances to the three other BP-sponsored cultural institutions. Grant-in-Aid at the British Museum and at the National Portrait Gallery is similarly around 40 per cent of each budget annually, while the Royal Opera House receives 25 per cent of its income from the state via Arts Council England. State funds have been a sturdy backbone for these large cultural institutions, not a dwindling resource as in the experience of smaller arts organisations dispersed across the country.

So how did Tate increase its budget beyond state funding? As anyone who has managed a project budget, a small household or a large institution will know, meeting expenditure with increasing costs by diversifying sources of income can be tricky and strenuous to say the least.

Tate built up its income in part from one of the major fund-raising options available to it as a charity: donors and trusts. The growth of this income strand came from gifts, legacies and the numerous individual donors supporting Tate since its inception. In 1923 Tate had received

Table 3.2: Tate income 1990–2014

Year	Self-generated income (including trusts, trading, donations, sponsorship and other)	Grant-in-aid	Total income	Grant-in-aid as % of total
1990–91	£2m	£13.7m	£15.7m	87%
1991–92	£2.8m	£15.2m	£18m	84%
1992–93	£2.4m	£16.0m	£18.4m	86%
1993–94	£2.9m	£16.5m	£19.4m	85%
1994–95	£6.2m	£17.2m	£23.4m	73%
1995–96	£6.4m	£18.9m	£25.3m	74%
1996–97	£10.1m	£18.8m	£28.9m	65%
1997–98	£12.7m	£18.7m	£31.4m	59%
1998–99	£15.5m	£19.2m	£34.7m	55%
1999–2000	£11.9m	£19.7m	£31.6m	62%
2000–01	£26.9m	£24.9m	£51.8m	48%
2001–02	£29.0m	£26.8m	£55.8m	48%
2002–03	£49.8m	£27.8m	£77.6m	36%
2003–04	£43.8m	£30.3m	£74.1m	41%
2004–05	£38.7m	£28.6m	£67.3m	42%
2005–06	£42.4m	£29.8m	£72.2m	41%
2006–07	£44.9m	£30.7m	£75.6m	41%
2007–08	£47.9m	£31.7m	£79.6m	40%
2008–09	£53.9m	£32.5m	£86.4m	38%
2009–10	£49m	£33.4m	£82.4m	41%
2010–11	£51.9m	£32.3m	£84.2m	38%
2011–12	£50.2m	£32.8m	£83m	40%
2012–13	£56.4m	£31.5m	£87.9m	36%
2013–14	£53.2m	£30.4m	£83.6m	36%

Amounts exclude income associated with capital expenditure – works of art purchased or donated and building projects.

Source: Tate annual reports.

£50,000 from the Courtland Trust for the purchase of works by a list of specific artists. In 1939 it received the Knapping Estate funds, which were designated for the purchase of works by artists who were alive within 25 years either side of the grant. From these distinguished beginnings, the coterie of benefactors grew. It multiplied in size during the renewed funding drive to diversify income from 1990 onwards.

Chin-tao Wu describes the change and points to Nicholas Serota as the art director of the shift:

> While there was no Development Office at the Tate in the 1980s, soon after Serota took over the directorship, one was established with six staff in 1990, 'development' being the vague but impressive sounding term for such trans-atlantic notions as fundraising and networking.[20]

With ample resources this team of well-rewarded development fund-raising officers set about the task of upscaling Tate's donors. It currently has a staff of at least thirty-five, headed by Rebecca Williams who came to Tate with twelve years experience of fund-raising in the arts and education sectors. There are now hundreds of benefactors, patrons and charitable trusts who give annually to Tate: legacies bequeathed, single or regular donations, and as a result of applications to relevant foundations. In 2012–13 Tate Development office raised £46.7 million[21] from donors, trusts, foundations and connected charities. Serota's strategy brought substantial rewards.

Tate also looked to its membership scheme to amplify its income and increase its purchasing power. Tate Members began life as the Society of Friends of the Tate Gallery in 1958, described at the time as 'an independent body for the purpose of purchasing works of art for presentation to the Tate.'[22] By the end of March 1959 it had 400 members and by 2013 the number had soared to 105,630. The group consistently provides a valuable kind of income: the members are able to make a lump sum donation to Tate to spend on buying artworks with few limitations placed on how the money should be spent.

A game changer in Tate's income strategy has been Tate Enterprises. It brings together Tate Catering, set up in the 1970s as a single outlet that has grown into a set of cafés and restaurants. The second division, with a confusing repeat in title, is Tate Enterprises, which combines Tate Publishing, set up in 1911, Tate Bookshop, and all shops and online sales. It is a highly profitable company and feeds money spent at Tate back into the bigger project. The Tate Modern bookshop is both popular and specialist, stocking a wide range of art magazines, as well as the latest books from Tate Publishing, which plays a leading role

in international visual arts texts, content and distribution. In 2012–13 Tate's trading income from Tate Enterprises was £28.4 million. This is a whopping, oft-overlooked sum of money that the organisation makes off its own bat, or more literally, off its own brand. For the Royal Opera House, self-generated income through ticket sales had always been an obvious source of funds, and forms over 50 per cent of its current income. For the British Museum, commercial sales form almost 25 per cent of the annual budget, and at the National Portrait Gallery it accounts for a third of its total income. The BP Ensemble lays its foundations with the earned income it generates through ticketing, and its cafés and shops.

Earned income fulfils the objective of increasing purchasing power and expansion projects, overheads and running costs because there are none of the spending conditions other funders might require. As a separate entity, Tate Enterprises does however have separate standards and policies from Tate. Tate Members are engaged in a long-standing argument with management over Tate Enterprises staff remuneration, which is sometimes below the London Living Wage and regularly uses zero hours contracts, a debate aired consistently at the Tate Members annual general meeting. This sits incongruously beside Tate's positive promotion of working standards at Tate, its Diversity Policy and staff care programmes.

The Development Office applies for public funds beyond Grant-in-Aid, allowing Tate to access wider state support. Options include the Heritage Lottery Fund, the Big Lottery Fund and Arts Council England (ACE), which distributes some of its own Grant-in-Aid from government and a section of the National Lottery funds designated for the arts. With the cuts to Grant-in-Aid for Arts Council England in 2011, the lottery funds form almost half of arts funding for organisations that do not receive Grant-in-Aid directly from the government but obtain state support via ACE instead: from 2012–15 ACE distributed £1.4 billion from Grant-in-Aid and £1 billion from the National Lottery. Tate makes effective use of this additional source, alongside other public funds such as the Arts and Humanities Research Council and the European Regional Development Fund, as a source

of additional income. In 2012–13 Tate raised close to £3 million from public funding sources.

Finally, there are the corporate sponsorships. Tate began its corporate sponsorship programme in the early 1980s as part of the endeavour to increase organisational capacity. Alan Bowness was under substantial pressure from Margaret Thatcher's government and from Tate trustee Peter Palumbo, a property developer, to follow the market logic and sign up to the corporate sponsorship agenda. His refusal reached a dramatic impasse when Palumbo criticised Bowness for his reluctance in a newspaper interview and Bowness threatened to resign. When Serota took the helm towards the end of Thatcher's reign in 1988, he was less scrupulous about funding sources but he also found that trusts and foundations were much more forthcoming than corporate sponsorships.

Tate's corporate membership programme started in 1984, and developed into an exclusive programme in the 1990s. Business members had access to special openings and the option of booking corporate events in Tate spaces. Businesses paid between £10,000 to £25,000 and access was limited to fifty people per membership to increase desirability. Chin-tao Wu describes the specificity of Tate corporate membership:

> While American museums generally have a broad-church approach to their corporate membership (and much lower subscription fees), the Tate plays the exclusivity card. This is why Anthony Thorncroft [writing in the *Financial Times*] remarked: 'Companies feel safe at the Tate.'[23]

It is precisely because of this exclusivity and prestige that it is hard for Tate to argue it would struggle to find a replacement for BP. By the very desirability it offers sponsors, it undermines any case purporting BP is irreplaceable.

One of the first companies to sign up to the scheme was Britoil. It became one of the first instances of oil sponsorship at Tate alongside what was then Mobil Oil. Britoil was originally a nationally owned company set up in 1975 to operate in the North Sea and ensure national

supply and profit. It was privatised in 1982, and in that same year chose to give back a small token to the nation that had previously benefitted from its entire profits, by sponsoring Tate from 1984–88. In 1988, BP set out to acquire Britoil, finally persuading the UK government to relinquish its majority shareholding by agreeing to certain conditions. This may or may not have included continuing the Tate sponsorship, which BP took up in the following years. Whether out of obligation or choice, the company clearly saw the sponsorship as a valuable asset and has maintained the relationship.

An approach to the corporate sector is not a novel turn in the new millennium, nor is it a source of income that is only just beginning to grow – for Tate it is a well established programme, possibly already stretched to the maximum of its potential capacity. In the financial year 2011–12, Tate received £4 million from corporate sponsors and events.[24] By way of comparison, Tate Members donated £5.1 million to Tate in the same year. BP sponsorship of the BP Ensemble is a miniscule slice of organisational income across the board. The BP sponsorship of approximately £500,000 was 0.6 per cent of Tate's annual operating income in 2012–13, which was £87.9 million.

In the wider picture in the UK, business support has not risen up to fund the arts following the cuts, despite commendations of corporate sponsorship by Maria Miller and other politicians since the financial crisis. In fact, corporate sponsorship decreased nationally over four consecutive years from 2007–11. Frayling's system might not be so 'dependent on sponsorship from companies' after all.

Beyond quantity, the quality of corporate sponsorship funding is also an issue. If a monograph or collection were for some reason hard to fund, such as being politically controversial or not widely known, it would make the specific source of available funding more valuable to the gallery. At Tate, the BP brand has been consistently associated with one major curatorial project at a time, all of which have been exhibitions so fundamental to Tate's brand that securing alternative funding would be easily surmountable. From 1990–2000 BP sponsored Tate's 'New Displays'; from 1998–2000 it sponsored the Tate Gallery of British Art 'This is Britain' advertising campaign. BP gained multiple press opportunities by changing the name of the major permanent, free

exhibition at Tate Britain, which defines the gallery and the institution, with each ordinary rehang: the *BP British Art Display* launched in 2005 later became the *Walk through the 20th Century sponsored by BP* and was made the *BP Walk through British Art* in 2013. In all these cases, Tate could have easily found other sources – trust, state or corporate funding – therefore BP's money diminishes in potential to add something qualitatively more valuable to the balance sheet.

Similarly at the British Museum, BP's alignment with the *Shakespeare* and *Vikings* exhibitions demonstrate the choice of popular content by the sponsor: both displays could have attracted other sources of funding or sponsorship. Likewise with Shell's sponsorship of Rembrandt at the National Gallery – the exhibition would without doubt be attractive to other sponsors. Simply put, BP and Shell sponsorship, however negligible, is also replaceable. The choice of exhibits to sponsor displays the association the companies want to buy from Tate, British Museum and the National Gallery, rather than fulfilling any marginal funding need for the cultural institutions.

Even when a sponsor is associated with a specific exhibition, it has not necessarily enabled the event to take place. Emma Mahony, a curator at the Hayward Gallery from 2001–08, comments:

> As for the money, all corporate sponsorship went towards the bottom line – to the costs of running the Southbank Centre as a whole. It was never put into the exhibition budget, unless it was specifically for a new commission.[25]

Not only do oil sponsors evidently prefer blockbuster exhibitions like *Vikings* at the British Museum or the *Walk Through British Art* at Tate, the contractual sum often serves the organisation's overall balance sheet rather than increasing the exhibition's budget.

Beyond exhibitions, expansion projects might seem a cue for the helpful corporate sponsor to offer additional funds. Good examples of Tate's success in gaining additional funding come in the shape of new building projects. The funding goal for the Tate Modern Project, the extension to Tate Modern, was £45 million. This was reached through

fund-raising from Heritage Lottery Project (£4.9 million), Tate Members (£1 million) and the remainder from a range of private individuals and foundations. Tate achieved the renovation of Bankside Power Station to create Tate Modern with £50 million from the National Lottery and £85 million largely from private trusts and foundations including Sainsbury's, Westons and Vivien Duffield. Tate Liverpool did receive some sponsorship to reach its goal of £6.5 million set in 1986, from Granada TV, but the vast majority of funds for the project came from charitable foundations the Esmée Fairbairn Foundation and the Moores Family, a special government grant of £500,000 and £4.5 million from Merseyside Development. Success was not down to corporate sponsors but a mix of public funds and private foundations' support.

Decades later the exponential expansion plan has soared and the family of Tate's fabulous four has been replicated in the global reincarnations of Guggenheim and the Louvre. Guggenheim now mirrors fashion designers whose labels are underlined by cities of power and influence. Like 'Issey Miyake: London, Tokyo, New York', Peggy Guggenheim's galleries can now announce themselves 'Guggenheim: New York, Bilbao, Abu Dhabi'. Growth is global and importance is measured in miles. Tate learned its own brand had the most potential to become a solid source of income and its journey through the twentieth century exemplifies the economic shifts that have shaped the twenty-first century global art museum.

In Canada and Norway national oil companies' close relationship with the state makes murky the already watery notion of corporate philanthropy. National oil company sponsors concurrently boost the income of the arts and the state. In the UK, within the same period that BP announced its five-year £10 million sponsorship deal with Tate, the Royal Opera House, the British Museum and the National Portrait Gallery, all oil and gas companies operating in the North Sea – including BP – were given a tax 'break', or get-out clause, of £3 billion by Chancellor George Osborne.[26] This followed the £100 million worth of cuts to the arts that were made in 2010–11. The summer of 2012 therefore saw the resulting movement of three large sums of money across spreadsheets in the state's coffers.

Arts organisations across the country folded following the £100m cuts; BP legally avoided paying tax potentially worth hundreds of millions of pounds; and the company basked in the glow of the Cultural Olympiad and Olympics sponsorships alongside handing over (approximately) £500,000 to each of Tate, the Royal Opera House, the British Museum and the National Portrait Gallery. If the oil and gas companies had been properly taxed, perhaps the arts cuts wouldn't have been necessary – along with a number of other significant public sector cuts. Put like this, the flow of finance ultimately lands in the company's favour.

Despite the need that remains to increase arts funding nationally, corporates should not be misunderstood as plugging the gap: because so far the reality is that they simply are not, for which Tate is a prime example. Naomi Klein describes the risk of perpetuating this narrative in 'No Logo':

> The most insidious effect of this shift is that after a few years of Molson concerts, Pepsi-sponsored papal visits, Izod zoos and Nike after-school basketball programs, everything from small community events to large religious gatherings are believed to 'need a sponsor' to get off the ground ... we become collectively convinced not that corporations are hitching a ride on our cultural and communal activities, but that creativity and congregation would be impossible without their generosity.[27]

Corporate sponsors are glorified like a figure of fate, capable of dictating culture. In the case of Tate, rather than acknowledging the resources put into development departments to expand and diversify income from a broad range of sources – the bulk of which is gained from sales, state grants and funding bodies, charitable foundations, members and donations – publicity presents BP as protector of the gallery, rather than the detractor it would be seen as otherwise. BP is defended as an essential agent in Tate's livelihood in the way described by Klein above, yet in reality it is negligible and merely a minor part of the organisation's diverse income.

Ethics and accountability

During the period in which the museums were incorporated as non-departmental public bodies (NDPBs), Prime Minister John Major was embroiled in the government scandal of the decade, around ministers' acceptance of bribes from lobby groups in exchange for scripted parliamentary questions. He wanted a show of ethical standards, and engaged QC Michael Nolan to steer the Committee on Standards in Public Life. Major missed the point and suggested the group met in private, but Nolan made the project public in both process and output.

Nick-named the Nolan Committee, it called on all non-departmental public bodies, including Tate, the British Museum, the National Gallery and the National Portrait Gallery, with the rallying cry: 'Holders of public office should act solely in terms of the public interest.' The ambiguous phrase 'public interest' bends to the convenience and bias of different groups and what is or is not in the so-called public interest may be fiercely debated. Being or belonging to the public is open to interpretation, but as non-departmental public bodies the NDPBs are measured according to some possibility of public accountability.

The Nolan Committee outlined seven qualities desirable in those who hold public office and are called to act in the public interest. The Seven Principles of Public Life are: selflessness, integrity, objectivity, accountability, openness, honesty and leadership. The choice of seven values for public figures to live by carries a certain holy weight – the virtuous opposite of Catholicism's seven deadly sins. But unlike inherited morals, ethics require a look at organisational values and aims to ask what in a given context is the ethical choice. In the blurry territory of public standards, these seven sum up a set of ethical principles.

The Nolan Committee upheld the view that those in positions of power should act with utmost care and responsibility, especially with regard to other financial obligations. Their proposition raises questions around certain aspects of oil sponsorship at NDPB museums. Even from outside the museum, the powerful influence of corporations in public life has the potential to skew endeavours to follow the seven duties. But when oil executives sit on the boards of galleries, it becomes difficult to see how those individuals and other staff could genuinely

practise selflessness, integrity, objectivity, accountability, openness, honesty and leadership to hold the public interest higher than their private concerns.

Several direct associations between the oil industry and museum management are notable in some of the UK's largest cultural institutions. At the Royal Opera House, Peter Mather, BP Group Regional Vice President for Europe, is an Honorary Director, and at the British Museum he is part of the Chair's advisory group. Mather was closely involved in lobbying against European emissions standards that would restrict imports of tar sands from Canada – a project in which BP is heavily invested. He is further tied up in the corporate sponsorship web in his position on the board of lobby group Arts & Business.

Over at the Southbank Centre the Chair of Trustees is Rick Haythornthwaite, who worked in exploration and production for BP from 1978 until 1995 after which he took a more senior role within Premier Oil. Haythornthwaite stayed within the sector and rose to the position of chair of energy company Centrica, one of the UK's six largest power companies. Helen Alexander preceded Haythornthwaite on the Centrica board and was a trustee of Tate during the same period. During a Tate Ethics committee meeting on the subject of BP sponsorship Alexander made a quiet disclaimer noting the potential for the public to perceive in her a conflict of interest based on the proximity of the power sector with the oil industry.

Nigel Hugill, Chair of Trustees at the Royal Shakespeare Company was part of Mobil Oil early in his career. There are also familial connections: Mark Getty, Chair of Trustees of the National Gallery, is the son of Paul Getty, founder of Getty Oil; and Sir Charles Dunstone's father is an executive at BP – Sir Charles is Chair of Trustees of the National Maritime Museum.

Lord Browne of Madingley embodies the longest standing connection between oil and the arts in the UK. Browne's commitment to BP sustained the majority of his working life, from 1966 until 2007. He was joining the family trade: Browne's father joined British Petroleum in 1957, shortly after it changed its name from the Anglo-Iranian Oil Company. John Browne recalls a trip to Iran aged ten at which point he 'fell in love with the oil industry'.[28] On his father's advice he joined

the company aged only 18 during a break from university which would never end – he rose up the ranks to serve as chief executive officer from 1998 until 2007. John Browne has described his deep connection with BP by saying that the company is 'in his DNA'.[29]

Within the BP Ensemble, the friction between these principles and the presence of John Browne is especially heated. Browne held a position on the British Museum Board of Trustees from 1995 until 2005, following which – having resigned from BP in April 2007 – he became a Trustee of Tate in May 2007, and soon became Chair in 2009. The ascension to the role of Trustee on both boards occurred neatly outside of his official relationship to the company: at the British Museum, BP sponsorship commenced on Browne's departure from the board, while at Tate the trusteeship began following the end of his employment with BP. However, the allegiance between Browne and BP remains clear, as do the ties to the oil industry of the other trustees that pepper London's cultural institutions. The intimacy between sponsor and staff mirrors the three positions held by Rockefeller family members – all related to the Standard Oil Company – on the Board of Trustees of MoMA, New York, in the late 1960s.

As persons responsible to organisational policies, the individuals listed are ill placed to question whether an oil company is an appropriate or acceptable sponsor. The Seven Principles of Public Life are seriously undermined when loyalties lie so firmly in the other camp. Were staff at these institutions wishing to initiate a critical dialogue around oil sponsorship, the presence of oil executives would likely diminish their resolve.

Public museums have a responsibility to remain accountable to the public, but it seems that certain corporations have significantly greater influence. If ethical decisions are to be made about oil sponsorship, the connections between decision-makers and the oil industry must first be critically examined, and finally evicted from the gallery and its processes.

Furthermore, public accountability through a democratic process gets sticky: where on the one hand oil sponsorship contravenes the commitments these NDPBs are called to make, answerable to the

public, on the other hand government ministers encourage the deals and misrepresent their true value to the arts organisations.

Another crucial guideline shaping art museums' responses to the oil sponsorship question is their own ethical fund-raising policies. Patrick Steel of the Museums Association recommends caution: 'Inappropriate sponsorship and bad practice arguably harm the reputation of all concerned.'[30]

The National Gallery and Tate both have fund-raising guidelines to follow reflecting the ways in which reputation is important on both sides of any sponsorship deal. The National Gallery's policy says sponsorship will be rejected if:

1. Sponsorship interferes with the Gallery's ability to fulfil its charitable aims;
2. Sponsorship might lead to an undue and inappropriate third party influence, or impression of such influence, on corporate decisions of the Gallery;
3. Sponsorship will incur a level of criticism from the press, public or any other relevant community of professionals resulting in serious damage to the Gallery's reputation;
4. Existing and future relationships with donors and supporters will be jeopardized.[31]

Tate's policy was formed in direct response to protests against BP sponsorship and similarly states that funding will be refused in case it:

1. Harms Tate's relationship with other benefactors, partners, visitors or stakeholders;
2. Creates unacceptable conflicts of interest;
3. Materially damages the reputation of Tate; or,
4. Detrimentally affects the ability of Tate to fulfil its mission.[32]

The keywords sing from the two lists: influence, jeopardy, relationships, reputations, mission. The song of the galleries' policies is fierce and frank: sponsorship must be considered very carefully. But powerful policies such as these risk remaining dusty on the shelf. Policies are

a script that, one day, must be read aloud, blocked out, rehearsed and enacted. As described in Chapter 2, the National Gallery's policy was brought to life in 2012, when Campaign Against Arms Trade built criticism to such a level as to result in 'serious damage to the Gallery's reputation', and Tate's decision to end its deal with United Technologies in 1986 followed protests by artists that received a great deal of publicity and therefore 'materially damaged the reputation of Tate', and at the same time harmed 'Tate's relationship with other … stakeholders' – those same artists.

Likewise, Tate and the National Gallery could breach their own ethical fund-raising policies in their contracts with BP and Shell. The National Gallery has been the focus of several protests by Greenpeace, putting Shell's presence as corporate partner under the lens of public scrutiny even before the Rembrandt exhibition sponsorship launched in 2014. Tate's relationships with 'other benefactors, partners, visitors or stakeholders' could be harmed by the number of visitors, members and artists who have all spoken out against the BP deal: over 300 artists and cultural workers signed letters calling for an end to the deal between 2010–12, over 8,000 gallery-goers and members added their name to a petition of Tate director Nicholas Serota on the issue in 2011, and numerous artists have spoken out on the issue, from Sonia Boyce and Conrad Atkinson, whose works are held in Tate's collection, to world-famous actress Emma Thompson.

Lord John Browne's position as Chair of Trustees at Tate could create an 'unacceptable conflict of interest', and Mark Getty's family legacy in oil wealth could give the 'impression of undue third party influence' over oil sponsorships at the National Gallery. BP and Shell could pose threats to 'the ability of Tate to fulfil its mission' and the capacity for the National Gallery to 'fulfil its charitable aims', because of the various ways in which the presence of oil sponsors conflicts with the intentions, projects and work of staff in various departments, as Chapter 5 will explore.

The extent to which the BP sponsorship could be considered in breach of one of the points in Tate's Ethics Policy is a fluid question. The Ethics Committee discussed BP sponsorship in early 2010 and recommended:

The continuation of the current relationship with BP and that the executive prepare a Q&A document on Tate's Sustainability Strategy, considering what questions we might be asked, and how we might respond to them.[33]

Their decision to recommend constructing media talking points on the issue indicates a perceived risk that BP materially damages 'the reputation of Tate' and harms 'Tate's relationship with other … stakeholders.' That particular meeting took place on 6 May 2010, just weeks after the Deepwater Horizon explosion and disaster began on 20 April. The newspaper headlines that day included 'Gulf of Mexico oil slick could increase 12 fold'[34] in the *Daily Telegraph* and 'Gulf oil spill threatens wildlife reserve created by Roosevelt'[35] in *The Guardian*. Accidents are unfortunately regular in the oil industry, and harmful impacts fundamental to everyday operations. The need for the Tate Ethics Committee – which meets on an ad hoc basis – to convene in response to a BP-related issue that could cause reputational risk for Tate all depends on how closely committee members look at the effects of the company's day-to-day operations.

The National Portrait Gallery says that it is committed to reducing the environmental impact of its operations, while Tate holds a number of awards for its efforts in sustainable working practices, from the Carbon Trust and Green Week. Tate has collaborated with Cape Farewell, the artists' group that creatively responds to Arctic ice melt, and in 2010 it held an event entitled 'Rising to the climate challenge: Artists and scientists imagine a better world'. But BP is third on the list of 90 companies that are responsible for two-thirds of man-made climate change.[36] It is a little absurd for an institution sponsored by the company that holds the bronze medal for causing climate change to hold events and receive awards relating to climate action and sustainability.

Given the breadth of commitments to DCMS and in their own policies, the British Museum, Tate, the National Gallery and the National Portrait Gallery are sitting on various sites of conflict between their stated aims and policies and their associations with BP and Shell. The narrative that oil sponsorship is vital to the arts is unsupported by the financial data, and it is clear that the relationship between Big Oil and the arts has been maintained for other political purposes.

4
Discrete Logos, Big Spills

BP describes itself as 'a major supporter of the arts with a programme that spans over 35 years, during which time millions of people have engaged with BP sponsored activities.'[1] The latter part of the assertion is quietly revealing. The real purpose of sponsorship is the opportunity to gain access to important audiences either during their engagement with cultural activities that are linked to BP or through wider awareness of the associations. Oil companies claim affection for the arts because doing so establishes their position as heroes rather than parasites. But an expression of love is at odds with an act of exploitation.

BP's association with Tate, the Royal Opera House, the British Museum and the National Portrait Gallery fulfils a vital function for the company. Public promotion of the relationship sits within a set of strategies BP undertakes to maintain its own survival, profitability and deeper embeddedness in the minds of its consuming publics. BP, and oil companies like it around the world, needs these arts associations to cover up the very harmful activities that, once connected to specific galleries, undermine the role and purpose of those galleries to serve their publics. The negative image oil companies wish to mask is then placed in the gallery and has its own impacts.

BP has problems. Its business model causes harm to workers, local communities, and the ecologies vulnerable to industrial oil extraction's every risk and mishap. Within the industry climate change receives occasional mention, but otherwise it remains an unspeakable collateral of daily operations. Various practical challenges are mitigated by engineering where possible, but public relations concerns are quick to escalate, and over the past thirty years the global press and latterly social media have tracked and shared every misdemeanour

with dizzying speed, exposés frequently equipped with alarming photographic evidence.

An intangible risk requires a more versatile mitigation. To survive an international onslaught of criticism and anger following a crisis, oil companies must first develop a relationship with the core values, experiences and highest held beliefs of a culture. As the threads of the sail come loose in the storm, the company must have a firm knowledge that the vessel is well anchored. When things go wrong, the company needs to maintain and reaffirm its position in the eyes – and hearts and minds – of its consuming publics. By seeding itself into our homes, sports events, work places, streets, galleries and museums, Big Oil convinces us of its own worthiness and centrality to our ways of life. Despite all the harm it may cause, it is still welcome in our lives. This process is called, in the PR world, a 'social licence to operate'. The social licence is everything to the business: it is fundamental; it is built and repaired daily; and it is a kind of insurance against expected negative impacts and crises of confidence.

The arts are prized within international oil companies' social licence to operate strategies. Cultural institutions offer access to high-level government figures at special events and on guest lists; and the association with the prestige and national pride of society's bedrocks gives a sense of security, and the idea that the company is as fundamental to what is public and shared as the histories and ideas embodied in the art itself. Companies sponsoring the arts freely acknowledge their support is rooted in an operational need and does not imply interest in specific arts or audiences, despite marketing attempts to suggest otherwise. As oil companies are increasingly losing social acceptability, the arts become more important to their survival.

Disaster is fundamental to business

Recent decades in the life of BP have been muddled and fraught with crisis and catastrophe. Accidents, legal challenges and political scandals have arisen on almost every continent. Shell, too, has followed a similar pattern. The list of some key contemporary manifestations of

BP's character and standards illustrate the company's need to artwash and unveil the potential resonances of its presence in the gallery. The examples of controversies surrounding BP extraction projects include cases in Algeria, Egypt, Azerbaijan, Georgia, Turkey, Colombia, Canada and the USA. Let's start with the most recent event of Hollywood apocalypse proportions, the Gulf of Mexico disaster – 'the biggest accidental oil spill in history'.[2]

The explosion of BP's Deepwater Horizon rig took place on Wednesday 20 April 2010. One hundred and twenty-six workers were on board the rig that day, as it drilled for oil in BP's Macondo oil and gas prospect. Macondo lies 40 miles south off the Louisiana coast of the USA, and takes its name from the cursed village at the heart of the novel *One Hundred Years of Solitude* by Gabriel García Márquez. The Macondo of García Márquez sees generations of one family lineage survive a multitude of obstacles, challenges and dramas. The Macondo oil field of BP caused the Deepwater Horizon to explode after oil began to gush at high pressure at the seabed where it was being extracted. The rig was 121 metres long and 78 metres wide and the fireball of the explosion was visible 35 miles away – the distance between Manchester and Liverpool. Eleven workers were killed in the blast.

News of the explosion soon reached Tony Hayward, who at the time was CEO of BP and probably still would be now, if not for the disaster. His name had been written down for the top spot long before John Browne's departure, and Hayward had been tight in Browne's inner circle of 'Turtles', nicknames for his coterie taken from the children's televised cartoon the *Teenage Mutant Ninja Turtles*. Both Browne and Hayward climbed the company ladder from entry-level positions, Browne in Alaska and Hayward in Aberdeen.

Hayward's downfall was his initial attempt to underplay the scale of the event. Even one month after it began – it lasted eighty-seven days in total – on 14 May 2010, Hayward described the catastrophe to *The Guardian*, 'The Gulf of Mexico is a very big ocean. The amount of oil and dispersant we are putting into it is tiny in relation to the total water volume.'[3]

The total water volume he referred to was a 1.5 million square kilometre sized ocean, with a shoreline of 27,000 kilometres in the USA

alone. It was as dismissive as comparing a spilled cup of coffee to an entire city, choosing to overlook the very nature of liquid to intermingle, disperse and spread the toxic substances far beyond measure. On 18 May 2010 Hayward claimed to a Sky News interviewer, 'I think the environmental impact of this disaster is likely to have been very, very modest.'[4]

Hayward was criticised for attempting to misrepresent the ecological damage of the spill, which continues to be felt years afterwards. The harm caused by the oil and the chemical dispersant Corexit on fisherfolks' livelihoods, sea-life and the Louisiana wetlands is considered by some to be 'immeasurable'.[5]

On 30 May 2010,[6] Hayward further injured public perception of BP and its leadership by making the comment 'I'd like my life back',[7] with frightening disregard for the tragic loss of life in the disaster. The US press plagued him for it and US citizens were in uproar. There were protests against BP all over the country. Hayward was grilled by US politicians in a special senate hearing in which he was called as a primary witness to give evidence under oath.[8] The hearing was broadcast live across several US television networks.

Furthermore, BP's credit rating received a series of downgrades, and between April and June the company lost $100 million in stock market value.[9] In many of the world's financial centres, including London's Square Mile, televisions in financiers' offices, carefully positioned beside the stock market displays, beamed footage of the unstopped oil gushing into the ocean as it was broadcast live. An asset manager for a large insurance company in London observed, 'We watched it constantly, the live feed on our screens for months.'[10]

The reports of BP's failed attempts to cap the well were a running news item throughout the summer of 2010. Economists diagnosed the company as being on the brink of financial collapse, and Tony Hayward later acknowledged, 'The confidence of the markets had been rattled.'[11] Confidence is crucial. Without sufficient conviction from investors, corporations' share values have been known to disintegrate.

Criminal charges were brought against the company, and in November 2012 BP pleaded guilty to fourteen counts including misleading congress and manslaughter.[12] The company paid the US

Department of Justice £2.5 billion – the largest criminal resolution in US history.[13] By mid-2013, BP had paid compensation costs approaching £30 billion[14] to companies and individuals affected by the spill. A civil trial to determine negligence began in New Orleans in March 2013 and in October 2014 BP challenged Judge Carl Barbier's ruling that BP was guilty of 'profit-driven decisions' amounting to 'gross negligence', which could see fines of up to $18 billion. The BP chief financial officer Brian Gilvary said he expected the company to fight the ruling for 'a number of years'.[15] BP was temporarily banned from signing new contracts in the USA, where almost 40 per cent of its oil production, and about 60 per cent of its sales are located.[16] This was the second US-based incident in only a five-year period. Previous to the Deepwater Horizon catastrophe, in 2005, a BP oil refinery in Texas blew up, killing fifteen workers. Following the Texas incident, John Browne was singled out for failing to flag the risk and was censured by a US safety panel.

BP's impacts have been felt and protested globally, from Canada, to Colombia, Azerbaijan and Algeria. These are not isolated, sporadic incidents, but a catalogue of damages presenting another angle on the company's deleterious effects in every frame. From 2006 to 2014 First Nations activists, environmentalists, institutional investors, and shareholders from all around the world have protested and lobbied against BP's operations in the tar sands in Alberta, Canada.[17] Environmental Defence, a large US-based NGO, names the tar sands 'the most destructive project on earth',[18] and Indigenous Environmental Network, a campaign group of First Nations and Native Peoples across Turtle Island (the continent those of us from colonial or settler states refer to as North America), has raised concerns around the alleged contravention of the United Nations Declaration of the Rights of Indigenous Peoples.[19] The enormous open-cast mining project is so large it is visible from space. The landscape of once verdant boreal forest appears from satellite photography as a desolate crater belonging to an entirely different planet. Communities have experienced numerous cases of water contamination from spills and waste-water seepage, with concerns about increased cancer rates, and the dramatic impacts on regional bird and caribou (reindeer) populations.[20] BP, Shell and other tar sands operators have begun to leave a legacy of untold devastation.

In 2006 over 1,000 Colombian farmers brought a human rights claim to the High Court in London, accusing BP of benefitting from a 'regime of terror'.[21] The group agreed on an out-of-court settlement said to be worth at least several million pounds.[22] In November 2009, ninety-five Colombian farmers brought another case against BP in London.[23] At each stage, farmers travelled across the Atlantic to state their case and seek some kind of justice. Represented by Leigh Day, the group made a claim for compensation due to the environmental impact on their crops of the Ocensa pipeline. BP managed the construction of the 800-kilometre pipeline from 1997.[24] The documents submitted in court claim:

> The region has been profoundly and adversely affected causing many farms to close or drastically reduce production and causing some farmers to leave the land.[25]

Leigh Day's public statements on the legal challenge include the confirmation:

> The case is progressing in the Technology and Construction Court (TCC) and is the first international case on environmental damage against an oil company in the British Courts.[26]

In 2010, BP Colombia sacked 200 workers in what appeared to be an act of revenge after a five-month strike in protest against BP's alleged 'on-going failure to address their social, environmental and labour demands.'[27] The trauma of the pipeline had now spanned a period of almost fifteen years for all involved. The British writer and activist Claire Hall puts in historical context both cases of concern around BP's involvement in human rights abuses:

> Since oil exploitation began in Casanare 20 years ago, more than 3 per cent of the population has been killed or disappeared. Community leaders have been murdered, persecuted, threatened and displaced by state-linked paramilitaries operating around BP's oil fields, often in partnership with Colombian Army leaders. BP provides support

to the Colombian Army's 16th Brigade, despite their long cruel history of human rights violations. A preliminary public hearing on BP's activities in Colombia stated that 'there is sufficient evidence to conclude that BP has a case to answer that it is complicit in the extermination of social organisations in Casanare as part of a direct strategy to maximize profits'.[28]

Hall's verdict is damning. BP no longer operates in Colombia, having handed over the operations in Casanare to another firm in 2011. Of the incidents, the company makes minimal comment on its website saying, 'BP learned many lessons through our experiences in Colombia.'[29] I wonder whether these lessons were in operational standards, or in masking its public image when mishaps arise.

From 2001 until the present day civil society organisations in Azerbaijan, Georgia, Turkey, Italy, Germany and the UK have united to challenge BP on the environmental and social impacts of its Baku–Tbilisi–Ceyhan pipeline. For each step along the pipeline, hands have joined to challenge the harm it has caused. Over 173 violations were found in a review of the Environmental Impact Assessment – a legal document companies are required to produce before commencing most types of industrial project – for the Turkish section of the pipeline.[30] Due to the efforts of the Kurdish Human Rights Project, the UK government censured BP for failing to investigate alleged human rights abuses in Turkey associated with its pipeline, especially involving Kurdish people.[31]

In 2011, BP came under further scrutiny over human rights concerns amid revelations of details of its close association with ousted Egyptian military dictator Hosni Mubarak.[32] BP is one of the largest foreign investors in Algeria, where it owns two gas fields together worth $5 billion. Hamza Hamouchene, chair of the Algeria Solidarity Campaign and researcher with Platform, said projects such as these were a contributory factor in 'the longevity of an authoritarian and repressive regime at the expense of the human rights of the Algerian people.'[33]

The full exhibition of BP's global entanglements evokes an incorrigible antagonist quick to evade responsibility and slow to listen to its detractors. The company's need to resolve its public image in the

context of this murky painting of its global activities is obvious. But on top of all this, even if every accident was prevented and all potential involvement in human rights abuses was contained, there is still a fundamental problem inextricable from BP's operational model. With each drop of oil unearthed and burned, the cloud of carbon dioxide wrapping itself around the planet thickens. There is no going back from this. There is only the option to minimise and curtail. In its current mode of production, for BP to pay a dividend to shareholders it must wreak havoc with the climate and holding shares in sixteen wind farms globally – BP's renewables assets in 2014 (discounting dubious biofuels projects) – cannot alter this fundamental aspect of its business model.

A social licence to operate

BP is not the first British-based oil company to face massive international public protests due to the potential human rights and environmental impacts of its operations. Shell's crises in 1995 in relation to the execution of the Ogoni Nine in Nigeria, activists against Shell's operations, and the Greenpeace blockade of the dumping at sea of the Brent Spar oil rig triggered decades of campaigning against the oil industry and informed corporations' public relations (PR) strategies and corporate social responsibility (CSR) programmes worldwide.

In 1995 Shell was accused of collaborating in the execution of nine community organisers who had been involved in protests against the company, including the internationally celebrated writer Ken Saro-Wiwa. The Ogoni Nine, as the men came to be known, were Baribor Bera, Saturday Dobee, Nordu Eawo, Daniel Gbooko, Barinem Kiobel, John Kpuine, Paul Levera, Felix Nuate and Ken Saro-Wiwa. With Saro-Wiwa as president, they were active in the Movement for the Survival of the Ogoni People (MOSOP). As part of the group, the nine men had mobilised opposition to Shell's operations in the Niger Delta since 1990, organising protests and campaigns that had the support of over half the population of Ogoniland. Ken Saro-Wiwa nurtured national and international solidarity activities through his poignant writing. The Ogoni Nine were hanged on 5 November 1995: the charges

were spurious, the trial named unjust and questions were raised over Shell's awareness of the decision to prosecute the men. After the executions, global public scrutiny on the cause and Shell's operations in Nigeria intensified. Over the following fourteen years family members rallied support in cities around the world from Lagos to London to Liverpool. In New York in 2009 Shell settled out of court with the Saro-Wiwa family in a legal action brought against the company for conspiring with the military government that hanged the activists.[34]

Shell ultimately changed its plans to sink the Brent Spar at sea following Greenpeace's unshakable occupation. In the early 1990s Shell had gained approval from the British government to sink the 14,500 tonne oil storage and tanker loading buoy off the coast of Scotland in the North Sea, but once Greenpeace activists started their occupation the world's media spotlight shone on the Brent Spar's decks. As activists were attacked with water canon, public support for Greenpeace's demands mounted. Although Shell continued to claim its plan to sink the Brent Spar was environmentally sound, the decision was made to take it to shore in Norway to be broken up for scrap metal.

The company faced two incidents that suddenly displayed the underside of its everyday operating practices for the world to see. Shell did not, however, decide to set out stricter operating guidelines to prevent further tragedy, but instead it focused full steam ahead on its public relations recovery plan. John Jennings, then Chair of Shell Transport and Trading, wrote in 1996: 'The events of the past year demonstrated the degree of complexity in the multinational operations of Group companies and the need to gain … licence to operate.'[35]

The idea that companies need a level of social acceptability in countries where their sales are located in order to continue their profitable operations began to be articulated in corporate contexts by Shell. The strategy developed here underpins their current sponsorship of the arts, and informs other oil sponsorship deals including those maintained by BP, and set up more recently by Statoil, Lundin, Total and others.

Jennings' concern was echoed in the following year by Jim Cooney, who extended the phrase to '*social* licence to operate' during his speech at a World Bank meeting in 1997. At the time Cooney was Vice-President

of International Government Affairs for Placer Dome, a gold mining corporation; he has since been involved in CSR programmes worldwide. The use of the phrase 'social licence to operate' had been seeded within the language and culture of the extractive industries. Rooted in Jennings' earlier reference, the idea became influential to PR thinking and practice by those involved in Shell's 1995 fallout and – crucially for the PR professionals – its recovery.

In late 1996 Shell launched what it called the 'Society's changing expectations programme',[36] a year-long piece of research to examine public perceptions of the company that would shape its PR and advertising strategies to come. This process brought together Tom Henderson, Shell's Project Director for External Affairs, whose work involved 'reputation management, corporate identity' and who specialises in looking at 'society's changing expectations of multinational companies', and John Williams, co-founder and chair of corporate PR firm Fishburn Hedges, and leader of the Shell team. Together they moulded the Shell crisis into a PR management framework. Henderson and Williams describe the diversity of the audiences that must be reached to obtain a 'licence to operate':

> Shell had to acknowledge that its stakeholders were now a much wider, more diverse and influential group than before. It had responsibilities that stretched beyond its traditional core of shareholders, customers, business partners and employees. It was this wider group that together granted Shell its 'licence to operate'.[37]

Shell's public image research sought to establish the breadth of possible audiences in a position to influence the success or failure of the company. Shell began to see that the 'licence to operate' was as fundamental to successful operations as any other aspect of the business, and could not be employed or outsourced – it had to be acquired quite differently. Henderson and Williams do not hesitate to emphasise just how important the 'licence to operate' would be to the company, and prescribed for Shell 'a global reputation management programme to "build, maintain and defend Shell's capital".'[38]

Shell's assessment, led by Henderson in close collaboration with Williams on behalf of Fishburn Hedges, identified seven key audiences and set objectives for the desired responses from each of these groups following the upcoming advertising campaign, including responses such as 'You can be sure of Shell'. They decided that certain audiences held more sway over wider public opinion and that the company must hone its message to these influencers to then secure a licence to operate from a broader public.

These influential audiences are known as 'special publics' and include business people, media executives, civil servants, high-level civil society and public sector officials, target readers of the *Financial Times* and *The Economist* and anyone else in a position to bear weight on major political and economic decisions. This group was isolated for attention, as they continue to be, because if the company can reach special publics, its message will be passed along the line to wider audiences:

> The key target audience should be special publics. It is opinion-formers that grant the licence to operate and often set the tone for how the general public hears about and assesses companies. The goodwill of customer audiences could be disproportionately affected by an adverse reputation among special publics.[39]

The distinction here between customer audiences and special publics is important: special publics are a vehicle to wider social acceptability. Henderson and Williams separated the audiences they wanted to focus on into three groups: commercial interest such as shareholders and investors; public interest (the ubiquitous phrase applied here in reference to the public sphere but not necessarily taking a particular slant on what is good for the public) including lobby groups, NGOs, politicians and the media; and personal interest – staff and possibly families of staff. Clearly two of these groups are more accessible to direct communication from Shell, but the jargonistic 'public interest special public' is necessarily a trickier target. This group is therefore the bull's eye for companies seeking to establish social licence.

Mass advertising was rejected because 'key external audiences needed a greater degree of personal communications before any mass

media were employed. Shell called this a PR-led approach.'[40] As such, the PR team sought to stage a new narrative around Shell, engaging audiences in this alternative story, showing Shell as they wanted people to see the company, rather than simply telling them information about Shell. Their 'report to society' entitled *Profits and Principles* incorporated events, briefings and print advertising. It was a kind of performative advertising: presented as a public opportunity to gain access to a genuine internal debate, Shell performed the question 'Can you seek profit without compromising your principles?' Audiences were presented with a Shell that is honourable, thoughtful and reflective in its business practices. None of these characteristics needed to be verifiable for the PR strategy to work, and indeed many of the same criticisms continued to plague the company over the following decades – but now it knew better how to maintain its social licence to operate despite any controversies.

The 'PR-led approach' saw Shell quickly seek out artistic means. As Henderson and Williams describe, Shell created a:

> Joint writing prize with *The Economist*, the first such joint marketing activity *The Economist* had undertaken. 'The World in 2050 Writing Prize', it has been aimed at opinion-formers across the world, inviting them to submit essays about how the world might develop in the next fifty years and the implications for public policy decisions to be taken today.[41]

Shell was asserting its own relevance and position in future economies through a PR strategy that sought to 'defend Shell's capital'. Like its 'report to society', this project gave Shell space to perform a persona of a responsible corporation with an important role to play in shaping society's outlook and principles. Henderson and Williams congratulate themselves on having attained for Shell a 'licence to communicate' as a means to be granted a licence to operate.

But the crises Shell was involved in remain unresolved or have been repeated in different places at other times. Greenpeace continues to campaign against Shell's environmental impact at sea, calling attention to the company's plans and attempts to drill in the fragile, melting

Arctic. Rather than seeing rising global temperatures and greater extents of sea ice melt as a warning, oil companies have set their sights on oil deposits miles beneath the ice cap of the polar north. Anna Galkina, Russian oil and investment researcher with Platform, reports that a spill in the Arctic would be catastrophic; the icy conditions rule out many of the emergency response techniques used in BP's disaster in the Gulf of Mexico, and research into more suitable methods remains limited.[42] In Nigeria, Social Action and the Movement for the Survival of the Ogoni People (MOSOP) find they must still organise to challenge Shell on water pollution and its association with human rights abuses in the Niger Delta. Where Shell has spent millions on PR strategy and advertising and has a number of sponsorships in London cultural institutions, it dodged calls from the United Nations Environment Programme to contribute to a US$1 billion start-up fund towards a clean-up project in the Delta, finally assenting in 2014.[43] Community members in Bodo, Rivers State, Nigeria took a legal challenge to Shell following two massive oil spills in 2008, but compensation talks broke down after Shell made an offer that the community called 'derisory and insulting'.[44] The concerns raised in the 1990s around Shell's business practices have not been resolved – but the company has developed a PR strategy to maintain its social licence to operate in the face of mounting public criticism.

Shell's PR strategy of closely analysing and selecting its key audiences is echoed in literature on 'social licence to operate' by Robert Boutilier, Ian Thomson and Leeora Black, in various independent works, and one collective piece titled 'From metaphor to management tool – How the social licence to operate can stabilise the socio-political environment for business'.[45] Boutilier, Thomson and Black are mining industry PR specialists whose entire careers are built on beautifying the slag heap. North Americans Boutilier and Thomson have built their careers in social licence strategy through decades of employment in mining and oil companies across several continents. Leeora Black is an Australian who found her mining industry image management portfolio closer to home. The three have developed a model which they recommend companies use – mining, oil and gas companies in particular – to gain social licence and continue their profitable operations. From the outset,

the mission to 'stabilise the socio-political environment for business' is a potentially controversial aim when the destabilising risks include the valid and reasonable concerns Greenpeace and MOSOP raised in the events described by Henderson and Williams.

Boutilier and Thomson define social licence as the 'acceptability of a company and its local operations',[46] placing emphasis on the wider public perception of the company itself, as well as the particular responses to specific extractive projects locally. As they measure it, 'the social licence granted is inversely related to the level of socio-political risk a company faces' and if social licence is 'withdrawn or withheld' the company will have 'restricted access to essential resources' including 'financing and markets'.[47] BP's difficulties in the global stock markets during the Gulf of Mexico catastrophe clearly demonstrate the rapid and potentially massive impact on financial resources that high socio-political risk can have. At that time, BP's social licence was threatened with being completely withdrawn by the US state, legislature and public. For BP, the USA represented both a local site of operations and significant market for their products, as well as a main home of its investment and shareholding – the largest lump of stocks is held by US bank JPMorgan Chase. BP needed to rebuild its social licence across these audiences, as Shell had done in 1995.

BP had a number of arts sponsorship deals and was also keen to exploit its position as sponsor of the Cultural Olympiad, secured in 2008. Following the Deepwater Horizon disaster in 2010 the company looked to the upcoming Olympics to be held in London in 2012 as a prime image recovery opportunity: again the world was watching. The arts programme alongside the sporting event was widely criticised because of the prescriptive directions given to artistic projects in receipt of funding, which included 'celebrating London and the whole of the UK welcoming the world' and 'using culture and sport to raise issues of environmental sustainability, health and well-being'.[48] These limitations seemed at odds with the choice of sponsors. Alongside Olympics sponsors Coca-Cola and MacDonald's, BP as Cultural Olympiad partner was under scrutiny regarding what work would be deemed acceptable, and what censorship of artworks or self-censorship of proposals might be going on behind closed doors. Nonetheless, the

sponsorship arrangement more than satisfied BP's immediate needs. Since the Gulf of Mexico disaster BP had the lowest brand perception score of all the Olympic sponsors. Following the Olympic Games polling on public perception of BP showed an increase of 8.5 per cent in trust and positive feeling, the second biggest leap in brand image achieved out of all the Olympic sponsors.[49]

Like Henderson and Williams for Shell, Boutilier, Thomson and Black's strategies all lead to in-depth audience analysis. Boutilier and Thomson look at 'stakeholder networks' by referencing Robert Freeman's definition: 'those who could be affected by the actions of the company or who could have an effect on the company.'[50] Where Shell was keen to focus in on the audiences it selected as significant, Freeman's wording is looser, encompassing groups that both the company itself impacts as well as those who could put pressure on the company or its operations. Leeora Black continues in this vein, defining stakeholders as anyone who has a stake or interest in the company, who could be affected by or could influence the company and its activities, and goes on to warn: 'An important point to remember is that stakeholders are self-defining. They define themselves in relation to the impacts and benefits of a company and not in relation to a physical distance.'[51]

Nonetheless, Black does concur with Shell's attention to 'special publics' as a key group to influence wider audiences. 'Special publics' equates to Black's reference to 'opinion leaders': 'For purposes of social licence strategy, your stakeholder identification should focus on *opinion leaders*.'[52] [her emphasis].

Black advises 'opinion leaders ... have some degree of power' and 'can influence perceptions by their behaviours'; they are broadly 'influential' and may have an 'official or unofficial representative role in the community.'[53] Each PR proposal sets its sights on the supreme special publics. Henderson and Williams looked to *The Economist* readership as a special public for Shell, and BP follows suit by going for the *Financial Times*. BP advertises its art sponsorships in the *FT Magazine*, chosen to impress special publics without them ever actually visiting an exhibition.

Boutilier and Thomson's model sets up a hierarchy of four potential social licence rankings. This stairway leads from teetering public

perception to a nirvana of social acceptance. Economic legitimacy is the base, founded on any financial gain or resource benefit for the stakeholder. They define socio-political legitimacy as the next necessary step, for which they reference philosopher Pierre Bourdieu's idea of cultural capital – access to networks and contacts – alongside interactional trust, which they describe as low-level acceptance of the company. Finally, the dedicated reach a bounty of institutional trust. Although socio-political legitimacy and interactional trust feature at the same level in the quasi-religious pathway to a social licence, Boutilier and Thomson note that, 'mining companies achieve interactional trust more easily than socio-political legitimacy.'[54] This is because of the scale on which each of those steps must be attempted – interactional trust can be bought at the negligible cost of fifty iPads for a primary school, but socio-political legitimacy can be quickly decimated in the global media, as the BP Deepwater Horizon catastrophe again demonstrates. Black describes how the final rung, institutional trust (also referred to by the management theorists as 'psychological identification'), is not usually attained: 'Psychological identification is rare and may take decades to evolve.'[55] Like monks or bodhisattvas, only the most committed will last the course to salvation.

When Tate celebrated twenty years of BP sponsorship in 2010, while the Gulf of Mexico disaster was devastating the southern US coastline's ecologies and communities of fisherfolk, BP's ascension in social licence gaming was centre stage. On display beside the Fiona Banner exhibits was the way in which BP had reached special publics via Tate, evidenced by the guest list. Via these opinion-formers the US and UK consuming publics' (again, major markets for BP products) psychological identification with the company had been granted from on high. It is this construction of 'institutional trust' which could protect BP's social licence to operate in a time of such crisis.

The fundamental cynicism of social licence as a management model or a PR strategy is that it aims to make the public accept companies' operations without actually addressing the valid concerns raised by 'stakeholders' and 'audiences' – by citizens, publics or simply *people*. Boutilier and Thomson defend the model by describing a new kind of social contract drawn up between companies and communities,

conveniently ignoring the massive power imbalance that shapes these negotiations, and the fundamental challenge this poses to notions of democracy. If the social contract is with the company, any responsibility to define or protect the ubiquitous 'public interest' is submerged into an entity whose main purpose is to mine and sell at a considerable profit. At the same time they point out that without a 'global social contract'[56] it is hard for bigger questions, such as climate change, to be addressed. In the globalised context of multinational companies operating across numerous legislative regions and attempts to apply the UN Declaration of Universal Human Rights within those differing legal structures, the power a company gains by cultivating a strong social licence should be scrutinised under the lens which this notion of a 'global social contract' suggests. Evidence published in 2014 suggests that almost half of all global extractive projects have faced resistance from local opponents.[57] Black is keen to note that NGO and civil society campaigns are one of the biggest threats to a company's social licence, capable of removing it entirely. This combative relationship with civil society again underlines the risk to democracies posed by the promotion of companies like BP and Shell as 'corporate citizens'.

Black falls back on the idea that attention to social licence will ultimately enable 'improved impacts' for local communities – but as BP's unmet pledges to people living along the Baku-Tbilisi-Ceyhan oil pipeline show, even commitments made to gain social licence for a project to be approved are often disavowed when the socio-political risk has been neatly avoided. As *The Oil Road* authors Mika Minio-Paluello and James Marriott describe, 'BP went to extraordinary lengths to assure all concerned that this pipeline would be different. Unlike oil projects of the previous century, this would be carried out to the highest social and environmental standards.'[58] The assurances were evidently empty promises.

George Weissman, executive committee chairperson for US tobacco company Philip Morris, observed that companies needed to find a new role, a new relationship with consumers, which he saw as requiring a greater intimacy and more personal qualities:

Obviously innovative approaches were needed to run our businesses, to develop new kinds of ties with the community … to make secure our democratic, capitalistic way of life. We are dealing here with basic, rock-bottom self-interest.

Weissman's advice, for oil companies, would be that rather than seeing themselves as simply fundamental to daily life in industrialised societies, they now needed to seduce the public into seeing them as part of the twenty-first century, rather than the hundred years that came before.

As questions of democracy rage and protests against the unaccountable power of multinational companies mount, the depiction of the corporation as a responsible corporate citizen by Weissman and others continues to gain momentum in reframing exercises by PR gurus. For oil companies, it is a major turnaround to seek: from evildoer damaging the planet, to responsible benefactor. Alex Carey described the cultural shifts from which we arrive in the twenty-first century: 'The twentieth century has been characterised by three developments of great political importance: The growth of democracy, the growth of corporate power, and the growth of corporate propaganda to protect corporate power against democracy.'[59] BP sponsorship of the arts has to be looked at within this context of building corporate propaganda.

Arts sponsorship to secure social licence

Strategies to cultivate a social licence by reaching key stakeholders, special publics and opinion formers led the oil companies BP and Shell to set up arts sponsorships deals in the UK capital that houses two of each of their global headquarters. Since 1990 the two companies have aligned themselves with almost of all of London's major cultural institutions. BP is or has been associated with Tate, the British Museum, the Royal Opera House, the National Portrait Gallery, the Science Museum, Almeida Theatre, the Royal Shakespeare Company and the National Maritime Museum. Shell has sought out relationships in parallel with the Southbank Centre, the National Theatre, the National

Gallery, the Science Museum, the Royal Opera House and the Natural History Museum. The focus on high profile, especially prestigious, and world famous institutions that are revered in the national consciousness is a deliberate and strategic one to target special publics and opinion formers. Whether these important audiences visit the galleries or not, the mere awareness of the association seals the companies' glossy façade.

Rena DeSisto, global arts and culture executive with Bank of America Merrill Lynch, sums up the thinking behind this strategy of obtaining a social licence in the comment:

> There are plenty of big corporations that do not support the arts, because they labour under the misapprehension that they are something extra, instead of a key marketing tool. If more [of them] knew how effective the arts can be in terms of employee morale, client outreach and burnishing your brand, they would be surprised and delighted.[60]

Bank of America is one of the largest arts philanthropists in the USA, spending $40 million annually on arts sponsorships worldwide. The reasoning behind their investments is likely to be based on demonstrable outcomes – a social licence achieved by 'burnishing your brand'.

Wendy Stephenson, Managing Director of Sponsorship Consulting, shares DeSisto's perspective, and described in 2005,

> Ten years ago a company would sponsor something, invite some people, have a nice party and walk away. Now they milk the sponsorship for what its worth because it's a marketing activity just like advertising, or PR, or direct mail.[61]

Sponsorship Consulting are a business consultancy based in London whose clients include Unilever, BP, Morgan Stanley – all of which have sponsored exhibitions at Tate – and who claim responsibility for setting up Shell's various cultural sponsorships. Stephenson's comments fill

in the PR strategy behind the companies' sponsorships at Tate and other museums.

George Weissman backs up Stephenson and DeSisto's position in further extrapolation of his advice for the twenty-first century corporation: 'Let's be clear about one thing. Our fundamental interest in the arts is self-interest. There are immediate and pragmatic benefits to be derived as business entities.'[62] BP, and other companies, might declare concern for the arts, but as Weissman makes explicit, their primary concern is 'self-interest': buying a social licence to operate from the arts. The 'immediate and pragmatic benefits' are access to influential special publics and thereby the acceptance of the company and its operations by communities and consumers in the ways identified by Boutilier, Thomson and Black that are necessities of corporate survival.

BP's turnaround in the global media after the immediate onslaught in the wake of the Gulf of Mexico disaster offers insights into the effectiveness of arts sponsorship to maintain a social licence when it is on the brink of being withdrawn. The company needed political support to survive the media storm, and alongside several high-ranking ministers and politicians, Tate Director Nicholas Serota stepped into the fray to declare that: 'We all recognise they have a difficulty at the moment but you don't abandon your friends because they have what we consider to be a temporary difficulty.'[63]

This followed several key statements from politicians and influential people in the press. Chris Blackhurst, *Evening Standard* city editor, wrote 'Stop putting the boot into BP – we need it to survive';[64] Andreas Whittam Smith of *The Independent* pronounced 'BP's success is a national concern';[65] and Boris Johnson, Mayor of London, undercut the role and recommendations of the US judiciary to advise, 'It was an accident that took place and BP is paying a very, very heavy price indeed.'[66] Serota's words were an act of vital solidarity. Thereby, the 'difficulty' was fashioned as 'temporary' – for the company – by Tate's 'friend' BP, and other powerful allies made in the careful cultivation of the company's social licence. The disaster is ongoing for the coastal fisher communities of Louisiana, where the harm done by the oil and the chemical dispersant Corexit has affected people's health and livelihoods forever. BP was able to weather a crisis in significant part

due to the prestige, social acceptability – and outspoken support from the director – that they purchase from Tate. Again, the 'immediate and pragmatic benefits' described by Weissman are self-evident. This financial contract is as fundamental to their operations as their outsourcing of drilling, transport and pipelines.

Arts academics, artists and cultural theorists have similarly noted the use of arts sponsorships for the purpose of 'burnishing' brands. The academic Chin-tao Wu assesses the reasoning behind arts sponsorship for corporations:

Alert to their symbolic standing in people's (consumers') minds, companies utilise the arts, replete with their social implications, as another form of advertising or public-relations strategy, or, to adopt the jargon of corporate culture, to go in for 'niche marketing'.[67]

Wu goes on to picture the sponsorship arrangement using an American colloquialism for the practice: the 'incorporated pocket-book', which Pierre Bourdieu refers to as the 'check account theory'.[68] Bourdieu explains that these terms illustrate the powerful potential of arts sponsorship, in a way which critically echoes George Weissman's focus on 'self-interest'. Whatever the amount the company donates in arts funding, they are able to take out ten times as much in social legitimacy. The museum–sponsor relationship acts as a bank account in which small deposits enable the withdrawal of vast amounts of cultural capital when required. Wu and Bourdieu approach the matter from a very different angle to Boutilier, Thomson, Black, DeSisto and Weissman, but their analyses nonetheless concur around the fundamental purpose of arts sponsorships for a company. This is about shopping for social licence.

Boutilier looks to Bourdieu's theory of cultural capital as an available tactic to manage socio-political risk and preserve social licence. Bourdieu's definition, however, is made as a critical analysis of class ties that reify structures of power. Bourdieu outlines cultural capital as a tradable asset made up of cultural knowledge and association to assert positions of power and status. Boutilier is not concerned by the elite exchange of accumulated cultural capital to obtain social licence, but Wu is more critical of this aspect of arts sponsorship:

It is in maintaining this influence that the accumulation of corporate cultural capital makes economic sense. Corporate giving serves not only to improve the company's marketplace position, but also to create and maintain business people's position within their elite circles.[69]

As well as PR, arts sponsorship is also about access: corporate events at galleries secure relationships within networks of power; dates with government departmental staff at the opera go hand in hand with successfully securing political support for major business deals. As well as progressing operational objectives these are the networks of elite power that BP needed in its time of crisis. Such relationships are nurtured through the company's arts sponsorship deals.

In 2010 Greenpeace revealed an example of these alliances in motion. Emails obtained via Freedom of Information requests showed Simon Worthington, a senior advisor at BP Europe and previously BP's European Regulatory Affairs Manager focused on climate policy, manoeuvring a face-to-face meeting with a senior figure at the European Commission by saying, 'Let me know if you have an urge for the Opera.'[70] Worthington's senior colleague Peter Mather, BP Group Regional Vice President for Europe, is an Honorary Director of the Royal Opera House. Worthington was keen to use the sponsorship deal for its primary function – not supporting the arts in the UK, but oiling the wheels of regulatory negotiations in the company's favour. Cultural capital has many uses for an oil company, and arts sponsorship proved to be a smooth technique of extraction for Worthington and Mather.

Tate has a specific appeal as an arts source of a social licence that can enable access to these elite circles. Its position in the national and global contemporary arts scene offers sponsors prestige not only by association, but also by access to networks of power such as those Worthington sought. Chin-tao Wu notes,

The reason why the Gallery is able to market itself effectively is because it is placed at the top of the pecking order of contemporary

public art galleries in Britain, and enjoys, as we have seen, an artistic aura of authority and acceptability in the public consciousness.[71]

Within the art gallery model, Tate also has a number of specific features appealing to oil company sponsors. The original museum idyll was imagined as a quasi-religious site. William Hazlitt described his visit to the Joseph Angerstein collection in 1822 shortly before it was purchased to be the kernel of the National Gallery collection, as: 'A sanctuary, a holy of holies, collected by taste, sacred to fame, enriched by the recent products of genius.'[72]

The architecture of older museums tells the philosophy of visiting the designers wished to instil. Corinthian columns endow a sense of higher thinking, as climbing steps to enter more literally suggests. Large, open, cathedral-like spaces lend a kind of holiness and imply a reverent approach. The art historian Brian O'Doherty describes how this ambiance of holiness is created in the contemporary art museum:

> The ideal gallery subtracts from the artwork all clues that interfere with the fact that it is 'art.' Some of the sanctity of the church, the formality of the courtroom, the mystique of the experimental laboratory joins with chic design to produce a unique chamber of aesthetics.[73]

Although the features may have shifted over the centuries, most galleries continue to seek to deliver a cleansing holiness, and it is this sacred space that is so appealing to the corporate PR department, creating the potential to 'burnish your brand'.

Tate has plenty to offer as far as sacred spaces go. From Tate Britain's Grecian riverside entrance, to the Tate Modern Turbine Hall's ceiling that reaches heavenly heights in cathedral-esque magnificence, Tate spaces have the kind of splendour Hazlitt described in the contemporary model outlined by O'Doherty. And Tate's holiness extends further. O'Doherty argued that in the modern gallery 'the presence of that odd piece of furniture, your own body, seems superfluous, an intrusion.'[74] However, art gallery toilets often in fact play their part in creating an ethereal experience even when tucked away, especially at Tate.

A contemporary gallery is ill-equipped without a seamless, well-lit, aesthetically minimalist set of loos.

O'Doberty's 'intrusion' of the visitors' bodies' need for nutrition is also well attended to at Tate. Following Saatchi & Saatchi's rendering of the Victoria and Albert Museum in a 1988 advertisement, 'An ace caff with quite a nice museum attached,'[75] Tate Enterprises have ensured that eating at Tate is part of a divine experience. Sandwiches and snacks are branded Tate, and café staff uniforms similarly bear the imprint 'For Tate, by Tate'. The food at Tate restaurants is on trend with creatively traditional fayre. When visitors eat and drink Tate, they ingest and imbibe the holiness of the Tate brand. Like the toilets, Tate has taken the previously sidelined bodily needs, and incorporated them into a divinity of good taste. Although some might argue that the shop sullies the gallery, it could also be said to add another layer of contemporary ethereality. The Cornerhouse, an independent arts centre in Manchester, held an exhibition in 1999 titled *Taste: The New Religion*, which examined the myriad ways in which consumer culture operates according to semi-religious principles guided by an overarching search for good taste. Taking together the chic gallery and the added elements of exquisite lavatories, branded food and taste-defining shops, all mean Tate can offer BP a slice of the divine. In the PR mission to build trust and 'psychological identification', association with this sanctity helps a great deal. Nothing counterbalances the sins of the harmful impacts endemic to the oil industry better than a good dose of holiness.

BP, through its association with Tate, the Royal Opera House, the British Museum, the National Portrait Gallery and others, has been able to access the various forms of social acceptability and cultural capital necessary to maintain its social licence to operate through a period of crisis. It has built the approval of special publics via a relationship with the prestigious arts institution; the company has nurtured its own position of power in relation to political elites; and the twenty-year length of the sponsorship deal has held the potential for psychological identification or trust to develop, buffering the company against the onslaught of criticism it faced in the global media from 2010 onwards.

Figure 4.1: BP flag at Tate Britain. Photo credit: Richard Houguez, 2012.

Fake it 'til you make it: simulating authenticity

Margaret Thatcher believed corporate sponsorships were a cornerstone of cultural policy. The corporate arts sponsorships in London were not set up solely as a result of the careful strategising of oil company CSR teams or the outsourcing of specialist PR to external agencies. These deals have been expertly manipulated into existence and carefully positioned within arts funding discourses. In the UK this agenda has been driven by an organisation set up in 1974 – originally as the Association for Business Sponsorship of the Arts, now named simply Arts & Business (A&B) – with the central aim to promote alliances

between corporations and cultural institutions. A&B are a specialist lobby group; they are not a quango or a think tank, but a kind of lobby group-cum-PR agency specialising in one kind of public relations medicine – arts sponsorship.

A&B acts as an opinion-former on the issue, intervening in social debate to advocate for the companies wherever it can. The organisation has refined their arts sponsorship logic and strategy beyond the casual frankness of Weissman's assertion of 'self-interest' and the easy science of DeSisto's recommendation to 'burnish your brand'. Its former Chief Executive Colin Tweedy has made numerous remarks in response to criticism of oil sponsorship of the arts, including a quote which he attributed to A&B's founding chair Lord Goodman in 1976: 'I don't care where the money comes from – it could be laundered by the Mafia. If it comes to the arts, it's good money.'[76] Lord Goodman, a lawyer, who in the 1970s was chair of the Arts Council, English National Opera and director of the Royal Opera House, is famed for his political negotiating skills and was later the subject of scandal for having stolen millions of pounds from a close friend over decades. Tweedy and Goodman refuse to concede in their collective comment that potentially dangerous reasons lead the donor to deposit money in a convenient social institution. The line scripted into Goodman's character by Tweedy does the opposite of what was intended; rather than refuting criticism, it underlines a cause for concern. There is no good or bad money, but there are indeed some very ethically dubious sources of funding.

BP has direct influence on A&B due to Peter Mather's appointment to the organisation's Leadership Team. Mather's balletic position extended between several influential tables in the conversation around oil sponsorship of the arts – A&B, BP, the Royal Opera House and as advisor to the chair of the British Museum – reveals a careful craft in social lubrication. A&B holds an annual awards dinner to honour sponsorship deals both recent and longstanding, and it organises events bringing together key figures in arts and business to maintain a network of cultural capital. In 2013 A&B gave BP the Outstanding Arts Achievement Award, and in the following year the Sponsorship Awards crowned Des Violaris, the Director of UK Arts and Culture for BP, with a special prize for achievement in the arts. Violaris joined BP

after the merger with Amoco, where she worked previously, in 1999, and she was appointed to her position during the late-1990s BP revamp led by Browne that included the helios logo, the beyond petroleum oil company advertising concept, and British art at Tate Britain with BP. In interviews, Violaris seems like she would prefer to work in the arts rather than oil, making her a winning candidate for BP's performative engagement with the arts.

A&B house is a well-stocked, private arts and cultural policy library, which I gained access to during this research. It also produces reports persuading the value of corporate sponsorships. A key set of publications in their series is *Beyond Experience*.[77] It is written by Tina Mermiri, Research Manager at A&B, alongside Joseph Pine and James Gilmore, the duo of management advisors renowned in their field for the book *Authenticity: What consumers really want*.[78] Pine & Gilmore brand themselves by joining their surnames with an ampersand in all published materials, which A&B have neatly adorned themselves with in the same fashion.

The three groupings of public relations strategists play different complementary roles in the rehearsal of artwash. Where Henderson and Williams are the actors on stage, speaking the lines about the value of arts associations to reach opinion-formers, and Boutilier, Thomson and Black are the set designers, arranging their blocks of theory to build a picture of social licence, Tweedy and Mermiri with their consultants Pine & Gilmore are the theatre directors, standing back to arrange the entire scene.

Released in 2009, *Beyond Experience* seeks to demonstrate 'how businesses can offer their consumers authenticity and meaning through their use of and engagement with the arts.'[79] Leading on from Boutilier, Thomson and Black's aim of building trust and creating 'psychological identification' between the company and the public, the paper examines how arts sponsorships can be applied to offer 'authenticity and meaning' to the sponsor. Pine & Gilmore argue that the arts and the authentic are part and parcel, commenting, 'We suspect the desire for authenticity is particularly pronounced among consumers of art.'[80] Many Tate visitors might not consider themselves 'consumers' of art, nor would this likely be the dynamic Tate curators would want to construct.

Yet Pine & Gilmore's reasoning for seeking out this notion of the authentic in fact closely parallels Shell PR specialists Henderson and Williams' realisation that they must attempt to reach opinion-formers. As Henderson and Williams point out, 'The goodwill of customer audiences could be disproportionately affected by an adverse reputation among special publics.'[81] Despite the emphasis on art as a vehicle to obtain authenticity, cultural alliances are primarily a route to reach influential audiences. Where Pine & Gilmore tell a story of corporate pursuit of the arts to attach company brands to some ambiguous authentic ideal, what they really mean is to access and build their brands in the eyes of special publics.

The A&B method recommends the association of the company with specific monographs or period displays as a step beyond alliances simply with the gallery. Mermiri elucidates on the purpose of this strategy for companies with a vital qualification:

> From a marketing perspective, it is of course expected and required for the art to have a PR value attached to it. Even so, businesses that simply try to art wash themselves in order to restore trust, will not always succeed. A business or brand seeking to provide authentic experiences, and especially through the arts, should be fully integrated in the production process with its respective cultural partner.[82]

But the oil company's endeavour is based in PR, and it is not an appropriate or qualified collaborator in a gallery's creative process. Mermiri's contradiction here exposes a fundamental irreconcilability in the laboured exhortation of the strengths of A&B's model as somehow aligned with the arts. In fact for the companies they work with the ultimate need is indeed to artwash – and buy a social licence based on a falsely constructed idea of trust. Artwash is the performance A&B clumsily stage manage.

Pine & Gilmore's concept of 'rendering authenticity' is an interesting one in relation to arts sponsorship and the maintenance of a social licence to operate for an oil company such as BP. Both words 'rendering' and 'authenticity' warrant close examination. Mermiri dissects the idea:

The issue of authenticity is particularly relevant in light of the current economic climate, because whether related to the arts or not, authenticity evokes sentiments of trust. Trust is often what prompts consumers to engage with a business and their economic offerings and trust is that which defines brand loyalty. This ensures long-term relationships between provider and consumer.[83]

The logic here closely parallels Boutilier and Thomson's idea of psychological identification, and is similarly focused on building 'long-term relationships' and enduring social licences. Her understanding of trust is not built on transparency, accountability and responsibility, but is abstracted into an aura of 'authenticity' seeking to produce 'brand loyalty'.

The arts are found to be the ideal source of the 'authentic' by Pine, Gilmore and Mermiri, who all refer to 'meaningfulness' as a desirable quality of the arts, in the eyes of their business sponsors. Mermiri states, 'The arts can therefore offer and induce authentic experiences, inspiration, empathy and escapism; they can be didactic, challenging, political, emotional, motivating and lots more!'[84] This enthusiastic list of what the arts can offer business – that nimbly pulls in political art as something to co-opt – is echoed in zealous harmony by Pine & Gilmore:

> We argue in this and any economic climate, that the arts, which are becoming increasingly present in people's lives and are inherently considered meaningful, can help restore trust and maintain brand loyalty for a business by engaging their customers in more direct and innovative ways.[85]

The way in which Pine & Gilmore understand the arts as being meaningful lacks any deep engagement; meaningfulness here has no specific moment or purpose, but is an object for sale. Arguably this resonates with the financial aspect of the global art market, but the difference is the application of this objectified meaning onto the public image of a corporation. The oil company is supposedly made authentic too. But authentically what? The real impacts of BP are an authentic aspect of the company, masked by the sponsorship façade.

In the trio's polemic meaningfulness becomes merely something the company buys to persuade consumers of its own social acceptability. Ignoring centuries of religious rituals, philosophical thinking, and indeed arts and culture, Mermiri comments, 'As people are beginning to re-assess their priorities, the latter part of 2008 and most of 2009 have been characterised by their search for meaning.'[86] This lack of appreciation of history belies a superficial strategy. Their project idealises a notion of the authentic that is rooted in faking it.

Authenticity has thus been associated with 'meaningfulness' and the arts, but Pine & Gilmore go on to more closely define it as 'purchasing on the basis of conforming to self-image', a marketing logic that recommends consumers are more likely to buy products that most embody their personal idea of themselves. They categorise authenticity into five modalities: 'natural, original, exceptional, referential and influential'. Each of these types is then applied to the arts to prescribe a dizzying array of techniques for corporations to 'use art to render authenticity'. Ultimately Mermiri and Pine & Gilmore advise businesses that the value of art sponsorships lies in responding to this challenge: 'While authenticity has long been the centre of attention in art, it is now time for companies to understand, manage, and excel at rendering authenticity.'[87] They readily acknowledge that this strategy works best when the company presents its motive as purely – authentically – founded in concern for the arts. Therefore when BP describes itself as 'one of Britain's leading sponsors of the arts', it is following Pine & Gilmore's recommendations to foreground the sponsorship in terms of commitment, rather than the self-interest disclosed by Weissman. BP and other oil sponsors must perform – or render – the part of the supportive benefactor.

Mermiri admits 'rendering' could be problematic, but reiterates the push towards corporate authenticity nonetheless. She says,

Though Pine & Gilmore's concept of 'rendering' authenticity as the next business imperative may seem to be counter-intuitive and to a certain extent oxymoronic, it is not, especially when they suggest doing so through culture. The arts are in themselves authentic, because of the inherent value, meaning and emotion they stir in

people, which should not change whether a business supports them in doing so or not.[88]

She argues that the arts cannot lose their authenticity through sponsorship. Mermiri's insistence that sponsors do not alter what artists make or how their work is presented ignores those artists and curators who argue precisely the opposite. In the specific case of Tate and BP, the presence of an oil sponsor at the threshold of certain exhibitions undermines the initial purpose and potential impact of the artwork, as will be explored in depth in Chapter 5.

Pine & Gilmore do not share any of Mermiri's hesitancy around the oxymoronic use of the word 'render'. The lack of authenticity or honesty is made evident by the proposal to 'render' it; this pretence of acceptability doubly highlights the deficit of social licence. Pine & Gilmore assert wholeheartedly:

'Rendering authenticity' will one day roll as easily off the tongue among executives and managers as 'controlling costs' and 'improving quality', for rendering is precisely the right term for what's involved. When consumers want what's real, the management of the customer perception of authenticity becomes the primary new source of competitive advantage – the new business imperative.[89]

Where Henderson and Williams noted 'society's changing expectations', Pine & Gilmore look to 'customer perception of authenticity', and similarly their project is void of integrity: where Shell failed to genuinely answer the question it performatively asked its special publics, 'Can you seek profit without compromising your principles?', Pine & Gilmore support BP's attempt to render authenticity without meaningfully building any kind of real trust with the wide range of stakeholders impacted by oil extraction and combustion.

In this way, the recommendation for companies such as BP to render authenticity manifests features of cultural theorist Jean Baudrillard's 'simulacrum'. A simulacrum is, according to Baudrillard, a hyper-real world of imitation, and simulation is the process by which real meaning is replaced by signs and symbols which imitate reality. Baudrillard

might have seen numerous simulacra at play at Tate. These would include the construction of 'culture' masking social realities and divisions, the setting up of art as something pure and sacred, hiding the dirt and financial dealings of the art market. With regard to corporate sponsorship, the simulacrum is that of the company as being philanthropic. This mirage obscures the PR deal that the arrangement consists of in economic terms. The simulation is of 'corporate citizen' BP, now replete with an authentic beating heart of national cultural prestige. To 'render authenticity', based on Baudrillard's concept of the simulacra, is in fact to 'simulate authenticity'. As Baudrillard describes in *Simulacra and Simulation*: 'To simulate is to feign to have what one doesn't have.'[90]

BP attempts to feign an authenticity, or some basis for building trust and brand loyalty, through its arts sponsorships. It simulates having a social licence to operate as a means to procure one. It is through this pretence of 'authenticity' that BP aims to build the 'psychological identification' necessary to sustain a social licence to operate that can survive the frequent ecological and human rights crises associated with its global projects.

Pierre Bourdieu makes a similar parallel between Baudrillard's simulacra and corporate sponsorships when he says, 'Patronage is a subtle form of domination that acts thanks to the fact that it is not perceived as such. All forms of symbolic domination operate on the basis of misrecognition.'[91]

The sponsorship, as recommended by Pine & Gilmore, must not be seen to be purchasing social licence, to be buying power over consumer's perceptions, but must instead be perceived as 'authentic' support. Baudrillard states in *Simulacra and Simulation*:

> It is no longer a question of imitation, nor duplication, nor even parody. It is a question of substituting the signs of the real for the real, that is to say of an operation of deterring every real process via its operational double, a programmatic, metastable, perfectly descriptive machine that offers all the signs of the real and short-circuits all its vicissitudes.[92]

BP must make its social licence by creating a simulacrum of 'leading Britain's arts sponsorships'. Through rendering or performing its adoration for the arts, BP achieves what it pretends. Artwash allows the company to blend the edges of its mask into a complexion audiences believe in.

As Pine & Gilmore prescribe, the simulation of an authentic social licence becomes true, in accordance with Baudrillard's depiction of simulacra. Baudrillard depicts simulation as a threat to our capacity to distinguish between the 'real' and the 'imaginary'.[93] As such, for Baudrillard there is no 'authentic': the simulation is the real and the authentic. Artist Hans Haacke critiques Baudrillard for missing the impact this has in his analysis of simulacra, saying, 'What he [Baudrillard] and his followers have lost since is a sense of history and social conflict. There is no reality, no reason to fight. It would be ridiculous to fight a simulacra.'[94]

The simulation of authenticity in the association of BP with art and Tate masks the real world impacts of that simulation – the purchase of a social licence to operate that enables them to continue their harmful operations. Where BP sponsorship at Tate is a simulacra of an authentic 'corporate citizen', the real world impacts of that deal are to protect the company's ability to continue devastating lives, livelihoods and the ecologies of the planet.

This reality, however uninvited, is still present at Tate as long as BP remains a sponsor. To some extent this follows music writer and cultural theory blogger Mark Fisher's understanding of capitalist realism, a world in which the corporation is sanitised and its impacts are reframed as harmful but not the worst. Fisher describes,

> Capitalism is what is left when beliefs have collapsed at the level of ritual or symbolic elaboration, and all that is left is the consumer-spectator, trudging through the ruins and the relics … capitalist realism presents itself as a shield protecting us from belief itself.[95]

When supporters of oil sponsorship attempt to persuade the benignity of Big Oil's vast harm as a necessary impact of the highest way of living that has no possible alternative, the oil sponsor in the gallery becomes an emblem of success for this nihilist narrative.

I will argue differently to Fisher however, that the presence of Big Oil in the gallery does retain a sticky contradiction less easily neutralised. Although oil sponsorship bolsters the projection of oil corporations in a capitalist realist world of bad-but-the-best-option, the case of oil sponsors concurrently reveals the torn seams of this fantasy. Big Oil is not neatly absorbed into the signage of the gallery, but prickles and sparks reactions. It is the disjuncture between the sponsor and the gallery that gives rise to a critical response to Big Oil in this context.

5
The Impact of BP on Tate: An Unhappy Context for Art

The Turner Prize winner Grayson Perry said of the 2012 Cultural Olympiad: 'The texture of the Olympics is not a happy context for art. It is too corporate and too governmentally organised. Art is such an organic process that you can't really corral it.'[1] Perry's artworks are notoriously unbridled, and it follows that the artist would be sensitive to enclosure. Although he sees a disjuncture between art and corporate interests in the case of the Cultural Olympiad, Perry refrained from making a similar judgement on BP sponsorship at Tate. After the 2010 Tate Summer Party oily splash, he commented, 'I don't think that when people come out of an exhibition, they think "Oh, wow, I'm going to buy BP petrol now."'[2] Neither do I, because advertising usually has a more subtle persuasive process. For Perry the Olympics is a distant territory safe for comment, however Tate is too close to home to criticise. But BP's presence in galleries is also not a 'happy context for art'. His criticism applies to corporate sponsorship of the arts more broadly: the presence of a corporate sponsor confines artistic possibility. Beyond the advertising benefit for the company, oil sponsorship impacts on curating, artists and their artworks, and audience experience.

Tate makes an interesting and important case study to consider this question not only due to its influential position within a global network of modern art museums, but also because Tate's policies, public statements, and progressive persona illustrate the many internal contradictions of Big Oil in the gallery. Tate's Ethics Policy states that

funding will be reconsidered if association with the sponsor might 'detrimentally affect the ability of Tate to fulfil its mission'.

Tate's mission, like that of the other London galleries, is essentially to keep an open door to anyone wishing to look, learn and experience. The British Museum's funding agreement describes the institution as 'a space for the benefit of the general public'.[3] The National Gallery seeks to 'provide access to as much as possible of the collection' and is committed to finding 'imaginative and illuminating ways to nurture interest in the pictures among a wide and diverse public'.[4] The DCMS–Tate Terms of Reference say that the purpose of the gallery is 'to increase the public's understanding and enjoyment of British art from the 16th century to the present day and of international modern and contemporary art.'[5] Offering access to art is an enormous undertaking fulfilled by numerous departments: curating, learning, events, conservation, marketing and fund-raising, among others. As teams seek to achieve the agreed goals, patterns emerge displaying how BP hinders these endeavours.

Curating with BP in the picture

In 2012 Tate took part in an online event called *#AskACurator* on Twitter. Over a two-hour period one afternoon Twitter users could post their questions to three key curators at Tate, among staff from other galleries. A barrage of tweets came in from those concerned about BP's presence at Tate. Helen Little, the only Tate curator to respond to the questions, rejected the proposition that sponsorship was part of her domain, saying (in 140 characters or less): 'Corp sponsorship is important to arts & allows us to do what we do, but my area is C20th Great British art – any Qs on that?' (sic)[6] Little put up the smokescreen: she presented corporate sponsorship as an enabler of Tate's work, when in fact the sponsorship is a tiny percentage of income. She also distanced her role and expertise away from the issue raised. For Little, there was no question to answer about the impact of the BP logos in the gallery spaces where artworks within her specialism of twentieth-century British art are on display.

But the logos are up to something in the gallery. Advertising executives extol the repetition of a small logo, such as a tick or a green mermaid, on the bodies or in the hands of numerous people walking down a street. These small signifiers are powerful beyond their size. The effect is multiplied by their repetition around the gallery and the specific context of the exhibitions through which the company is promoted, such as the *BP Walk Through British Art*. By suggesting that the BP logo is either irrelevant or discrete and therefore acceptable, curators ignore the advertiser's argument that when the logo appears inside the gallery space and at each entrance to an exhibition, it is well placed to register certain associations with the visitor. BP logos impact upon visitors' experiences in the gallery.

The art historian Brian O'Doherty's description of museums as being hermetically sealed, cut off from the outside world, was met with criticism as curatorial styles and thinking moved on. The curator Iwona Blazwick, Head of Exhibitions and Displays at Tate Modern from 1997–2001, and later director of the Whitechapel Gallery, shaped Tate differently to O'Doherty's clinical look and feel. Blazwick writes, 'The exhibition space, be it museum or laboratory, can no longer be understood as neutral, natural or universal, but rather as thoroughly prescribed by the psychodynamics of politics, economics, geography, and subjectivity.'[7] No place is without its own resonances, and the space in which art is displayed plays an important role in how audiences understand the artworks. Blazwick continues, 'Works of art are rarely encountered in isolation. They are experienced in relation to each other and articulated by the architectonics of a building and the unconscious choreography of other people.'[8] Rather than being completely set apart, various aspects of the space impact upon the art and its reception. Blazwick's argument troubles Little's comment dismissing the BP question – so as to suggest the logos have minimal impact on visitor experience – because all of the features of the building and the space are given significance in Blazwick's understanding of the gallery.

Nicholas Serota, Tate director from 1988, has had associations with the gallery since he joined the Young Friends of Tate aged twenty-three. As chair of the group in 1969, Serota staged experiments in the role of art in society by squatting buildings in South London where they

Figure 5.1: BP flag at Tate Britain. Photo credit: Mel Evans, 2014.

held art classes and lectures for young people. The autonomous activity challenged management, and when staff asked that Tate's name be dropped from the project, the group Young Friends of Tate folded. Questions around art and interpretation remained however. In his work and writing on galleries and exhibitions Serota offers a theory of curating that looks for conversations between artworks and the ways curators' choices amplify cross-referencing. He calls this creating 'climatic zones', saying in a 1999 lecture,

Artists are generally represented by several works presented as clusters, which has the effect of creating overlapping and merging

zones of influence. As a result unexpected readings and comparisons occur.[9] In my view we need a curator to stimulate readings of the collection and to establish those 'climatic zones'.[10]

Serota aims to generate understanding in connection rather than in isolation, in the space between artworks rather than focusing only within the frame.

Nicholas Serota has worked in curating and leadership in art galleries across the UK including Modern Art Oxford, where National Portrait Gallery director Sandy Nairne worked alongside him as an undergraduate volunteer, and as director of the Whitechapel Gallery in London, where he preceded Iwona Blazwick. Serota and Blazwick are significant characters not only in their power and influence over the feeling in the art community around oil sponsorship, but also in their direct power over the current situation and what follows from here. Where Serota has a history of encouraging cultural sponsorships and his position on BP doesn't stray from his current path, Blazwick is more of an unknown sum – and given her career path so far, it is possible she will follow in Serota's footsteps to the top spot at Tate. The views on curating, which both of these important figures present, raise key concerns about oil branding in the gallery.

Blazwick and Serota's analyses taken together provide an understanding of the role of the curator in relation to the presence of the corporate sponsor. Logos are architectural features, and are also powerful symbolic objects. The BP helios enters the visitor's conscious or subconscious imagination and becomes one thing the artworks 'are experienced in relation to'. Whether located beside a painting, in the title of a gallery set in stone above the entrance arch, engraved in frosted glass walls, or noted by a guide or in audio-description, the physical allusion to the oil company BP is present, and the works of art are experienced in relation to this presence. Visitors hold the BP logo in their awareness as they encounter the artworks, the building and the other people in the gallery.

Furthermore, art audiences usually go to museums geared up to interpret what they see or hear about on the walls in front of them, often expecting that interpretation to be shaped by description panels

or audio guides. In any new space, people analyse the signs and signifiers in their vicinity to understand what is happening around them. Declining to attend to influential factors in any given context or neglecting to unpack meaning from significant elements present is no way for curators to be excused from an ethical responsibility to consider the impact of a sponsor in a gallery. For Tate curators and learning department staff, the questions which Blazwick and Serota raise about context do not go away if they do not engage with them but they are more at risk of their curatorial decisions being limited, or being thought to have been limited by BP, if they dismiss the logos' significances. The curator's role in arranging the space and considering the multiple readings generated by the proximity of elements in 'climatic zones' means that the powerful intervention the logos make in the gallery places BP branding firmly within the territory of curatorial consideration.

In 2012 the British artist Patrick Keiller had a commission at Tate Britain in which he installed a version of his broader project *The Robinson Institute* inside the full glorious length of the Duveen Galleries. It made for a wonderful meander through Keiller's exploration – via the fictional character Robinson, previously evolved through his films *Robinson in Ruins* and *Robinson in Space* – through factual histories and geographies of south and south-west England, using his own and other works in Tate's collection. The stories Keiller weaved together linked sites including the Aldermaston Atomic Weapons Establishment with the history of the Anglo-Iranian Oil Company now known as BP.

The Duveen Galleries are directly adjacent to the exhibition at that point titled *A Walk Through the Twentieth Century*, 'supported by BP'. Visitors stepped from being guided by BP in one part of the upper floor at Tate Britain, to being confronted with anti-war art by Peter Kennard and vintage BBC documentaries about oil extraction in Iran. The list of exhibits in one area of the gallery illustrates the kind of climatic zones created by Keiller as artist-curator:

British Council, *Potential War Areas*, 1942 (English version), 1945 (Arabic version). Oilfields and pipelines marked in red.
British Pathé, *Oil for the 20th Century*, 1951.

Patrick Keiller, *Footage from Robinson in Ruins*, 2010. RAF Brize Norton, Harwell, Greenham Common, the Atomic Weapons Establishment at Aldermaston and the Government Pipeline and Storage System.
Peter Kennard, *Haywain with Cruise Missiles*, 1980.

The proximity of the exhibition to *A Walk through the Twentieth Century* in the adjacent rooms created a climatic zone in which audiences read the BP logos prestigiously branded on the walls in conversation with Keiller's offering of content readable as deliberately antagonistic to BP. There was a subtle challenge to the sponsor. Keiller uncovered the controversies of the company within the building and provided an antidote to broader silence on BP's activities.

Serota's 'climatic zones' are therefore also a space opened up by the very differences between things positioned in proximity to each other: 'unexpected readings' includes conflicting messages. The US art critic Barry Schwabsky describes a curator as,

> Someone who brings things together in a considered way, taking into account everything that is antagonistic as well as compatible in the things brought together … how do things fit together? What is the space created by the differences among them?[11]

The BP logo is officially endorsed at Tate, and this act carries meaning: Tate gives BP a nod of approval as it says to visitors, check out this art. Audiences experience the art at the same time as interpreting Tate's relationship with BP. If the art relates to the oil industry or the environment in any way, a conflicting dynamic arises between artwork, gallery and sponsor.

In the early 2000s Tate consulted with a major audience research analyst to look into what its audiences sought from their encounter with Tate. The report found four motivations for a museum visit: social, intellectual, emotional and spiritual, all of which can give rise to 'cognitive dissonance' if the visitor experiences something antagonistic during their visit. Leon Festinger defined cognitive dissonance in 1957 as 'being psychologically uncomfortable'. He said that, 'in place of

dissonance one can substitute other similar notions such as "hunger", "frustration" or "disequilibrium".[12] Festinger noted that the person experiencing cognitive dissonance would seek to resolve it in some way, by avoidance of the cause or by a change in opinion, but that this process might be troubling or insurmountable. Like the jarring image of British American Tobacco logos in the gallery, for some Tate visitors the presence of BP blocks their intellectual, emotional and spiritual engagement with art at Tate. BP undermines the very things Tate's audiences seek out in their visit.

When Sebastião Salgado's exhibition *Genesis* opened at the Natural History Museum the association with the mining conglomerate Vale was quickly picked up on as an unfitting choice for a collection of work seeking to capture the landscapes and wildlife least affected by industrial expansion. Barely a single review of the photography was made without reference to the harsh contradictions of the mining company. Obviously Salgado, having accepted the sponsorship, was unwilling to criticise Vale's role in the ecological destruction of the kind he meanwhile sought to curtail in his self-identified environmentalist work. The curator of the exhibition and the artist's wife, Lélia Wanick Salgado, has a long-term relationship with Vale – her father worked in the company from its early beginnings. The contrast between content and sponsor almost seemed to cynically provide the exhibit with a highly charged and popular press story angle. For the company, it seemed a careful play to redeem its image following receipt of the notorious 'Public Eye Award' in 2012 for having the 'most contempt for the environment and human rights'[13] in the world. Yet the fact remained for some visitors, that the cognitive dissonance between the artwork and the sponsor aroused a sense of shock and betrayal: the lasting impression became one of hypocrisy rather than the intended call to conservation.

The Natural History Museum had a comparable previous case of mixed messaging when it accepted Shell sponsorship of its Wildlife Photography of the Year exhibition. Shell brought with it associations of harm to wildlife and habitat destruction from Nigeria to the North Sea, while the exhibition itself seeks to celebrate life on earth, with specific commendation of photography that captures wildlife in danger

or under threat of extinction. The sponsorship only lasted three years – for the consecutive awards given in 2006, 2007 and 2008 – before the weight of cognitive dissonance became too much to bear.

The BP name or logo becomes an antagonistic element in a Tate exhibition or institution in a similar way. BP carries associations of ecological damage, loss of life and livelihood, and threatened human rights. Therefore the conflicts between Tate's exhibitions and BP are multiple, enveloping genres such as landscape and single form sculpture, including exhibitions of anything from political art movements to *Energy and Process* (to quote the title of a Tate Modern exhibition) and monographs of artists such as Joseph Beuys. The celebrated works of Joseph Beuys in the Tate collection are testament to Beuys' influence as an ecologist who explored land, resources and labour in his art practice. One of Beuys' famous performances was the planting of *7000 Oaks* as a gesture to reforest the industrial town of Kassel in Germany. Beuys was notoriously specific about how his art should be displayed, and although it is impossible to say since Beuys is sadly deceased, it seems unlikely that a co-founder of the German Green Party would have been comfortable for his art to be exhibited in association with BP. For audiences, situating Beuys' work in a gallery that is sponsored by BP creates an uncomfortable contradiction.

These conditions ask audiences to endure a feeling of cognitive dissonance in order to 'access and appreciate' the art on display. The cognitive dissonance BP causes through its presence at Tate is best exemplified when BP assumes the role of curator in the *BP Walk Through British Art*. BP is in an influential position over the artworks in the gallery and, thereby, the social narrative of the twentieth century and subsequently of Britishness – rather than the curators, artists and visitors solely defining their own understandings of cultural history. The frequency with which BP's name, logo and guidance appear in this gallery crystallises the concern, but the repercussions remain relevant throughout all of Tate's galleries due to the broader association.

Many of the paintings in *BP Walk Through British Art* are given new readings when placed in a BP-guided context. The beautiful landscapes of Thomas Gainsborough, George Stubbs, John Constable or William Holman Hunt painfully resonate with news images of oil

spills across agricultural land or boreal forests stripped to mine tar sands. The fear and desolation of William Orpen's bleak post-conflict battlefield *Zonnebeke* (1918) and Winifred Knights *The Deluge* (1920) – interpreting Noah's Ark and the great flood – echo photographic portrayals of disasters associated with climate change. Post-World War Two works in the collection directly address themes of industrial refuse (Tony Cragg, *Stack*, 1975), imperialist proliferation of arms (Peter Kennard, *Defended to Death*, 1983) and post-colonial global poverty (Bill Woodrow, *Elephant*, 1984). The BP-coated gallery in which these works are displayed undermines the challenges and questions posed by the artist to the audience. BP creates an obstacle to the engagement with the artworks the visitor has sought out, and that Tate has committed to provide.

The disjuncture aggravates visitors and artists alike. The Lowry exhibition at Tate Britain in 2013 evoked consternation from visitors who refused to ignore the cognitive dissonance of L. S. Lowry's art alongside BP branding. Most notable was Boff Whalley, a musician from the British band Chumbawumba, whose proliferation of popular, political, alternative music spanned three decades. Whalley described on his personal blog the feelings he experienced that led to his decision to leave Tate Britain part-way through his visit to the Lowry exhibition out of disgust at the number of BP logos in the gallery:

> BP, BP, BP. All very subtle and low-key, but it becomes downright infuriating. The naïve and simple beauty of Lowry's paintings, the wearied crowds on their way to work or to the football match, the landscapes teeming with chimneys, the big pale northern skies greyed by factory smoke, none of it needs or demands the attachment of that little green and yellow flower that yells 'Oil'.[14]

Whalley compares the excited thrill of his trips to Tate as a schoolchild from Burnley with the angry disappointment of his long journey from the north of England to the gallery at Millbank as an adult. His story poetically speaks volumes for the experiences of other gallery goers for whom the alignment of their favourite artist with the oil company BP generates either a paralysing disgust or an intellectual and spiritual

conflict that is not easily resolved. For Tate and Tate curators, these reactions should be a point of contention and deep concern. A sponsor cannot be said to add value to a cultural institution if it is in fact detracting from visitors' enjoyment and acting as an obstacle to the gallery's mission and function.

There are several artists who have work held in the collections, display or event programmes at the various London galleries that accept oil sponsorship who have been outspokenly critical of oil sponsorship. The novelist Margaret Atwood expressed her disapproval while speaking at a Southbank Centre event; visual artists Sonia Boyce and Conrad Atkinson both have works in Tate's collection and have come out against BP; playwrights Caryl Churchill and Mark Ravenhill, whose plays have been produced by the National Theatre, both oppose oil sponsorship. The composer Matthew Herbert, who has commissions at the Royal Opera House and the National Gallery, made the reproof, 'In trading our cultural legacies so nakedly for such tainted cash, some of Britain's most powerful stages for creative expression have knowingly undermined the very integrity of that expression.'

Raoul Martinez, whose work has been exhibited three times in the BP Portrait Award, gingerly approaches the possibility of boycotting oil sponsored exhibitions:

Like any artist I want my work to be seen, and having my work selected to hang in the National Portrait Gallery was a real honour. If, en masse, artists decided to boycott BP-sponsored institutions perhaps it could be a worthwhile tactic. The next best thing is for artists associated with these institutions to speak out. As an artist I certainly don't want my work to be part of a PR campaign for corporations that are a threat to our democracy and environment.

I don't think any artist wants their work to be used as a fig leaf for the oil industry.[15]

Collective boycott is most feasible in large, time specific exhibitions involving a substantial number of artists, but some artists are unwilling to wait for such an opportunity at Tate. Richard DeDomenici declined a Tate commission in 2014 on account of the BP sponsorship. DeDomenici

commented on Twitter: 'I've just turned down £900 to do something at Tate Britain because the event is sponsored by BP. Am I an idiot?'[16] His question generated a shower of support for the act from his followers on the social media channel. Despite the loss of income and career opportunities, DeDomenici chose to avoid showing his artwork in an oil-sponsored gallery to make clear that like Perry, for him it is 'not a happy context for art.'

Art in social context

The artist Hans Haacke is convinced that political questions must be asked inside galleries. His entire body of work interrogates corporate power in and around the site of the art museum:

> Art institutions are political institutions. One could say that they are part of the battlefield where the conflicting ideological currents of a society clash. The art world, contrary to what is generally assumed, is not a world apart. What happens there is an expression of the world at large and has repercussions outside its confines.[17]

The curator Iwona Blazwick places Tate alongside the more critical attempts to locate art in the social context that Haacke espoused. Blazwick recognises an inevitable presence *inside* the gallery of *outside* questions: politics are present and cannot simply be ignored or left to a different department. Furthermore, Blazwick defines the role of the curator in arranging cultural and political landscapes to offer insight and pose questions to the visitor. Blazwick describes how Tate has in the past asked itself, 'Is it possible to reconnect art with social and cultural history, to locate it in a wider context of ideas and circumstances?'[18] She calls for a conversation between the artworks on display and connected political issues.

Similarly, Anna Cutler, Director of Learning at Tate, sees learning processes in the gallery and nurturing critical consciousness as inextricably linked. Cutler is interested in the particular potential of 'cultural learning' for audiences throughout the gallery. She worked

in youth arts management before her position at Tate, which looks at education beyond schools and adult programmes to consider how learning is a fundamental part of any gallery visit. Cutler examines patterns of audience experience in Tate galleries and concludes that learning at Tate aims to change perspectives and pique critical consciousness: 'Key findings repeated through the research can be identified as increased confidence, a shift in attitudes and behaviours, improved motivation and sustained engagement. There is also evidence of an increase in critical thinking applied beyond the learning environment.'[19] In the picture Cutler presents, the role of the gallery is to enable audiences to question, reconsider, and engage critically with the art and ideas exhibited in the gallery.

This trend is echoed by Victoria Walsh, Head of Adult Programmes at Tate Britain from 2005–11, who writes that the role of the learning department is to incubate discourses that might influence the whole institution itself as well as the wider society, saying 'the Education Department can be viewed as performing the most radical and the most conservative practice in the museum – producing and reproducing new discourses and narratives.'[20] Toby Jackson, the first Head of Interpretation and Education at Tate Modern, backs this up: 'Much of our work is to challenge the calm face of the museum, to bring into the museum the debates which are being rehearsed outside.'[21] Tate curators seek to consider artworks in a social context, to curate exhibitions that allow art to reverberate with its contemporary politics, and Tate learning department staff share this aspiration in their programming.

But BP acts as an inhibiting influence on the staff and their decisions regarding curating and learning. There are several examples of BP, Shell, other oil and fossil fuel companies and unnamed corporate sponsors either silencing or censoring artists, curators and internal processes involved with particular exhibitions, learning projects and events at galleries in London and around the world.

Emma Mahony, curator at the Hayward Gallery – part of the Southbank Centre – from 2001–08, noted several cases of conditions of sponsors limiting the content of several exhibitions:

During my time as an exhibition's curator and organiser at the Hayward Gallery corporate sponsors often had stipulations that impacted on curatorial decisions. In one particular instance a work of art was censored as it was felt that it would reflect negatively on the sponsors' image.[22]

In Canada Imperial Oil and the Canadian Association of Petroleum Producers were found to have attempted to remove exhibits from a display at the Canada Science and Technology Museum in Ottawa because they felt their industry was presented 'too harshly'.[23] Journalists and activists made critical comments when, at the Science Museum, London, Shell sponsorship of the climate change gallery commenced with a statement from the museum 'neither confirming or denying' that climate change was real, with minimal attention paid to the role of fossil fuel companies in creating the crisis.

At the University of Wyoming Art Museum, British artist Chris Drury's sculpture *Carbon Sink: What Goes Around Comes Around* was taken apart and removed after fossil fuel industry executives complained that the artwork was too critical of the coal industry. Drury's log sculpture in a whirlpool arrangement was intended as a

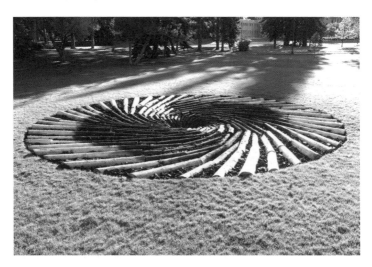

Figure 5.2: *Carbon Sink: What Goes Around Comes Around*, Chris Drury, University of Wyoming Art Museum. Photo credit: Chris Drury, 2011.

comment on global warming and Wyoming's changing climate. The artist said the sculpture was 'intended to return to nature through decay' and would 'probably be gone in 5–20 years'[24] – had it not been for the coal industry's intervention. The energy department in the university has touted vice-presidents from companies including Marathon Oil and Arch Coal. Marion Loomis, director of the Wyoming Mining Association, voiced industry concerns about the artwork, saying, 'They get millions of dollars in royalties from oil, gas and coal to run the university, and then they put up a monument attacking me, demonising the industry.'[25] Apparently royalties and sponsorship come with a hefty cost in censorship.

As well as direct censorship, sponsors can inhibit curators and learning department staff in myriad informal ways. Jude Kelly, Artistic Director of the Southbank Centre, describes how sponsors influence curatorial decisions even without limitations drawn up in contracts or objections in response to specific artworks: 'Edicts from on high are not necessary; it functions more subtly, in an "everyone knows BP won't like this" kind of way.'[26] Kelly made this statement in a frank and honest tête-á-tête at an event hosting top figures from a range of arts organisations. The event centred on the risks of censorship in the arts and was hosted by London-based NGO Index on Censorship. This comment from Kelly carries significant weight. Hugely respected in her field, she has directed over one hundred theatre productions and before Southbank was a theatre director at the West Yorkshire Playhouse and Battersea Arts Centre; she has also consulted on government policy for learning and the arts. The informal, self-censoring system Kelly highlighted is necessarily hard to measure, but is nonetheless evident.

When James Marriott and Jane Trowell of Platform were invited to speak at a London Literature Festival event at the Southbank Centre in 2010, the duty manager attempted to censor the reading materials which the speakers had made available to the audience. The staff looked through the reports, looking for content critical of Shell – who was still a sponsor at the time – which they deemed unacceptable for the Southbank Centre. Senior staff later apologised for the incident, but nonetheless it demonstrates exactly the subtle power Jude Kelly was talking about.

Tate staff effectively brought Liberate Tate into being in January 2010 during preparations for an event titled 'Disobedience Makes History'. John Jordan from The Laboratory of Insurrectionary Imagination, the artist invited to give the workshop, was told by Tate staff not to bring up the subject of Tate sponsors. The artist Amber Hickey, who at the time was working in collaboration with Tate learning department on the event, describes the situation:

> As the days of the workshop came closer, one of the curators sent an email stating, 'Ultimately, it is also important to be aware that we cannot host any activism directed against Tate and its sponsors, however we very much welcome and encourage a debate and reflection on the relationship between art and activism.'[27]

These limits to 'debate and reflection' reveal that Jude Kelly's intuition was correct. BP's powerful presence subtly and effectively undermined the original intention behind the workshop programme. In fact, the attempt to close down a questioning of BP brought it closer into the spotlight: Jordan presented the email to the workshop participants and they made the first performance as Liberate Tate on that day.

These incidents of BP, Shell and others either censoring or influencing staff decisions are only a dusting from a hidden story. In fact, it is impossible to know exactly how many curatorial decisions at Tate have been influenced by caution around BP. Any works looking at ecological damage, resistance to oil resource land grabs, or works from parts of the world in which BP has a complicated history will likely arouse hesitancy for a curator or someone in the learning department of a BP-sponsored space. As Jude Kelly put it, however interesting and important the artworks might be, 'everyone knows BP won't like this.'

Numerous high-profile international artists including Ben Jones, Matt Vis and Tony Campbell have made artworks in direct response to the BP Gulf of Mexico disaster. It seems unlikely that a Tate curator would propose the purchase and exhibition of such works, for fear of challenge from the sponsor, and yet such works offer curators a particular opportunity to connect art with the social history of oil. Tate holds ten of Conrad Atkinson's works in its collection, but so far no

curator has proposed to buy his recent work *The Oil Ship*. Parodying an *Evening Standard* news poster and the BP–Tate relationship, it bears the words 'PAINTING OF DEEPWATER HORIZON WINS TURNER PRIZE'. Across town at the V&A, which has received sponsorship from Shell but not BP, curators snapped up a signed print and the proceeds of sales were donated to Liberate Tate.

Even when there is no censorship or self-censorship, contradictions emerge between the aspirations of staff including Blazwick, Cutler, Walsh and Jackson and the sponsor. As part of the project conjured up by senior staff, Tate shapes the gallery as a site of social interaction and political debate through panels and conferences on art and political philosophies. In 2013, Tate held an event named 'The politics of the social in contemporary art'. The conference programme asked, 'Can art intervene in social relations? What are the implications of involving art and its audiences in an ethical problem? And how do such practices relate to art's social institutions?'[28] At the event panellist Beka Economopoulos, co-founder of US-based arts collective Not An Alternative, chose to respond to these questions by referencing the unsanctioned performance work of Liberate Tate and the ethical problem of Tate's acceptance of BP sponsorship. Economopoulos presented Liberate Tate as an example of art that makes the politics of the social in contemporary art visible by critically addressing the sponsor BP, and went on to encourage Tate to end the deal. Staff attempted to bring her speech to an early close, but she refused to acknowledge their indications. Her presentation received a standing ovation.

Economopoulos drew out the core hypocrisy of the event. If Tate sees itself as one of 'art's social institutions' and recognises the potential of art to 'intervene in social relations', mounting opposition to BP sponsorship is an immediate opportunity to put thinking into practice. If not, the opening up of this dialogue is disingenuous: Tate refuses to take action on its own ethical dilemmas but by articulating the question without actually answering it, Tate reifies its persona and buffers criticism. It was a dramatic moment of internal contradiction: the progressive voices, having been invited to the picnic, may well have something to say that the host would prefer to leave off the menu. This moment demonstrates a worrying strategy on the part of the global

gallery: it is able to contain criticism without actively responding to the said challenge.

Tate Live, sponsored by BMW, again feasts on a network of live artists work, made predominantly around progressive ideas of identity politics and social activism. Begun in 2012, it built on over ten years of collaboration with the Live Art Development Agency, including the exhibition, event and publication *Live Culture*. Tate describes the project:

> *Live Culture* was a framework to appraise key shifts in performance art over the last few decades: its increasingly hybrid nature and disruption of global and cultural borders; its use of risk and extremity in confronting the art and politics of the body; its impact on social activism and political intervention.[29]

Here again Tate invites into its spaces artistic practice that sits uneasily beside BP sponsorship. It distinguishes a role for itself in relation to social activism only insofar as it does not require itself to take a position on the issues.

The curator and critic Carolee Thea proposes that the curator's intention to open political dialogue is often subdued into a reiteration of existing power structures. As Thea sees it, the important question is not only whether to connect art with social history, but rather whose history/herstory is told through the exhibition's social and cultural narrative. She reflects on a discussion held between ten international curators:

> In addition to exploring larger cultural themes they also discuss the artists as pawn or catalyst for inspiration versus the curator as mediator between artist and society, the obligation to educate viewers, patrons, sponsors, collectors, and bureaucrats to support an encapsulating vision of a history.[30]

Curators already feel required to fit artworks and exhibitions into a broader meta-narrative supportive of the status quo. At Tate, the presence of BP amplifies these limitations. The pressure to maintain a

sanitised image of the company inhibits their capacity to articulate a social narrative around the artworks they curate. It forces curators to place their work in a BP-safe meta-narrative. Were a curator to want to initiate a consideration of the oil corporation in social and cultural history, or a questioning of the politics of arts sponsorship, the influence of the sponsor might prove too much of an obstacle. Blazwick, Cutler, Walsh and Jackson's aspirations for the gallery are to open out social and cultural questions, but BP branding forces curators to reify the status quo. Their mission, to trouble accepted norms within the gallery and in doing so to re-articulate questions of wider social importance, is hindered by the association with BP. Conversations around climate change and culture or environmental racism and art cannot be explored in any real depth or with a view to action and change in a gallery branded with the BP logo.

Tate houses the world's largest collection of Surrealist artworks, whose manifesto tasks practitioners with questioning the politics of the day. Tate celebrates the work, but hesitates in responding to the challenge. In late 2013 Tate Liverpool held an exhibition titled *Art Turning Left: How values changed making 1789–2013*, which explored the ways in which left political thinking has shaped artistic practices. A series of events ran alongside the special exhibition, including presentations from curators and a talk with Tate Liverpool director Francesco Manacorda exclusively for Tate Members. The purpose of the exhibition was not to propagate the views presented, but rather to consider their aesthetic impact, as Manacorda describes,

> The exhibition moves away from the political messages behind the works and claims about the ability of art to deliver political and social change, and instead focuses on the effect political values have had on the processes, aesthetics and display of artworks.

It was possible for Tate to make certain gains by presenting this work: the associations with artists on the left include free-thinking, progressive politics and often youth cultures and for Tate, this link is beneficial to present its own persona in a similar light.

While the *Art Turning Left* exhibition ran at Tate Liverpool, a second politically charged exhibition was held in Tate Britain, *Art Under Attack: Histories of British Iconoclasm*. Here, incidents of the destruction of art for religious or political reasons in Britain were traced through history from the sixteenth century. One of the most notable stories is the Suffragettes' practice of smashing windows to gain political momentum. This activity extended to smashing the glass of pictures in galleries, including Manchester Art Gallery, following which gallery directors discussed whether to ban all women from art galleries. They settled on restricting the carrying of an umbrella inside the gallery. This exhibition makes an interesting counterpoint to *Art Turning Left*. While both fit into Iwona Blazwick's project to 'reconnect art with social and cultural history', their content is somewhat depoliticised. At Tate Liverpool the focus on making and display subtracts from the revolutionary ideals, and at Millbank the exhibition's focus on criminal damage forefronts the activity instead of the politics that informed it. Many of the political movements represented in both exhibitions, from the Reformation to votes for women, are widely celebrated turning points in history that have shaped modern life. Tate maintains its progressive persona, but withdraws from the political questions that would trouble BP sponsorship.

Ultimately, this public persona cannot incorporate BP into the picture. It is contradictory to seek to act as a site of political debate at the same time as sidelining the criticisms of BP as though the sponsorship were irrefutable. Where curators and learning departments staff aspire to question social issues and raise critical consciousness, BP's presence puts the art on display in a very specific social context: of uncritical corporate power and propaganda.

BP, Tate and the post-colonial

In June 2012 the Shell-sponsored National Gallery invited queer performance artist Bird La Bird to do a performance in the gallery displaying their pre-nineteenth-century collection. *Presenting Pomp* inserted less known histories and raised issues of gender, race and class

to bring the colonial narratives in the artworks to the fore. Bird La Bird writes on the making of her performance:

Many times when I visited the gallery it was full of kids, having a day off school and a great time. The school kids of London reflect our multicultural city. I wondered about how British history can be taught to twenty-first century school kids. What kind of national portrait does the collection present when many of the people in the portraits were architects of, or at least benefitted from, the Atlantic slave trade, colonialism and class exploitation?[31]

The gallery tour Bird la Bird led gave a radical re-reading of the figures exhibited compared to what is written on the short portrait descriptions. Her practice explores the many connotations present in the art museum for visitors young and old.

Certain artworks are laden with resonances once a visitor looks through BP-tinted spectacles. The issues of cognitive dissonance and a prohibitive influence on curators arise not only in relation to specific artworks however, but also with regard to the policy agendas of different staff and departments. As part of its DCMS-mandated mission to increase the public's 'access and appreciation of British and Modern art' Tate staff asked themselves the question of how the gallery serves the public when its visitor demographic is not representative of the public. *Art Newspaper* reported 'in 2006/07 Tate Britain had 49,000 Black and Ethnic Minority visitors (3%) while Tate Modern had 200,000 (4%).'[32] Aware of its own critics around diversity, Tate initiated the collaborative research project into 'Britishness and Visual Cultures' as part of a strategy to increase access for Black and minority ethnic audiences.

These questions arose out of the contemporary political climate. When Tate Britain reopened it doors in 2000, the Macpherson Report, a government investigation into racism in the police force, had recently been published, and it named institutional racism as 'the collective failure of an organisation to provide an appropriate and professional service to people because of their colour, culture or ethnic origin.'[33] Its publication in 1999 followed six years of high-profile campaigning

by Doreen Lawrence, the mother of Stephen Lawrence who was murdered in broad daylight by a gang of racists in London in 1993. Doreen Lawrence called for answers to her son's killing in the face of police ineptitude, intimidation and undercover surveillance by the police. Her campaign 'Justice for Stephen' continues, but along the way she has achieved significant political gains, one of which was this imperative to look at racism in all aspects of British society. For Tate, this political context alongside New Labour's cultural policy placed Tate Britain in the spotlight. Under a new name the gallery's expression of 'Britishness' brought up questions about the politics of representation: how to understand Britishness in the twenty-first century? As Tate considered what it means to be British, the government called for a multiculturalism capable of proactively challenging racism in all instances. The 2004–2006 Tate Report noted that the Interpretation and Education Department would play a central role in delivering the objectives laid out for organisations such as Tate in the Macpherson Report. Tate has established itself as a leader in learning practices in gallery settings, and although audiences and access at Tate encompasses all the organisation's activity, emphasis is placed on the responsibility of the learning department to address policy agendas.

To these questions of what active response the art museum should make to the challenge of institutional racism in Britain, Viv Golding makes the case for a reconsidering of the gallery's educational role around race and racism in her 2009 book *Learning at the Museum Frontiers*.[34] Golding is senior lecturer in the department of Museum Studies in the University of Leicester. The only school dedicated to thinking on museum practices in the UK, it is deeply engaged in querying and questioning the modern museum and the ways in which it can change or be changed. Golding bases her analysis in questions that speak to Tate's aims to address cultural policy objectives and enable critical thinking in the gallery. Similar to Toby Jackson's desire 'to bring into the museum the debates which are being rehearsed outside', Golding centres her thinking on 'the notion of the museum "frontier"', saying, 'It is vital to the book's antiracist intention. The "frontiers" refers to an effective sharing of ideas and the development of programmes both inside and outside of the museum.'[35]

Golding sees in the specific prospect of displaying heritage and culture in the gallery a significant potential to critically rethink race and racism. By focusing on learning in the museum, she also directly addresses the challenges made by the Macpherson Report, and proposes that 'the museum can help by taking the responsibility to examine our "policies and methods" for signs of the "institutionalised racism".'[36] For Golding there is an opportunity here: 'the collections are shown to have a new and positive power to challenge racism by progressive learning.'[37]

What Golding proposes requires much more than demographic research. It demands a deeper engagement with museums' origins, artworks and buildings. Museums have histories held in their collections that speak through every exhibition. When visiting a gallery, people learn this history as well as the specific ideas of the artists or artefacts on display. For some museums, such as the British Museum in London or the Canadian Museum of Civilization in Gatineau, protests against the content of collections are part of wider discussions and legal questions about the 'colonial loot' that makes up the bulk of these museums' material. In both the UK and Canada, the same museums have been the target of protests regarding their oil company sponsors.

Galleries and museums, especially in their learning and curating departments, play a crucial role in framing and fixing culture at particular historical moments, whether looking back or considering the present. Golding proposes that museums, in their role as conservationists of culture and as institutions with histories marked and indeed founded on the stolen riches of empire, must have 'creative approaches to education and learning as a useful part of antiracism at the museum frontiers.'[38] For Golding,

The concept of museum frontiers marks a major revaluing of Black knowledge, not simply by 'adding on' previously marginalised or excluded discourses in the temporary exhibition space – to leave the classic canon basically preserved – but rather to locate Black perspectives right at the heart of theory building.[39]

The challenge made here for Tate and other galleries is to bring anti-racism to the heart of strategy and planning in curating and

learning departments. To what extent Tate answers this call relates to how the institution is inhibited in its response by the association with BP.

In the oil industry as in the arts, staff diversity has gained and lost traction over the decades. Strategies on staff diversity around race, gender and class are as familiar to Tate and other large art museums as they are to BP and similar sized multinational corporations. Policies were popular among leaders across sectors in the 1990s, but twenty years on the attempts to depopulate boards of white men have largely come around full circle in the corporate world. There has been some success in shifting cultures in the art world. Chin-tao Wu tracked substitutions on Tate's Board of Trustees from the 1960s until the 1990s, and found a slight shift from 100 per cent male boards in the 1960s and 1970s to 25 per cent female boards in the 1990s. Conversely, Wu saw that despite a broader spread of educational background in the 1970s, by the 1990s the Tate board had been entirely public school educated. In 2014, the Tate board was much more mixed however: 57 per cent women and 43 per cent men; white people were a majority but were not the only represented group as they had been previously, national and ethnic background was more diverse, and the educational background of the fourteen was varied.

At BP, the trajectory flips: John Browne instigated a diversity campaign in the early 2000s when he was directly challenged by senior manager Patricia Bellinger, an African-American woman, who then took on the role of Group Vice President of Global Diversity and Inclusion. Over five years the board of directors was altered and Bellinger won an award for the company. But another decade on and the board has re-routed along previous trends; 80 per cent of the board are white men. In both organisations, the fluctuating patterns around governance make-up become superficial if questions around racism and sexism in the core activity are left unanswered. At Tate, these issues are addressed in programming, learning, curating and management. But at BP concerns around environmental racism go right to the heart of its business.

Environmental racism specifically describes the greater impact of ecologically damaging projects on communities of colour. There

are clear examples of environmental racism in several of BP's major extractive projects. BP's push to expand the tar sands in Alberta, Canada, has brought the company under fierce criticism in Europe and North America. Over a five-year period several First Nations groups have brought legal cases against different mining and transport companies. In January 2013 First Nations activists blocked the only route in and out of the tar sands in Fort McMurray. The US President Barack Obama was under intense pressure in the form of mass public protests and trade union mobilisation to reject a major pipeline that would transport syncrude, the oil-like product of the tar sands, from Canada to the USA, because of the impact on First Nations peoples' lives and livelihoods.

As well as bringing health issues, BP's operations threaten First Nations peoples' capacity to pass on cultural practices from one generation to another, a process intrinsically tied to the land and regionally specific histories. Clayton Thomas-Muller, representing the pan-Turtle Island advocacy group Indigenous Environmental Network, challenged the BP board at the 2011 BP annual general meeting about the effects the BP Husky Sunrise extraction project in Canada is having on First Nations peoples:

> How does the Husky Sunrise project impact us? Well to start with, there are several parcels of land dedicated to the use of trappers from the First Nation. Because the animals have disappeared, these traplines are no longer used for trapping. These traplines have become islands of cultural identity. We use them to escape the industrial activity and as a place to teach our children traditional ways. We are a people whose very cultural identity is linked to the land. The Husky Project has interfered with traplines in the area, reducing access for the local people and taking away the peace of the bush life. High traffic volumes and industrial activity have taken away the peace and quiet and in some cases, taken the land itself.[40]

On one continent, a grandmother strives to pass on language, craft and survival skills while across the land or sea another elder takes her grandchild to see the Picasso. Neither wishes to silence the other. But in Canada BP risks ending a cultural conversation between generations

and communities. And BP sponsorship in London covers this up, in the guise of providing access to the latter familial pair. While BP profits as it destroys First Nations groups' access to their ancestral lands and ways of life, the small change it offers as sponsorship to Tate is said to be acceptable because it preserves a largely European cultural heritage. Why should it be acceptable that one attempt to conserve culture in fact eliminates another group's endeavour to do precisely the same thing? These connotations to the BP logo pose an obstacle to Tate's objectives around access, audiences and diversity issues.

Three exhibitions held at Tate between 2006 and 2008 offer insights into both Tate's attempts to practice anti-racism – through the lens of Golding's 'frontier' – and the ways in which the presence of BP as sponsor comes into conflict with the work of Tate staff and the experiences of Tate's audiences. *East-West: Objects Between Cultures* (2006), *Blake, Slavery and the Radical Mind* (2007), and *The Lure of the East: British Orientalist Painting* (2008) were all exhibitions that bore the reference 'supported by BP', and gave rise to conflicts between content and context. Each of these exhibitions inform the Tate research project 'Britishness and Visual Cultures' that was led by Andrew Dewdney of London South Bank University, David Dibosa of Chelsea College of Art and Design, and Victoria Walsh, previous Head of Adult Programmes at Tate.

The two exhibitions *East-West: Objects Between Cultures* (2006) and *The Lure of the East: British Orientalist Painting* (2008) both set out to engage 'a Muslim audience', considered a 'missing audience.'[41] Tate learning and curating departments sought to incorporate Edward Said's critique of 'orientalism' in their nonetheless problematically titled exhibition, *The Lure of the East: British Orientalist Painting*. Curators stated they both wanted to 'engage with 150 years of continued culture and post-colonial critique' at the same time as 'bringing the pleasure of the work before the audiences.'[42]

Both exhibitions took place in the political context of the British-American attack on Iraq, which saw ever-lessening public support for the British government's decision to go to war, and an unexpectedly high death toll to both Iraqi civilians and British and American soldiers, albeit on sizeably different scales. Dewdney, Dibosa and Walsh suggest

that the controversy of the *Lure* exhibition came as a surprise to some at Tate. The staff they interviewed said that 'the dramatic changes in the cultural, political and social context of the Middle East and Britain's relation with the geographical region created a much more charged environment than when the exhibition was first considered.'[43] These comments seem a little disingenuous given Britain's over-a-century long history of invasions to facilitate access to Iraqi oil, usually in association with the Anglo-Iranian Oil Company, or as it is now known, BP.

To have BP sponsor these exhibitions at that time displays a devastating lack of sensitivity. During the period 2003–09 in which both the 2006 and 2008 exhibitions took place, BP was busy in negotiations with the Iraqi and British governments to gain access to drilling rights for oil fields in a newly 'democratised' Iraq.[44] While audiences were being asked to consider the historical and current relations with the 'Middle East', they were met uncritically and unapologetically with the company who was at that very moment engaged in the attempted sell-off of Iraq's resource wealth, which had been discussed in a secret meeting between the company and government in 2002. Greg Muttitt, author of *Fuel on the Fire: Oil and Politics in Occupied Iraq*, writes of the internal documents he uncovered:

> 'Iraq is the big oil prospect,' began the minutes of one meeting in the Foreign Office in November 2002. 'BP are desperate to get in there'. This was one of at least five meetings between government officials and oil companies in the run-up to the war. BP and Shell both denied any such meetings took place. In a meeting in October 2002, representatives of BP, Shell and BG (the former British Gas) asked Trade Minister Baroness Symons for the government's help in getting them some of Iraq's oilfields after the war. Symons agreed that 'It would be difficult to justify British companies losing out in Iraq in that way if the UK had itself been a conspicuous supporter of the US government'. In other words, if British forces fought in the war, British companies should get their share of the spoils.[45]

Apparently Tate curators were not awake to this resounding clash of post-colonial critique as their exhibition took place in a BP-sponsored gallery.

An event was organised at Tate Britain in association with the British Council in response to the exhibition, which asked, 'Is cultural diplomacy a new form of "soft" imperialism? What role do artists and intellectuals have to play in socio-political change in the region?' Where Tate had set out to engage new audiences and challenge institutional racism, its exhibition in association with BP had become part of a project of cultural imperialism to lubricate the theft of Iraq's oil wealth. In his 2003 preface to the republished *Orientalism*, Said reflects on the invasion of Iraq:

> Every single empire in its official discourse has said that it is not like all the others, that its circumstances are special, that it has a mission to enlighten, civilize, bring order and democracy, and that it uses force only as a last resort. And, sadder still, there is always a chorus of willing intellectuals to say calming words about benign or altruistic empires, as if one shouldn't trust the evidence of one's eyes watching the destruction and the misery and death brought by the latest *mission civilizatrice*.[46]

Tate staff failed to genuinely reflect on Said's post-colonialist critique in the curating choices and learning strategy behind *The Lure of the East* exhibition. The presence of the sponsor BP meant that the artworks alongside the logos were sewn together into an on-going narrative of imperialism and orientalism.

Rather than a partly publicly-funded cultural institution with staff that seek to encourage critical thinking, Tate became the 'cultural diplomat ... of "soft" imperialism' in the British Council's words, and the 'chorus of willing intellectuals' in Said's analysis. Tate acted for BP as a necessary, neutralising cog in its oil-war machine and BP disrupted any potential for Tate staff to fulfil their own aims of reflecting critically on racism in this exhibition. For visitors, there was a sharp incongruence in being asked to reconsider orientalism in British art in a gallery branded by BP during the Iraq War, which did not fulfil the 'spiritual and intellectual' engagement they sought.

The exhibition *Blake, Slavery and the Radical Mind* was held at Tate Britain in 2007, the 200th anniversary of the passing of the Abolition of

the Slave Trade Act. The focus was on 'Blake's poetry, prints and actions' and 'the circle of radical writers and artists associated with publisher Joseph Johnson' to explore the relationship between ideas of freedom and artistic expression with the wider abolition movement. Curator Mike Phillips indicated in interview with Dewdney, Dibosa and Walsh that he sought for audiences to understand the political context afresh:

> Not only to retrieve a British cultural history of radical artistic production that engaged, but was not defined by slavery, but also to create a disjuncture between the historical narrative of slavery and victimhood generated by government rhetoric around the 1807/2007 anniversary with the contemporary debates and experiences of racial inequality and cultural diversity.[47]

Phillips wanted to reframe understandings of the historical moment in which the Abolition Act was won as part of wider celebrations led by government, but also as an intervention to inject some critical perspective on the narratives being fed by ministers seeking to minimise public attention on continued racial marginalisation and oppression of Black people in Britain. Phillips' exhibition was designed to fit within the wider programme at the same time as pricking it slightly, and as such offered a rich learning experience to audiences encouraging critical reflection on the wider anniversary events, activities and public statements. Alongside the exhibition, the artist Faisal Abdu'allah led a participatory creative process with secondary schoolchildren, who together produced a work titled *Stolen Sanity*.

Tate and BP both have origins intertwined with colonial histories and the Transatlantic Slave Trade. Tate Gallery was built on the site of the first panopticon, Millbank penitentiary, the jail that incarcerated people later deported to the settler colony of Australia, where the nickname for English people remains P.O.M. (Prisoner of Millbank) to this day. Visitors are reminded of this history of the site allowing it to creep up through the building's foundations, yet the connection between Henry Tate, sugar and the slave trade has been given less space to critically permeate the building.

Henry Tate was a sugar refiner from Liverpool who worked his way up from the shop floor to head of the company that became eventually Tate & Lyle. In the past, Tate has distanced itself from the association. Up until 2007 its website pre-empted accusations with the description:

Sir Henry Tate wasn't born until 1819 and he did not start his sugar refining business until 1859, many years after the abolition of slavery and his fortune did not come from sugar production. Sir Henry was merely a bulk purchaser of cane sugar and there is no evidence that his business came any closer than that to the post slavery Caribbean plantations.[48]

This comment was presumably edited out in a website make-over just in time for the 2007 anniversary events because it is so defensive as to be obviously aware of the relevance and importance of the connection. The industrial production and consumer market for sugar were products of the slave-owning economy, therefore the initial Tate collection and the building at Millbank are a cultural legacy of colonialism.

Although the slave trade was prohibited in the UK in 1807, slavery itself was made illegal only in 1833 and the trade in human lives continued through the nineteenth century: three million people were still held captive as slaves in the USA by the late 1800s, and 'freed' people in the Caribbean were immediately coerced into other forms of indentured labour. The passing of the 1807 Act neatly side-stepped the responsibility for the transatlantic slave trade in the first place. It marked a time in British history in which Britain defined its culture on new terms. The historian Catherine Hall describes the historical moment:

Forgetting Britain's role in the slave trade began as soon as the trade was abolished in 1807. A similar process took place in relation to emancipation in 1833. As soon as chattel slavery was abolished in the British West Indies, Mauritius and the Cape, the British began to congratulate themselves on their generosity. Abolition was redefined as a demonstration of Britain's commitment to liberty and freedom, and its claim to be the most progressive and civilised nation in the world.[49]

The 1833 act to abolish slavery in Britain was in part made politically possible by an epic buying-out of anti-abolitionists, which saw half the national budget of Britain – £20 million pounds[50] – handed out in compensation, not to the formerly enslaved people, but to the slave-owners, their families and debtors. This money was significant spending power in the cultural reformation of some kind of post-slavery Britain. The galleries set up in the nineteenth century and artworks bought and commissioned were deeply entangled in this moment of cultural reformation enabled by the wealth of both the slavery era and the abolition period.

Current oil trading routes echo almost exactly the routes of slave ships across the Atlantic Ocean between the early 1500s and the late 1860s.[51] That the oil industry mirrors the slave trade in points of both extraction and consumption, and shares financial centres of trade and profit, is part of a wider economic legacy of slavery which continues to create suffering despite the ending of the trade itself. The writers of *The Next Gulf: London, Washington and Oil Conflict in Nigeria* examine the parallels between Nigerian oil exports and the transatlantic slave trade, asking if 'the flows of oil, gas and money in and out of Nigeria [between] 1995–2005' represent a 'new Atlantic Triangle',[52] and saying that,

> The three corners of the Atlantic Triangle between the Delta, the colonies of Virginia, Maryland (and later the new city of Washington) and London, a pattern had been set that would be repeated centuries later. The wealth from the slave trade fuelled London's rapid growth. When Britain established Nigeria in 1914 it was declared that only British companies might prospect for oil in the colony. It gave Shell and BP a monopoly over Nigerian oil.[53]

For the audience this backstory gives rise to a clawing cognitive dissonance on arrival at an exhibition reflecting on the abolition of slavery that is sponsored by BP. Through sponsoring the exhibition BP aligned itself with the 'radical artistic production' and the side of freedom and democracy, positioning itself in the abolition narrative alongside the heroines and heroes. Like the nineteenth-century

government, slave-owners, banks and merchants, the company profits from the oppressive system previously established; then when the politics change, it assumes the role of benefactor.

Where Phillips had wanted to subvert government rhetoric around the anniversary, BP's presence silenced critical thinking about the legacies of colonialism. For the secondary schoolchildren participants in the artistic production of *Stolen Sanity* with Faisal Abdu'allah, the presence of BP is particularly eerie: their critical reflection on slavery is framed – and as such bounded by – an oil company with its origins in colonialism whose harmful impacts are currently felt around the globe, traversing trade routes that retrace the Atlantic Triangle.

Beyond exhibitions, questions around BP, Tate and the post-colonial reverberate through Tate's buildings. The insertion of British Petroleum into Tate's gallery buildings poses challenges to the ways in which Tate's learning department and curating staff like Blazwick, Cutler, Walsh, Jackson, Phillips and the curators of *Lure* and *East-West* seek to locate the gallery in history and how they position the museum as post-colonial.

Tate's newer buildings speak profoundly of post-industrialisation and of a shift from colonial empire to the ubiquitous possibility of something else. They are more comfortably aligned with former church buildings that now house bars and clubs, and old canal or waterside warehouses that have been gentrified into expensive apartments. Tate Liverpool is one such dockside warehouse that once acted as a merchants' trade point for spices, teas, spirits and cloths brought from around the British colonial empire. Its wide spaces and high ceilings become an ideal early twenty-first century gallery. Dewdney, Dibosa and Walsh describe how the opening of Tate Liverpool marked:

> One of the most significant entries into cultural politics for Tate as an institution. Separated off from the neo-classical architectural language of heritage and power that defined the Tate Gallery in London, Tate Gallery Liverpool's contemporary conversion of its spaces in the Dock firmly located it in the present, and with it the politics of the present.[54]

It was opened in 1988. The decision to convert came after the Toxteth riots in 1981, which sparked rioting in major cities across the country. According to Frances Spalding's history of Tate, published by Tate in 1998 and now out of print, the Toxteth riots were caused by 'the ultimate collapse in relations between the police and mainly black residents of Toxteth, who were sick of what seemed to be officially tolerated harassment.'[55] Alan Bowness, Director of Tate at the time, had been working on a 'Tate of the North' project, and after the riots approached Michael Heseltine, then Environment Minister, who allegedly fought with Thatcher over his new-found urban regeneration mission to 'save' Liverpool. Apparently the two men 'spoke for ten minutes and Heseltine pronounced Tate Liverpool a wonderful idea.'[56]

The race and class dimensions of this decision are problematic: in some sense they demonstrate a progressive attention to social issues, at the same time as betraying a paternalistic approach. The 2011 riots across England – including Liverpool – following the murder of Mark Duggan, a young Black man, by police in Tottenham attest that institutional racism in the police force remains unresolved in the eyes of many people and communities across the country. In Liverpool the initial local reaction to Bowness and Heseltine's proposal was not grateful delight. Many Liverpudlians immediately rejected the idea that any Tate gallery with its obvious connotations of sugar and slavery would find a suitable home in a city felt still to be coming to terms with its colonial legacy.

For Toby Jackson, who at that point was the new Head of Education at Tate Liverpool, actively engaging with these important questions was seen as necessary and indeed fundamental to the project:

> Jackson readily identified the need to develop a strategic way forward to overcome this resistance that would directly take on the questions of power, politics and representation that he was regularly confronted with when he met with local groups of potential audiences.[57]

Tate Liverpool established itself – differently to Tate Gallery at Millbank – as an art museum that sought to constructively engage with cultural politics. As such, both in site and purpose, Tate Liverpool stands out

from galleries founded in the nineteenth century. It is a kind of post-colonialist museum, a site that holds a colonial legacy but seeks to be something critically evolved beyond that inheritance.

Tate St. Ives and Tate Modern together subtly suggest a cultural shift into a post-fossil fuel era. Tate St. Ives is a former gasworks, and the main spaces echo the cylindrical buildings that previously occupied the site. Tate Modern is a refurbishment of the Bankside Power Station, retaining the coal then oil powered industrial title for its largest space, the beautifully expansive Turbine Hall. The Tate Modern Turbine Hall operates as both a gallery and as another, liminal space – of transit and of limbo, becoming home to many stray wanderers on a windy day, and known affectionately to some as London's largest crèche. Opened in 1993 and 2000 respectively, Tate St. Ives and Tate Modern join Tate Liverpool in establishing cultural motifs for the twenty-first century museum. The symbolism of historicising a form of power generation implies its demise or reformation. For these sites to become galleries crystallises a moment of cultural change.

A suggestion of a move away from fossil fuels is embedded in the act of visiting a gallery that was once a power station. One of Tate Modern's newer gallery spaces is The Tanks: a set of high and wide cylindrical vats, formerly the oil tanks that supplied the power station during its oil-fuelled phase, which sit adjacent to the Turbine Hall and were opened in June 2012. Up until the actual launch Tate had been referring to them in all publicity as The Oil Tanks. It remains an unanswered question whether the criticism of Tate's association with BP led to the shift in branding, but the editing out of oil from the title of the celebrated new space displays a telling sensitivity. The new gallery itself adds a different feel to the whole building, the cold quiet polished stone enveloping the visitor, almost like a visit to an archaeological site or a Stone Age cave. Envisioning the oil that once filled those spaces in its wait to be combusted makes the very process of oil-fuelled power generation feel historical itself.

South London was once the reserved territory of working class people, as Doreen Massey discusses in her turn of the millennium piece 'Bankside Local International': 'Within London, Tate Modern marks a new assertiveness. From the restaurant you can stare the city and St.

Paul's more equally in the eye.'[58] Tate Modern changed its environs as well as the actual architecture of Bankside Power Station. There is a new gasworks proposed in London, no longer at Bankside or Battersea, but in Southall, a predominantly British Asian part of the city. This demonstrates one shift that is taking place: the environmental racism of shifting polluting energy projects onto poor and Black communities. While there is no longer a gasworks but a gallery in St. Ives, there were several proposed new coal-fired power stations in smaller coastal English towns such as Kingsnorth in Kent, plans that are currently shelved due to local opposition, but again raising issues of environmental justice when power projects with extremely negative health impacts are thrust upon poor communities. Power generation that once happened in cities close to consumption is now being pushed outwards, with proposals going as far as solar power in the Saharan desert primarily for European markets, again an example of environmental racism with obvious colonial resonances.

Massey ends her piece on Tate Modern with the proposition: 'The challenge is to combine this reborn centrality with a real embeddedness in place – and to preserve within its new-found authority that old ability, on occasions, to cock a snook at the powers that be.'[59]

If Tate Modern is to maintain this capacity to challenge power, the presence of Big Oil sits uneasily as a consolidation of the oil industry's hegemony over culture and infrastructure, disavowing Tate's progressive potential. Where the British Museum revels in empire, the family of Tate galleries together speak more viscerally of post-industrialisation. BP at Tate Britain inhibits critical reflection on the colonial legacy of the building, the collection and the name all four galleries share. The association of all four Tates with BP restricts critical thinking and vital re-imaginings inside these gallery spaces.

BP arrived at Tate in 1990 and paired up with the National Portrait Gallery shortly after in 1992. At around the same time, the company returned its headquarters to their original site in Britannic House on Finsbury Circus. The architect Edwin Lutyens designed the building for the Anglo-Iranian Oil Company in 1921, and once the company was nationalised in 1954 and named British Petroleum greater government investment imbued it with stately grandeur. Finsbury Circus was and is

a sought-after location, the largest park in the financial district boasting a bowls lawn from 1925 and a bandstand from 1955. The ornamented exterior of the Lutyens building is so detailed that in 1996 an anti-roads activist was able to free-climb the outside to drop a protest banner. The interior was accorded with all the stately decorative glory: patterned carpets and wallpaper in royal blues and blood reds, paintings on every wall, oak meeting tables and a parlour for guests to wait in instead of an icy foyer. BP first moved out in 1967 – in favour of a more modern aesthetic – to the first building to exceed St. Paul's Cathedral in height on Ropemaker Street also in the City of London, and stayed there until 1987. But in 1991 the company returned to Finsbury Square.

In 2002 BP would move again, this time away from the financial district to a location closer to government and royalty on St. James Square, just off Pall Mall. The new home is less extroverted than the original HQ, the grandeur lost in the corporate gloss. The main meeting room, under Browne at least, was said to be a sci-fi extension of the CEO's office at the touch of a button. Despite the executive glitz, a certain splendour was lost. Without the stately venue at Finsbury Square, BP needed somewhere to meet and greet. The company marked its centenary in 2009 with a party at The British Museum, where a sponsorship deal was arranged in 2005. The public institutions became extensions of the office space of BP. The BP of the 1950s and 1960s was a state company with its own stately buildings, but now it is a private company that uses state buildings for a key aspect of its work.

Tate Britain is older than BP. The gallery at Millbank opened its doors twelve years before the founding of the Anglo-Iranian Oil Company. The same struggle between modernity and post-modernity BP faces in its failure to really go 'beyond petroleum' is evident in the changes and challenges faced by museums wishing to create or re-establish themselves for the twenty-first century. For Tate the post-industrial aesthetic of its buildings mirrors the learning staff's consideration of post-colonialism in the gallery. As Golding argues, Tate and other galleries have a role to play from foundations to fund-raising to understand the past in order to create the future. But BP is irreconcilable with this aim, because its current projects demonstrate the very same tropes of community displacement and ecological damage that post-colonial critics examine.

For Tate staff, whether curating exhibits or running a variety of learning programmes, this question is every day present, and with every passing year of sponsorship, made more pressing.

The work of Tate curators, events and learning departments, and the theory that informs their work, sheds light on Tate's ethics policy in relation to BP sponsorship. The policy tasks Tate staff and Trustees to consider whether BP might: 'Harm Tate's relationship with other benefactors, partners, visitors or stakeholders … [or] detrimentally affect the ability of Tate to fulfil its mission in any other way.'

In each arena of curating and learning, it is evident that BP sponsorship has caused problems for Tate: from cognitive dissonance for audiences, to undermining the choices of curators, conflicting with learning programmes, and emerging unexpectedly as a bone of contention between artists and the gallery at events and in commissions. As BP seeks to prolong its place in our lives, Tate experiences ever more ripples of opposition to the relationship.

By covering up BP's harm Tate subsumes itself in that same controversy. The overblown presence of BP does a disservice to what Tate is: a public body made up of creative, critically conscious curators and learning department staff. It restricts the potential Tate has to creatively consider how to both reflect and shape the wider culture in social, political and ecological arenas. Perry's suggestion that the 'texture' of corporate sponsorship 'is not a happy context for art' holds true: BP is as gritty as sandpaper and as caustic as acid when it coldly brands its logo in Tate's galleries.

6
Opposition to Oil Sponsorship and Interventions in Gallery Spaces

In 1791 the French revolutionary assembly decreed that artworks held in King Louis XVI's and other royal collections were to be publicly owned, and in doing so founded the Louvre art museum in Paris. The Louvre's first governors were the painters Hubert Robert and Jean-Honoré Fragonard, the sculptor Augustin Pajou and architect Charles de Wailly. While the King was held prisoner in the adjacent building, the newly named Museum Central des Arts was opened up to the public in 1793. Artists were given priority over mere mortal members of the public, who were only granted entry at weekends. Decades earlier in 1753 the British Museum had opened to the public, but access was only granted on weekdays and on receipt of a written letter of request, which limited accessibility for the vast majority of people who were both illiterate and worked six days a week. The French revolutionary assembly reclaimed art for public benefit and made more intimate the relationship between art collections and national or international publics. It opened out questions about the public relationship with art that continue to this day in various debates on the role of art in society.

Relationships between art museums, their artists and audiences have adjusted from the first public galleries to the twenty-first century era of online audience–museum interaction on social media. Nowadays, Tate, the British Museum, the National Portrait Gallery, the Royal Opera House and other museums ask audiences 'What do you think?' via

response cards and digital technologies inside its galleries, Twitter and Facebook profiles and email newsletters. These invitations could elicit a multitude of responses. Members, artists and activists who object to the implicit propping up of the oil company by the nation's largest cultural institutions are part of a diverse response to a conversation initiated by the cultural institutions themselves.

The Guardian's culture editor Jonathon Jones reacted to objections to BP and Shell arts sponsorship demanding, 'Why not do something useful like join Occupy?'[1] His blasting was misplaced: activities challenging corporate power in gallery spaces interlink with similar tactics in other arenas and the strategies are mutually reinforcing. Performance protest in gallery spaces is part of a diverse range of political arts practice because it seeks to intervene in social and political spheres at the same time as taking a distinct focus on the practices of art galleries. The content of performance interventions, commentary, revelations of internal documents, petitions and membership resignations all make up a burgeoning movement to eject BP and Shell from the arts and culture. Together, these many actions open out a critical new angle on the presence of BP and its implications: these practices represent the potential for change.

Performing protest in gallery spaces – a growing global movement

Artists have stirred up questions around ethics, equality and social justice in direct challenge to galleries and museums for several decades and creative responses to oil sponsorship resonate with a history of varied artistic practice in confrontation with the art museum. The different groups that have made work inside galleries to challenge the institutions – on a range of different issues from sponsorship, the actions of board members in their wider political roles, to the gender split of artists exhibited – have all used and countered the conventions of the gallery space to make it a contested site. These works respond to the space both physically and conceptually, and often take place within a wider context of artistic activity or action within artist communities.

This activity situates itself both inside and outside the museum; both within and outside of understandings of 'art'.

Many artists were critical of the New York Museum of Modern Art's relationship with Governor Nelson Rockefeller during mass protests against the US military attack on Vietnam. The Guerrilla Art Action Group formed in 1969 and made a series of spectacular unsanctioned performances inside gallery spaces that challenged those museums' sponsorship deals and trustees, and urged the art world to join the public call to end the war. On 18 November 1969 the group made a performance intervention in the gallery space in which they strapped bags filled with pig's blood beneath their clothes and spilled them in the gallery. The performance was called *Blood Bath*. Printed papers were thrown up and floated down to the pools of blood on the gallery floor: the group's *Call for the Immediate Resignation of All the Rockefellers from the Board of Trustees of The Museum of Modern Art* read as follows: 'There is a group of extremely wealthy people who are using art as a form of social acceptability. By accepting soiled donations the museum is destroying the integrity of art.'[2] They went on to point out that 'the Rockefellers own 65% of the Standard Oil Corporation' among other concerns that the donations were 'soiled'.

Just days earlier the group had made a performance at the Whitney Museum of American Art, New York, to highlight the gallery's refusal of the Art Workers' Coalition's request for galleries to close for Moratorium Day – the day on which two million people protested against the war, believed to be the largest protest in US history at that point in time. Four performers created a circle of red pigment on which they threw a bucket of water. By beginning to clean the area, they encompassed more space in the gallery with their red, bloody mess. In an art action one month earlier the group questioned Xerox sponsorship of the Metropolitan Museum of New York; in another unsanctioned performance at MoMA two months later they positioned parents and children in front of Picasso's *Guernica* in a 'memorial service for dead babies'.[3] The Guerrilla Art Action Group was active until 1976, with an evolving practice of political art that frequently questioned the ethics of museums by intervening in gallery spaces.

Gustav Metzger is famous for his practices of 'auto-destructive' art and his engagement with environmental concerns but most notoriously he called for an Art Strike from 1977–80. Metzger's project was – and continues to be – critical of the commercialisation of art objects by way of being placed in private galleries for sale, and he argues that art will only flourish once it is liberated from auctioneering and private sale. By withholding his labour from the art market during this period, Metzger made an intervention in the industrial institution of art that expressed his concerns about waste and environmental damage.

The Guerrilla Girls are an artist group who have heeded their calling to act as 'the conscience of the art world'.[4] The group got together in 1984 after curator Kynaston McShine commented at the opening of the New York Museum of Modern Art's exhibition that any artist not included in the show should reconsider 'his' career. White male artists were overwhelmingly represented in the works on display. Frida Kahlo, a Guerrilla Girl (the group preserves members' anonymity by using deceased women artists' names, reinforcing those artists' presence in art history), describes their collective action after the exhibition opening:

We decided to find out how bad it was. After about five minutes of research we found that it was worse than we thought: the most influential galleries and museums exhibited almost no women artists. We decided to embarrass each group by showing their records in public. Those were the first posters we put up in the streets of SoHo in New York.[5]

The Guerrilla Girls' humorous posters have called out sexism and racism at galleries and exhibitions on numerous occasions. Their tactic is to plaster nearby streets or use billboards and banners to embarrass the art museum on their own turf. Their work has also included unsanctioned performances and events inside and outside galleries, as well as feminist gallery-goers guide books and other publications. In 2013, their work was included in *Art Turning Left: How Values Changed Making 1789–2013* at Tate Liverpool, and in a monograph exhibition at the Alhóndiga cultural centre in Bilbao.

The Art Not Oil Coalition first drew public attention to oil-art sponsorship deals in London by holding creative protests outside the National Portrait Gallery on the opening nights of the BP Portrait Award over several years from 2004. Then in 2006, the group took on the Shell-sponsored Wildlife Photographer of the Year exhibition at the Natural History Museum and poured a black oily substance on several exhibits, without damaging any photographs: the mucky oil dribbled down the striking back-lit images of vivid wildlife scenes. In 2008 the Natural History Museum looked for an alternative sponsor, the conflict between Shell and wildlife photography having been made uncomfortably public by Art Not Oil.

A quick glance around London revealed more galleries with oil sponsorship. The art collective Liberate Tate – the group that I am part of – was formed in 2010 to focus on Tate's relationship with BP by making unsanctioned live art inside Tate spaces. Liberate Tate describe their/our work as 'creative disobedience': artwork that enacts an antagonism and challenges power. Iwona Blazwick wanted the gallery to be a site of 'social and political debate' and the discussion the group catalyses around BP sponsorship at Tate certainly achieves this – although perhaps not quite in the way she intended.

Since the beginnings described in Chapters 1 and 5 – the attempt to censor mention of sponsorship at a Tate workshop, and *Licence to Spill* where oil-like molasses was poured and spilled at the Tate Summer Party – Liberate Tate has made many more performance interventions in Tate spaces. In September 2010 *Sunflower* was performed in Tate Modern. A halo of oil reminiscent of the BP 'helios' logo was painted on the Turbine Hall slope. The circular shape emerged as, one by one, forty figures in black expelled black paint from tubes adorned with the BP logo.

On the first anniversary of the start of the BP Gulf of Mexico disaster, in April 2011, Liberate Tate questioned how to respond to the loss of life incurred by the oil industry. The resulting performance *Human Cost* was a durational piece in the Duveen Galleries at Tate Britain: a male performer (often gendered as female by audiences in the context of Tate's exhibition *Single Form* that was largely made up of female nudes) undressed and lay naked on the gallery floor in the foetal position,

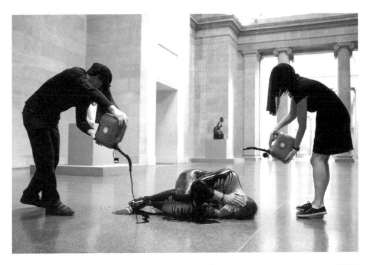

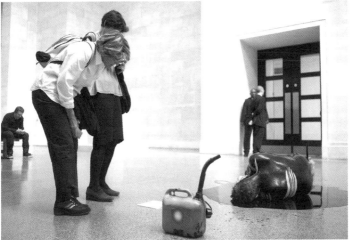

Figure 6.1: *Human Cost*, Liberate Tate, April 2011, Tate Britain. Photo credit: Amy Scaife, 2011.

covered in oil poured by two veiled figures, for 87 minutes – one for every day of the BP spill. The tender, tragic image of the performance has been seen and shared thousands of times globally.

In 2012 Liberate Tate gave Tate *The Gift*: over a hundred people carried and assembled a 16.5 metre wind turbine blade at the foot of the slope of the Tate Modern Turbine Hall. When security staff attempted

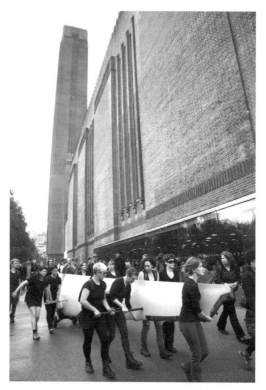

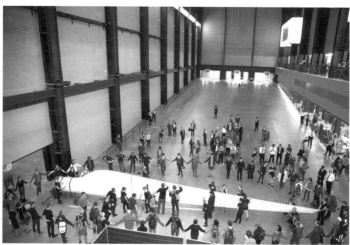

Figure 6.2: *The Gift*, Liberate Tate, July 2012, Tate Modern. Photo credit: Martin LeSanto-Smith, 2012.

to block the blade on entry, performers beguiled them with the calm determination that comes with the knowledge that a plan is safe and good and will take as long as it takes, and as the final piece was put into place the crowds gathered at every balcony began to cheer. The blade lay across the full width of the space like a beached whale; a polished bone-like object holding sadness and beauty, lay on its side as an offered alternative to oil: use me instead.

The artworks make distant events feel present in the gallery, intangible data is teased out to become visceral and meaningful, and Tate's own programming is prodded with a questioning critique of BP's associations. On a dark winter's evening in January 2012, following news of BP's plans to drill for oil in the Arctic, four veiled figures carried a 55 kilogram piece of Arctic ice on a palanquin – with lights beaming up through the large, crystal-like block – from the recent site of Occupy at St. Paul's cathedral, across Millennium Bridge and into Tate Modern where it was laid down to melt. During the BP Gulf of Mexico trial in New Orleans, the group streamed a live video feed of performers whispering the trial transcript online over a week at Tate Modern in a performance titled *All Rise*. When Tate Britain held an event to re-open the chronological rehang of its permanent collection in 2013, renamed the *BP Walk Through British Art*, fifty Liberate Tate performers in black veils formed a procession through the gallery spaces, stopping in different choreographed formations in each decade to count, in unison, the increase in *Parts Per Million* of carbon dioxide in the atmosphere. Days before a tribunal hearing to consider Tate's withholding of BP contractual information, Liberate Tate made *Hidden Figures*, a participatory performance involving hundreds of performers and visitors playing with an eight metre by eight metre square of black cloth, in conversation with Tate's exhibition of Kazimir Malevich's *Black Square*. Performance documentation of *The Gift* is held in Tate's archive, and the group has presented their work at numerous events including the Live Art Development Agency's Trashing Culture and (Re)Fresh, V&A's Disobedient Objects exhibition debates, as well as at the academic conferences Performing Protest and To Hell With Culture.

More groups sprung up to join the campaign led by Art Not Oil, all of which, like Liberate Tate, make performance interventions that

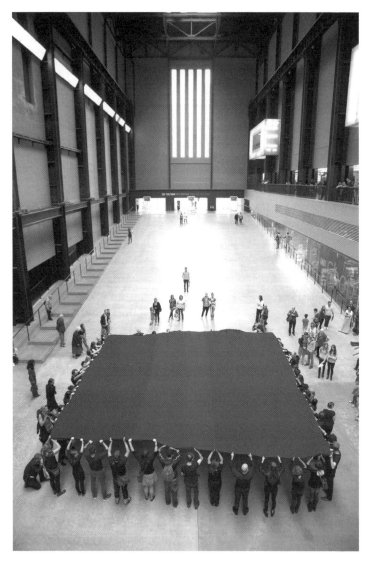

Figure 6.3 (above and opposite): *Hidden Figures*, Liberate Tate, September 2014, Tate Britain. Photo credit: Martin LeSanto-Smith, 2014.

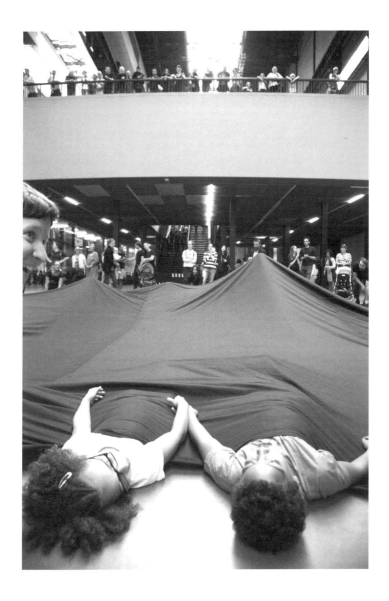

Figure 6.4: *All Rise,* Liberate Tate, April 2013, Tate Modern. Photo credit: Mel Evans, 2013.

resonate with the art form of the cultural institutions they seek to challenge. In 2011 and 2014 dancers performed at screenings of live opera BP Big Screens events in Trafalgar Square, London, to protest against BP sponsorship of the Royal Opera House. Shell Out Sounds, a participatory guerrilla choir, sung their opposition during the orchestra's interval at the Shell Classic International Series concerts at the Southbank Centre until the deal ended in 2013. Their dissenting songs were backed up by a group of artists and writers who had exhibited or presented at the Southbank Centre and wrote a letter in collective criticism of Shell sponsorship – Mark Rylance, Mark Ravenhill, Labi Siffre, Helon Habila and the Guerrilla Girls were among the chorus of Shell's critics. Among various other tricks, Science Unstained entered a Fracking Quiz at the Shell-sponsored Science Museum in London with the playful objective of linking each one of the compere's questions to Shell's involvement in fracking around the world. Art Not Oil continues to challenge the National Portrait Gallery: in June 2014 twenty-five performers spread throughout the gallery poured oil on their faces and tweeted photographs of *#25PortraitsInOil* days before the opening of the twenty-fifth BP Portrait Award and months later the group visited the National Gallery to stage songs and dramas in opposition to Shell sponsorship of the Rembrandt exhibition.

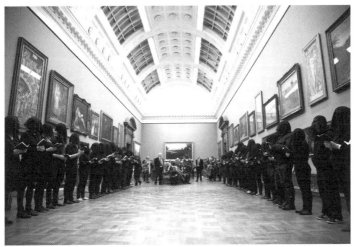

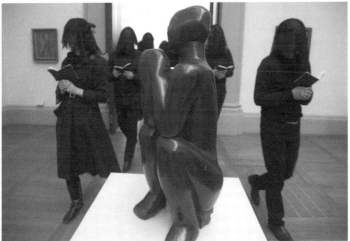

Figure 6.5: *Parts Per Million*, Liberate Tate, December 2013, Tate Britain. Photo credit: Martin LeSanto-Smith, 2013.

Art Not Oil has a theatrical wing: the Reclaim Shakespeare Company formed in 2012 in response to BP sponsorship of the Shakespeare Festival; they took to the stage before the Royal Shakespeare Company's performances began to express their objections to BP sponsorship in iambic pentameter. By intervening on stages – including the Royal Shakespeare Theatre in Stratford-upon-Avon – before the lights dim to signal the start of the official piece, the performers confront the

institution in its own recognisable theatrical form without distracting the other actors. The group has been well received by audiences who have in the main applauded them – except on the evening when the crowd was made up largely of BP staff. At the Royal Shakespeare Company's production of *Much Ado About Nothing* in the West End of London, two performers took the roles of BP and the Royal Shakespeare Company and performed the script:

> RSC: You seek my help in being virtuous?
> BP: Nay, I seek your help in *seeming* virtuous.
> For a thousand ducats, thou shall proclaim
> My innocence to these simple people,
> To wash away the memories of my misdeeds,
> Distract them from the destruction of the earth.
> RSC: A thousand ducats: 'tis a fine price! *(aside)*
> BP: By your reputation, I will mine own mend.[6]

The support from actors and audiences was vital to the group's impact: the Royal Shakespeare Company is said to be reconsidering any future BP sponsorship.

With one oil sponsorship deal down, the Reclaim Shakespeare Company switched focus to the British Museum, where the contract has been significantly more long-standing. In April 2014 Norse gods invaded the BP-sponsored Vikings exhibition and later that year hundreds of 'actor-vists' staged a Viking 'flash-horde' inside the Great Court of the museum. Props for the latter performance included a fifteen-metre fabric longship and decorated cardboard Viking shields, some of which were confiscated when police arrested one performer at the entrance. The performer was released without charge, but the police kept the shield: the group remains confident of designing and constructing all the props it needs for future performances.

Creative interventions to end oil sponsorship are going global. Stopp Oljesponsing av Norsk Kulturliv are a group of artists and musicians who set up public debates and activities to challenge Statoil sponsorship of cultural events: in 2013 the group pushed the oil company to step back from one music sponsorship deal. In Brazil in 2011, a group of

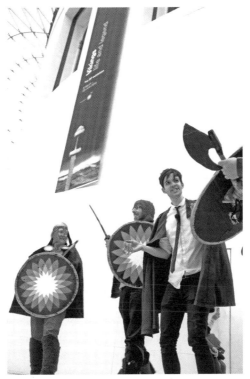

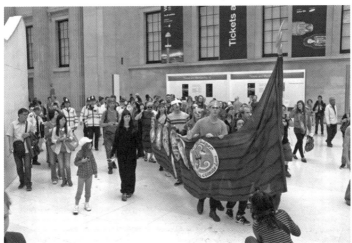

Figure 6.6: 'Viking Flash-horde', Reclaim Shakespeare Company, June 2014, British Museum. Photo credit: Hugh Warwick, 2014.

artists spilled oil outside the Museu de Arte Moderna in Rio de Janeiro to protest all oil and mining arts sponsorships, including deals with Vale, Petrobras and Chevron. The large pool of oil lay in wait by the entrance, inviting visitors to walk through the spoils of sponsorship as they entered the gallery. In Canada, when the Museum of Civilization in Gatineau, Quebec announced it would accept funds from the Canadian Association of Petroleum Producers an unlikely objector set up camp outside the Gatineau museum holding a placard reading 'CAPP pollutes snow',[7] which turned out to be the material out of which the figure had been made.

Artistic strategies to intervene in sponsorship arrangements are currently being employed on issues other than oil, too. Boycott the Sydney Biennale, a group of artists whose work was to be exhibited as part of the Biennale that joined together to take a stand against sponsor Transfield, started their campaign by addressing the Biennale directors:

> We appeal to you to work alongside us to send a message to Transfield, and in turn the Australian Government and the public: that we will not accept the mandatory detention of asylum seekers, because it is ethically indefensible and in breach of human rights; and that, as a network of artists, arts workers and a leading cultural organisation, we do not want to be associated with these practices.[8]

At first the directors' response was minimal, so the group stepped up its strategy and a number of artists pulled their work out of the event and rescinded their fees, including Libia Castro, Nicoline van Harskamp, Sara van der Heide, Nathan Gray, Ahmet Ögüt, Ólafur Ólafsson, Agnieszka Polska, Charlie Sofo, and Gabrielle de Vietri. The strategy of building resistance among the exhibited artists led to the collapse of relations between the Biennale and the sponsor, and the directors ended the deal two weeks before the opening. Luca Belgiorno-Nettis, chairperson of both the Biennale and Transfield, immediately handed in his resignation. In their actions the group of artists and cultural workers were able to challenge the Biennale's ethics, the company's operations and government policy.

In 2014 several groups in New York took action to confront gallery ethics. Not An Alternative – following their challenge to Tate around BP – created the *Natural History Museum*, a two-week long event questioning oil sponsorship of science and culture held at Queens Museum. Months earlier across town at the Guggenheim Museum, the Global Ultra Luxury Faction (G.U.L.F.), in collaboration with an offshoot from the Occupy Wall Street movement, Occupy Museums, made an unsanctioned performance intervention to criticise the labour conditions in the construction of Guggenheim Abu Dhabi. The groups hung banners and a manifesto made from aluminium foil along the famous inner ring of balconies inside the gallery. They then showered illustrated bank notes resembling US dollars, instead inscribed with the mantras 'Speculative global museum' and 'No sustainable cultural value'.

Of all these many interventions from different decades, cities and subjects, some are more and some less recognisable as art, or equally as protest: some groups are thought by audiences to have been invited, others are assumed to be unsanctioned. The positioning of the confrontation both inside and outside the gallery manifests different potential strategies for change. These artists all sit both inside and outside the museum, and it is this boundary that holds space for the sparks of social debate to catch fire.

Institutional critique and the sponsor

Criticism of gallery sponsors has arrived by invitation as well as unsanctioned intervention. Institutional critique began to be outlined as an artistic practice in the late 1960s through the work of artists including Hans Haacke, and was later redefined by Andrea Fraser and others. The hallmark of this kind of work is a querying of power within the museum: power over content, display, history, politics and meaning-making. Several artists have selected sponsors as the target of their institutional critique in artworks commissioned by the galleries themselves.

Hans Haacke's renowned body of work questions power, challenges galleries and implicates sponsors to examine corporate influence and

control. In a work at the Museum of Modern Art (MoMA) in New York in 1970 that reinforced the message of the Guerrilla Art Action Group six months earlier, Haacke invited visitors to vote by placing a slip of paper in a transparent perspex voting box, making visible the responses to the question: 'Would the fact that Governor Rockefeller has not denounced President Nixon's Indochina Policy be a reason for your not voting for him in November?'[9] The work was part of the *Information* exhibition curated by Kynaston McShine – who a decade later unwittingly sparked the formation of the Guerrilla Girls. At the time, the Rockefellers sponsored MoMA, and while the Governor Nelson Rockefeller was no longer chair of the board of trustees of MoMA, his brother David Rockefeller now held the position, and their sister-in-law Blanchette Rockefeller would later become president of MoMA from 1972 until 1985. *Moma Poll* occurred during an intense period of protests against the US attack on Vietnam, and was not available for viewing by the curators before the opening of the exhibition. The following morning David Rockefeller demanded Haacke's work be removed from the exhibition. The gallery director John Hightower refused, and David Rockefeller himself claims to have pushed for Hightower's dismissal eighteen months later.[10]

In 1990 Haacke made *Helmsboro Country*, another artwork dissecting the relationship of corporate sponsors with the arts. In this piece, Haacke constructed a two-metre-long cigarette box filled with rolled Bills of Rights marked to look like enormous cigarettes. As well as several arts sponsorships, Phillip Morris contributed financially to Senator Jesse Helms' election campaign, who in 1989 had accused the US state arts funding body the National Endowment for the Arts of 'soaking the taxpayer to fund homosexual pornography.'[11] The cigarette box resembled a Marlboro packet, and was accompanied by the full Helm's quote, the details of Phillip Morris' electoral campaign support, and quotes from Phillip Morris' advisor George Weissman on the value of arts sponsorships for corporations (that it is in their best 'self-interest') – all used to demonstrate the disdain for artistic freedoms that underpinned the corporate sponsor's financial support for the arts. Haacke's work entered the cultural dialogue around tobacco sponsorship of the arts at the same time as, across the Atlantic, Conrad

Atkinson's painting *The Art of Tobacco* (another newspaper poster, this one bearing the words 'PORTRAIT OF LUNG CANCER VICTIM WINS JOHN PLAYER PORTRAIT PRIZE') was exhibited at galleries in London and Edinburgh, months before the Imperial Tobacco sponsorship ended at the National Portrait Gallery. The artistic responses to tobacco sponsorship fed changes in the public mood.

In that same year, 1990, Haacke made an installation in Berlin critical of Daimler-Benz arts sponsorships in Germany and Mercedes sponsorships in New York, on account of Mercedes' manufacture of engines for Nazi military vehicles and Daimler-Benz's use of forced labour in concentration camps, and furthermore the company's supply of vehicles to the South African military and police during apartheid. The installation positioned a rotating Mercedes logo atop a remaining watchtower in the 'death strip'[12] between East and West Germany. The work was commissioned by the municipality and opened several months prior to reunification.

Following the successes of works including Haacke's, the notion of 'institutional critique' as a genre of artistic practice came under criticism itself. The curator Iwona Blazwick describes how the celebration of such works within the institution of art could undermine their potential for effective or genuine critique: 'These deconstructive tendencies have created a genre known as "institutional critique" which, ironically, has itself become the subject of museum shows. In such ways museums absorb their critics.'[13]

The potential for co-optation is not a predetermined result however. The performance artist and theorist Andrea Fraser continues a critical evaluation of the impact of this kind of practice, and says that institutional critique must be understood as the examination of social relations with the objective of affecting change. Fraser's definition of 'critically reflexive site specificity'[14] can be applied to any of the performance interventions made by groups outside of commissioned works, which are necessarily less susceptible to absorption by the institution.

Patrick Keiller's *The Robinson Institute* exhibition at Tate Britain in 2012 could be considered as an example of institutional critique in a number of ways, including the positioning of the exhibits in the space

and the choice of objects for the exhibition, which included books and maps. Keiller created an exhibit that was both carefully ordered and confusing at same time: rather than leading the audience with clear prioritisation of hundreds of objects in a chronological or narrative structure, visitors were left to stumble across linkages and meanings themselves. The physicality of the exhibition is an institutional critique by refusing to adhere to the convention of hanging artworks on walls – instead Keiller carefully arranged them on metal frames and tables in numbered areas that invited cross-readings between works.

The Robinson Institute could also be read as an institutional critique of BP sponsorship because there was the potential for a critical reading of BP's operations inside a BP sponsored space. However, Keiller's position as a commissioned artist gave him a sanctioned platform. By curating the debate inside the gallery for itself, the institution was able to control the discussion around BP and its practices. Any potential to criticise BP was matched with the risk that the exhibition became a display of Tate's capacity to question BP while simultaneously upholding the company.

The limitations of commissioned critical practice within the gallery give rise to the need for challenge that arrives unsanctioned from outside the gallery programme, in the form of the performance interventions previously described. These activities are a kind of institutional critique, but from a position which is less easily absorbed or co-opted. Fraser extrapolates on the issues resulting from programmed criticism and addresses possible, more effective, alternatives and Anna Cutler, Director of Learning at Tate, links Fraser's argument with the French psychotherapist and philosopher Felix Guattari's principle of ecosophy to conclude that any institution is created by all the people who make themselves part of it – as staff, visitors, members and indeed critics.[15] Cutler asks artists to see themselves as part of the whole and Fraser calls for a reassertion of our agency in reproducing the institution:

> Every time we speak of the 'institution' as other than 'us' we disavow our role in the creation and perpetuation of its conditions. We avoid responsibility for, or action against, the everyday complicities, compromises and censorship – above all, self-censorship – which

are driven by our own interest in the field and the benefits we derive from it.[16]

When the group Boycott the Sydney Biennale invited exhibited artists to speak out, it claimed the institution as its own: the artists work is the body of the biennale, and as such they spoke from a position of 'us' and 'we' when they took the sponsorship deal to task. Each time artists signed letters calling on Tate and the Southbank Centre to drop BP and Shell sponsorship, they asserted their role as part of these institutions' wider social body, and similarly the performance interventions made by Liberate Tate and Reclaim Shakespeare Company have addressed Tate, the Royal Shakespeare Company and the British Museum as critical friends.

Practices of institutional critique were founded in a desire to change the art museum; and performance interventions share this desire to confront and alter the gallery. Both artistic methods and strategies also share similarities with the academic discipline of critical museology. Where some sites within the academy seek to replicate existing structures within the art institution, a growing body of discourse has developed in parallel to critically reshape working practices in art museums. Andrew Dewdney describes critical museology as: 'The effort to change the practices of museums along the path of their "democratisation", or, put another way, towards the realisation of the museum as fully public.'[17]

Criticism of galleries' ethics and sponsors, whether made as commissioned artworks or as unsanctioned performances, fit within this idea of democratisation. Concerns around the power of the sponsor or the gender split of exhibited artists relate to broader political movements for social change. To assert the museum as something which we are part of, as Fraser outlines, is part of making the museum 'fully public'; so, too, is the challenge to separate oil sponsors from the gallery, out of concern that their presence limits both the appreciation of art and the imagining of a culture beyond oil. The practices of institutional critique, critical museology and performing protest all operate from inside and outside the art institution in different ways

and the power of these strategies lies on a threshold, a liminal space both within and without.

Making space for change: the 'deviant art institution' and interstitial distance

Artworks like Haacke's *Moma Poll* and Guerrilla Art Action Group's *Blood Bath,* or Keiller's *The Robinson Institute* and Liberate Tate's *Human Cost,* share political concerns despite arriving in the gallery space differently by invitation or intervention. The commission or lack thereof affects the possible ripples caused within the status quo of the institution in relation to the political issue raised.

The efforts of artists to reason with galleries via formal letters is a strategy widely used to address the art museum from within – as part of a broader community of artists – at the same time as approaching from outside the gallery. Likewise performance interventions take a discussion that is taking place in various social spheres right to the heart of the gallery in question. Between Blazwick and Fraser's two analyses – that the museum 'absorbs its critics' versus 'our role in the creation of its conditions' – there is an opening of potential efficacy: to avoid co-optation, but to act from a position of care and responsibility for the whole, of which the friendly critic is a part. The position of institutional critics 'inside' or 'outside' the museum – and crucially how far in either direction – is central to the effectiveness of their strategy. These artworks' impact as institutional critique, be it by commission or unsanctioned, can be extended or limited by the positive reception of the gallery.

These tactics are both *inside* and *outside* the gallery and can open a new space. Emma Mahony analyses strategies for political change in the art museum and proposes that one technique for what she calls the 'deviant art institution' – a grouping that could encompass collectives such as Liberate Tate or G.U.L.F. – is to challenge the larger institutional body from within, but at an 'interstitial distance' to it. Mahony sees the public art museum as a structure that is susceptible to public political will. She takes the political philosopher Simon Critchley's strategy of

assuming an interstitial distance and applies it to the art institutional landscape. The 'interstice', or crack, becomes a critical action neither wholly reliant on state apparatus, nor entirely secluded from it. Mahony defines Critchley's interstitial distance in the context of art as follows:

> An interstice is an empty space or non-space between structured or established spaces. In effect, it is a space that does not exist. It needs to be created through political articulation, by working within the state to open a space of opposition against the state.[18]

To make an effective challenge to the ethics of the art museum, a confrontation needs to be made from within the gallery. This might mean from within a community of artists who hold a stake in the formation of the institutional politic, from within the public realm that can claim the museum as a public space, or, to be sufficiently confrontational to pose opposition, from physically within the galleries. This sheds light on the space to be opened out by artists wishing to create institutional critique in their work: not too close yet not too far, seeking to open up an 'interstice', or crack, of dissent within the institution. This opening is forged at an 'interstitial distance' between the inside and the outside of the institution.

Sometimes art as intervention might not have the proximity to the subject to give sufficient leverage to create a space within it, at other moments too great an intimacy and acceptance by the gallery might limit efficacy. A tightrope must be walked, or a route in especially carved. In this understanding, artists are critical friends of the larger institution: part of Cutler's Guattarian ecosophic whole, but acting at enough critical distance to make an effective challenge. In this way artworks can open up an interstice of opposition to the status quo of the gallery.

The work of the Guerrilla Girls exemplifies interstitial distance in relation to the art institution. The group surrounds their target gallery with billboard posters to communicate their concerns with visitors as they arrive, and shame the museum to change its practices. The group's proximity to the institutions it targets is further maintained by an increasingly warm reception and reinforcement by the global art

establishment, demonstrated by Tate's exhibition of the group's work in *Art Turning Left*, or Yoko Ono's inclusion of members on a panel during her curatorial programme of *Meltdown* at the Southbank Centre. Blazwick might argue that this reification is a sign of absorption by the institutions the Guerrilla Girls set out to critique, but according to Fraser's proposal that effective institutional critique must be 'critically reflexive', this participation and shaping of artistic standards and practices is precisely what enables their work to create an interstice in which to change the art museum.

Interestingly, when Hans Haacke's artwork *Moma Poll* was rejected by the chair of the MoMA Board of Trustees – and ultimately led to the dismissal of gallery director John Hightower – these consequences, if seen as part of the artwork rather than separate to it, enabled Haacke to open an interstice on the issue of the war and government policy more so than GAAG's art actions months earlier. The board discussed Haacke's work, but there is no evidence that GAAG's challenge was taken seriously. Although an artist group, GAAG positioned itself too far from the institution to effect change. The group's performances were too few and infrequent to open an interstice within the gallery. In parallel, Keiller's exhibition although similarly commissioned like Haacke, was insufficiently confrontational, and too well upheld by the institution to exert much influence. Tate was able to contain dissent around BP's activities without threatening to destabilise the status quo on the issue of BP sponsorship.

Liberate Tate's artwork *The Gift* employed a legal strategy as part of their performance. The 16.5-metre wind turbine blade was formally offered to Tate as a Gift to the Nation under the Museum and Galleries Act 1992. Under this guidance, artists may offer works to any public gallery that then must be considered by the board for inclusion in the collection. Documents obtained by the group show that their activities had previously been discussed at board level, but this legal strategy ensured that the board had to respond more publicly. It was rejected as such by the Board of Trustees on the recommendation of Tate senior curators, but the performance documentation of Liberate Tate's 2012 work *The Gift* is now held in Tate's archive.

To be selected for archiving is often seen as a mixed blessing for artists: it doubly recognises the significance of the work and devalues it in the same moment, by not being placed in the collection proper. It could be seen as an attempt by Tate to 'absorb its critics', yet the archiving also emphasises their impact as an art collective. As such, this piece of work demonstrates how an interstitial distance can be achieved in line with French philosopher Michel de Certeau's thinking in *The Practice of Everyday Life*. By utilising a legal strategy to reach the board of trustees, Liberate Tate was able to 'manipulate the mechanisms of discipline and conform to them only in order to evade them.'[19]

The archiving strengthens Liberate Tate's position in making an institutional critique from both outside the specific gallery and also from inside the broader institution of 'art' in Fraser's understanding. This position holds power because it locates an interstitial distance from which to challenge and seek to change the institution. Between the risk of speaking from too much distance to be heard, and the danger of being absorbed or appropriated, is a thin line on which effective institutional critique can tread. As described, the origin of the group occurred inside a Tate space as part of a workshop programmed by Tate, and this starting point partly enabled the collective to find an interstitial distance. The performance interventions the group went on to create are made in response to this internal decision and are therefore actions taken within the wider body of Tate. *Liberate* Tate, even in name, performs both from within and without, like *Reclaim* Shakespeare Company, Art *Not* Oil, Shell *Out* Sounds – each are within and without, opening up an interstice. By making institutional critique at an interstitial distance these groups spark off each other and ignite a flame of potential change in the gallery.

Locating this threshold sufficiently within Tate is also evident in the way that Liberate Tate foreshadowed Tate's own focus on live art in the opening of The Tanks in 2012–13. The Tanks' arrival as an alleged home for live art was preceded by Liberate Tate's practice of unexpected artworks in Tate spaces. The theatre-maker Andy Field articulates the necessary homelessness of live art in relation to Liberate Tate's work, describing the group's work as more fitting to the tradition of live

art than Tate commissions precisely because the performances are unsanctioned. Talking about *The Gift* Field comments:

> The performance demonstrated not only the subversion that remains an integral part of live art but also the challenge faced by the Tate in attempting to reproduce such a quality when it remains bound to sponsors like BP.[20]

The aesthetic dialogue between Liberate Tate's performances and Tate's programming again opens a potential site of interstitial distance. The group made an 'action to turn their own weapons against them', as recommended by Pierre Bourdieu in a discussion of Hans Haacke's work, echoing Michel de Certeau.

Unlike visual art, which places exponential financial value on the object, or theatre, which emphasises the importance of precise repetition, live art only exists in the live moment. Even if artists repeat performances as advertised there is usually an expectation for them to be iterative, and variation is designed into the performance. Live art photography often conveys a sense of the experience at the same time as leaving the viewer wanting more. All of the groups – Liberate Tate, Reclaim Shakespeare Company, Art Not Oil, Shell Out Sounds – make live art, because integral to the intervention is the location and the live moment of confrontation in a specific space. The work of these groups therefore fulfils Fraser's demand that effective institutional critique practises 'critically reflexive site-specificity': by opening a new space of dissension at an interstitial distance within the space of the gallery or museum they wish to change in some way.

The power and importance of institutional critique that operates at an interstitial distance is to start from a position within the gallery, and from that place to bring in questions from outside the gallery, arts centre or theatre – questions in which the cultural institution is directly implicated. The presence of BP and Shell inside London's largest cultural institutions brings with it a whole range of concerns over the companies' global operations. Artists whose performance interventions seek to, like the academic discipline of critical museology, effect the full democratisation of the gallery, act from within at an interstitial distance.

They follow Cutler's illustration of Guattari's principle of ecosophy: affecting change on the greater body of which we are a part. Critchley argues that the creation of interstitial distance is what engenders democracy, and proposes that such practices articulate Marx's notion of 'true democracy'. In the broader process of the democratisation of the twentieth-century art museum, performance interventions in gallery spaces may have a vital role to play.

7
Conclusion

The story of oil sponsorship in the art museum brings with it histories, politics and power plays that have been choreographed for centuries. The contemporary playing out of these dances reveals specific challenges around a cultural response to climate change and a new chapter in the building of a democratic museum. For oil companies, the line between positive and negative publicity associated with the deals is sometimes hard to trace. For artists, the need for freedom of expression will always be brought into sharper focus in light of the possible impact of sponsors' influence.

The story is told that the arts desperately need oil sponsorship to exist. But funding for large cultural institutions is diverse and oil sponsorship is minute compared to other sources. Sponsors proclaim that they adore the arts, yet Big Oil's purpose in sponsorship is evidently self-serving: the companies simulate an authenticity at the galleries to build the trust of special publics in order to maintain the social licence to operate that is vital to the industry's survival. Artwash, the other show in town, inhibits staff in their attempt to fulfil the organisational mission, and undermines visitors' engagement with the collection. But now artists around the world are gathering creative momentum in their call on the institutions to change.

Both inside and outside the gallery, space is being opened up to see some shifts on the issue. The cultural institutions of the BP Ensemble – Tate, the British Museum, the National Portrait Gallery and the Royal Opera House – are large organisations with over a thousand permanent staff. The first to break rank could emerge from any doorway. In the galleries' corridors and meeting rooms individual voices of change will find each other and turn up the volume.

The effect of Big Oil branding on learning departments' realm of activity warrants a co-ordinated response by staff looking at visitor engagement and critical thinking. When Anna Cutler was appointed Director of Learning at Tate in 2010, Serota professed that 'under Anna's leadership we aim to bring learning to the heart of what Tate does in the future.'[1] In a role encompassing all the learning processes within the gallery, cognitive dissonance in reaction to sponsors falls well within Cutler's turf. Curators like Penelope Curtis, director of Tate Britain and curator of a *BP Walk Through British Art*, shape how artworks from the collection are presented and how visitors experience the gallery, and could therefore choose to exercise influence over oil sponsors' logos in the space.

The fund-raising team's vital work does not occur without careful consideration of possible funding sources: not all sources of funding are welcome. Development officers draw ethical lines daily and one day oil will fall outside that line. Press and media departments deliver stories according to the public relations strategies agreed by the organisation. For these staff members there is an opportunity to present climate leadership positively by stepping away from oil sponsorship. Contracted staff employed by art museums' subsidiaries are equally invested in the policy of the galleries they work in and have possible recourse through trade unions. Gallery invigilators are the face and voice of the institution to the visiting public. Their particular experience of cognitive dissonance when paying lip service to sponsors they abhor could catalyse resistance within the institutional staff body.

At the 2013 Tate Members' annual general meeting Bridget McKenzie – a previous Tate learning department employee of ten years – Jamie Kelsey-Fry and Sunniva Taylor delivered their decision to resign as members because of BP, saying on behalf of fifteen members in total who felt compelled to boycott:

> We can no longer justify to ourselves being members of an organisation that is in bed with BP – an oil corporation whose very business model is reliant on destroying the climate, and thus life on earth as we know it.[2]

Visitors and members who shape galleries through various feedback mechanisms, are the audience body that give the BP Ensemble purpose, and in the case of members, offer funds for specific purchases. Their perspective is crucial. The artists – from those with work in the collection, to those with new commissions or events, all the way to the volunteer performers or assistants – whose art and labour give galleries life, may feel inhibited up to the final hurdle to raise their voice against the sway of an institution on whom their success or survival is dependent. Artists like Raoul Martinez, Matthew Herbert and Sonia Boyce speak out to defend the ethical character of their own community and sphere of existence. For many, the pressure to toe the line and preserve support within the art establishment is silencing. Where public figures in theatre, such as Caryl Churchill and Mark Ravenhill, have been outspoken on the issue, equally notable figures in the visual arts community have been less vociferous. Art galleries are currently significantly more splattered with oil sponsorship than theatres and visual artists may fear that speaking out could put relationships across the cultural estate at stake.

All these groups of artists, members, staff, cultural workers in the field, art history students, tourist gallery-goers, journalists, departmental officials, together make up part of a broader community of stakeholders that is fundamental to the being of the art museum, without whom there is no such thing. Each can query the ethics of the institution body of which they are part, via unions, members' boards, and by using other strategies of their own concoction. And likewise, the organisation has no choice but to move if and when the mood of its community reaches a tipping point.

Merely artwash

The position of an oil company is specifically precarious in a post-modern world of jostling economies, environmental regulations and wars that have cost elections. In her book charting the entire history of petroleum, Sonia Shah closes by saying: 'The end of oil's story is still being written, but it is clear that the conclusion nears. Much will

depend on how a thousand other stories end.'[3] One of those stories is cultural sponsorship, and the signs of a growing lack of acceptance of Big Oil can be seen clearly in products of popular culture today. Pop culture has always had an interchange with the high culture housed at Tate and other galleries, but by definition it offers a more cohesive temperature check on coming cultural shifts than the more conservation-focused museums are able to provide.

The 2011 *Muppet Movie* was met with fierce criticism by Fox news commentators, who reacted to the positioning of oil tycoon Tex Richman as the film's villain. Hollywood was accused of promoting liberal, anti-corporate, anti-oil politics. The oil executives in the playful children's story came with requisite 'baddie' pantomime cackles, and the mission of the Muppets is to overcome these enemies to save their theatre, underneath which the oil men want to drill. Whatever the film-maker's political intentions, the movie capitalises on a new version of the evil antagonist as provided by oil executives like Tony Hayward making catastrophic errors in the eyes of, primarily, the American public. The physical risk to the Muppets' theatre neatly mirrors the conceptual conflict between art and Big Oil.

In 2014 The LEGO Movie followed suit: the villain President Business was head of an oil company and his evil plan involved freezing creativity and play. The message was muddled by LEGO's concurrent co-promotion with Shell in which sixteen million Shell-branded toys made their way into playrooms around the world via Shell petrol stations, and following Greenpeace's creative tactics highlighting this contradiction in the same year as the film's release, LEGO ended the contract with Shell. The 2010 film Avatar tells a story analogous to struggles against Big Oil by frontline communities in Colombia, West Papua and Alberta, Canada – to name but a few sites of ecological destruction where fossil fuel companies have harmed the Indigenous Peoples' lives and livelihoods. Again, the fight to save a sacred site is fought against corporates who want to mine and drill the land.

These stories are taken up by film-makers and greeted warmly in the pop-cultural landscape not because of a political agenda as the Fox commentators fear. The widespread conviction in such narratives signifies a shift that has already taken place: that despite everyday

consumption of oil and its products, there is a tangible popular critique of extractives and their methods. Whether or not oil remains embedded within post-industrial cultures, it has still become precarious in its social acceptance as neutral or benign.

Even critiques of oil sponsorship have been replicated in pop culture. Anna and my performance as Toni and Bobbi described in Chapter 6 was reincarnated in a 2012 episode of Channel Four sitcom 'Fresh Meat' – the costumes were somewhat improved with a quick-release cord sewn into the actor's dress for easy spilling. The episode focused on an oil company's attempt to recruit undergraduates as part of their mission to gain the confidence of a new generation, a topic mirrored by BP's endeavours to integrate itself into the secondary school science curriculum. The sitcom closes with the performance as a rejection of the oil company and the wrongs associated with its operations. The critical chorus has expanded from famous artists and playwrights to A-list celebrities: in a BBC Radio 4 interview, actress Emma Thompson said 'Tate is sponsored by BP, these companies bury themselves into our culture, they must be challenged.'

The feeling of precariousness oil companies experience on the precipice of popular critique is replaced by a sense of security in being embedded at the cultural foundations of the nation. The British Museum, Tate, The National Gallery and the Royal Opera House all now carry the emblems of BP and Shell, situating the companies as part of the establishment and as part of culture at the start of a new millennium. This comfortable support may soon dissipate however. Just as pop-cultural signs herald a shift in public acceptance of Big Oil, a global campaign to mobilise investors and shareholders in major oil corporations has emerged that similarly stigmatises oil through the financial tentacles of the industry. So far fourteen universities in the USA and Europe have committed to divest their shareholdings in fossil fuel companies – millions of pounds worth of investments – big hitters include Glasgow University and Stanford. Cities, foundations and religious institutions are signing up too. The fossil fuel divestment movement demonstrates the lack of support among the sector that is perhaps most intertwined with the oil economy's survival. When one pound in every seven in pension pots goes to BP, it has significant

ramifications for pension providers to consider divesting from oil. Desmond Tutu pointed out the valuable similarities between the campaign to divest and movements to end oil sponsorship, saying:

> We need an apartheid-style boycott to save the planet. People of conscience need to break their ties with corporations financing the injustice of climate change. We can, for instance, boycott events, sports teams and media programming sponsored by fossil-fuel energy companies. We can encourage more of our universities and municipalities and cultural institutions to cut their ties to the fossil-fuel industry.[4]

The picture he paints is one version of the story of how oil ends that Sonia Shah predicted. The ending is now being written, in art, action, performances and intervention.

Signs of change

Chin-tao Wu challenged that an international movement was necessary to address the problems associated with corporate sponsorship of the arts. Her projection was quietly optimistic:

> Signs of impending strain and rupture within the system are admittedly few and far between, but it may well be that one day sites of resistance form to question and challenge what for the present remains the dominant order.[5]

With the emergence of groups like G.U.L.F., Stopp Oljesponsing av Norsk Kulturliv and Art Not Oil, Wu's premonition seems to have come to pass. The various interventions, protests and public statements that have been made in opposition to oil sponsorship have started to tip the balance. As the movement opening these 'sites of resistance' grows, so too does the possibility of revolutions in the art museum.

Even if not always intended as such, museums and galleries can still be claimed as democratic institutions. The Whitechapel Gallery opened

in 1901 with the sole purpose to 'bring great art to the people of the East End of London'.[6] The potentially paternalistic programme was later usurped for other purposes. In 1939 alongside the Stepney Trades Council, artist Roland Penrose of the English Surrealist movement – who was also a Quaker pacifist and prominent member of the anti-fascist Artists' International Association – organised the display of Picasso's *Guernica*. The painting told the horrors of the civil war and its exhibition raised money for the Spanish Republican government. Those involved swiftly made autonomous use of the Whitechapel as they saw fit and made it a recruiting post for the Republicans in the Spanish Civil War. Earlier exhibitions on the continent had raised money for Spanish Relief; here the price of admission was a pair of boots in a fit state to be sent to the Spanish front. When an art gallery is said to be for the people, there is no telling what they will do with it.

Picasso's *Guernica* has, of course, been connected to subsequent wars and moments in military history. As described in Chapter 6, the Guerrilla Art Action Group chose to hold a protest outside its exhibition at MoMA, New York, during the Vietnam War. *Guernica* prints have seen many sides of humanity: painted in 1937 and toured to mobilise against the fascist army in Spain, invoked as part of the call to end the attack on Vietnam, a copy now hangs outside the UN Security Council debating chamber. During the US and UK hijack of the official process to legitimise their invasion of Iraq a curtain was pulled over *Guernica* for the duration of the resolution meeting at the request of the US representatives. This darkly ironic act of blinkering revealed a fear of war, of accountability, of pacifism, and indeed of art. The artwork intervened in the process by its mere presence despite its redaction.

The political role for artists in shaping culture has long been debated. François Matarasso and David Batchelor engaged in a dialogue in which Matarasso rejected Batchelor's claim that 'artists have a responsibility to art, not to anything or anyone else', countering in *Freedom's Shadow* that:

> Far from being detached from any social or moral ties to the rest of humanity, artists live within a complex network of responsibilities. Some of these – arising from personal relationships or the condition of citizenship itself – are common to us all, but other issues emerge

from the responsibilities of the artist and the State to one another and the ethical framework within which artists work.[7]

Matarasso draws out a political and ethical role specific to the artist. In Batchelor's reply, he quotes Don Judd, 'Of course artists should oppose US involvement in Nicaragua just as dentists should.' This seems to miss Matarasso's point that artists have significantly more profile and influence in shaping culture and politics than dentists would ordinarily expect to have. Furthermore, what when the political battle in question is fought on the artist's territory, the gallery? Artists have a clear stake in the way in which their work and their inspirations are used for corporate gain.

Many artists make work to challenge oil culture. The African-American artist Ben Jones' collection of paintings *Thank You BP* has been exhibited globally, asking audiences to sit with the loss experienced by communities on the Gulf Coast following the BP disaster. As a monument to the Nigerian activists that were executed in 1995 following their protests against Shell, Nigerian-born British artist Sokari Douglas Camp made a sculpture called *The Battle Bus: A Living Memorial to Ken Saro-Wiwa*. Ruppe Kosselleck is a German visual artist who for over five years has collected the residue of oil spills found on beaches around the globe, and used it to make oil paintings. Kosselleck sells the artworks and uses the profits to buy shares in BP Plc – the entire project of heroic dedication and optimism is titled *Takeover BP*.

Visual artist, photographer and data visualisation designer Chris Jordan has explored numerous ways of viscerally communicating the devastation of oil as part of his *Counting the Numbers* series, which included a dizzying image of the fifty-one million barrels of oil consumed in the USA every minute. Russian artist Andrei Molodkin has been exhibited in the USA and Europe in a work confronting his own nation's relationship with oil. *Crude* was exhibited at a gallery in the oil state Texas that works specifically to build an artistic community critiquing the oil industry rather than uncritically co-existing.

The academic Viv Golding describes the changing kind of power represented by the modern museum:

I contend the museum has a part in a history of power. Museums have demonstrated the power of wealth and privilege – of the church, the king and the merchant since their inception. A new power – of the Nation and the citizen – can be traced to the establishment of the Louvre, to 'stand for the Republic and its ideal of equality'.[8]

It is the museum as the site of this power, of the citizen, that the founding of the Louvre so succinctly embodies, and that corporate sponsorship so casually undermines. Suggestions the corporate sponsor is neutral, or financially essential, or an innocuous figure – all are directly contradicted on a daily basis by oil sponsorship.

This undermining of democracy is echoed in corporate control of different public spaces, and in a tug of war between corporate practices of 'power over' that work against the idea of democratic public practices of 'power with'. Galleries and the state will continue to be moulded by corporates despite fundamental responsibility to the public, unless the public makes a challenge to this process. Where art for many is a sacred ground of reflection and expression, it has also become a battleground in a political war for corporate control in neoliberal democracies. When London hosted the Olympics, the Cultural Olympiad played a role in the displacement of homes, livelihoods and communities. Brisbane's municipal plans for the G20 to be held in the central business district in 2014 included an arts festival specifically designed to draw tourists and residents alike out of the exclusion zone, which dwellers would also be moved out of for the duration of the talks. The liberatory malleability of the arts can see them exploited by elites: the G20 will continue their talks undisturbed and dissent will be pushed out of an exclusion zone in a violent act that is made to look acceptable by the offering of art.

In the recent Tunisian uprisings, the wave of political action that ignited the Arab Spring of 2011, revolution was nurtured by activist artistic practices of iconoclasm against the existing political regime and the creation of a new political iconography to catalyse a new politics. Those in power manage art and culture in various insidious ways, but the people, too, use art to shape history. During the political protests around the meeting of the G8 in 2005, the feeling on the ground was one of being tightly stage-managed in a military drama of herding dissenting

cats. But by engaging in the performance of power it is possible to use art to rewrite the script in these moments. Art interventions in gallery spaces with the intention of evicting oil sponsors, challenging the ethics of the art museum and confronting racism and sexism in the art world are one creative act among many that seek to build real democracies and perform the power of the people. In the face of Big Oil's artwash, the arts are being reclaimed to confront corporate power.

Notes

1. Introduction

1. Wendy Stephenson, quoted in Farah Nayeri, 'Europe's Corporate Art Sponsors Seek More Bang for Their Bucks', *Bloomberg*, 3 March 2005.
2. Paul Bignell, 'Secret memos expose link between oil firms and invasion of Iraq,' *Independent*, 19 April 2011.
3. Mika Minio-Paluello, '"Heritage called in the cavalry" – investigation reveals oil company's role in Congo killings', *Platform*, 21 May 2012.
4. Mika Minio-Paluello, 'Oil companies provide equipment to military in Congo', *Platform*, 5 January 2010.
5. Ben Amunwa, *Counting the Cost*, London: Platform, 2011, p. 6.
6. Mohammed Mosaddegh, quoted in 'Mosaddegh's speech at the Hague (June 1951)', *Iran Review*, 8 June 2014.
7. Naomi Klein, 'Climate change is the fight of our lives – yet we can hardly bear to look at it', *The Guardian*, 23 April 2014.
8. Tina Mermiri, 'The Transformation Economy', in *Beyond experience: culture, consumer & brand*, London: Arts & Business, 2009, p. 15.
9. William Shakespeare, *As You Like It*, 1623.
10. DCMS Public Bodies Directory 2010: Information and Statistics.

2. Big Oil's artwash epidemic

1. Chin-tao Wu, *Privatising Culture: Corporate Art Intervention Since the 1980s*, London: Verso, 2002, p. 168.
2. Consultation on the Tobacco Advertising and Promotion regulations, Action on Smoking and Health, 2002.
3. 'Artist protest forces BAT to withdraw sponsorship', Press release, Action on Smoking and Health, 19 September 2003.
4. Consultation on the Tobacco Advertising and Promotion regulations, Action on Smoking and Health, 2002.
5. Jamie Doward, 'Ferrari-Marlboro F1 sponsorship deal provokes anger of the health lobby', 3 July 2011.

6. Patrick Steel, 'Money Talks', *Museums Journal*, Issue 106/5, May 2006, pp. 30–33.

7. Chin-tao Wu, *Privatising Culture: Corporate Art Intervention Since the 1980s*, London: Verso, 2002, p. 150.

8. Trish Carn, 'Finmeccanica and National Gallery part company early', *The Friend*, 18 October 2012.

9. Alice Oswald, quoted in William Skidelsky, 'Should the arts be selective about sponsors?', *The Guardian*, 10 December 2011.

10. Liberate Tate, 'Statement of support for the artists' Boycott the Sydney Biennale – end the Transfield sponsorship', www.liberatetate.wordpress. com, 20 February 2014.

11. Patrick Steel, 'Ethical Debate: Sponsorship', Museums Association, www. museumsassociation.org

12. 'Greenpeace protest disrupts Basel v FC Schalke 04 Champions League match', *The Guardian*, 2 October 2013; 'Greenpeace's Gazprom protest disrupts Real Madrid's Champions League conference', *The Guardian*, 10 December 2013; 'Greenpeace activists hid three days inside Lisbon stadium', *The Portugal News*, 24 May 2014.

13. Ingrid Hovland Holm, 'Friske vibber med oljepenger', *Bergens Tidende*, 5 April 2014.

14. Maja Kjelstrup Ratkje, 'Lettkjøpt dilemma?', *Morgenbladet*, 17 July 2014.

15. Synne Øverland Knudsen, quoted in Mari Brenna Vollan, 'Sier nei til oljeselskaper', *Klassekampen*, 17 July 2014. Translation: Sarah Keenan.

16. Ragnhild Freng Dale, 'Statoil ends music sponsorship after growing controversy in Norway', www.platformlondon.org, 16 December 2013.

17. Clemens Bomsdorf, 'Astrup Fearnley Museum criticised over oil company sponsorship', *The Art Newspaper*, 22 November 2012.

18. Frans Josef Petersson, 'Critical Collapse at Tensta Konsthall', *Kunstkritik*, 28 Febraury 2012.

19. Lisa Abend, 'Was a Swedish firm complicit in Sudan's war?', *Time*, 4 July 2010.

20. www.shelltosea.com

21. Mel Evans, 'Musicians react to oil sponsorship of the arts', www. platformlondon.org, 1 October 2013.

22. Fleadh Cheoil na hÉireann Press Release, 6 August 2014.

23. 'Statement from Godspeed You! Black Emperor on Polaris', *Constellation*, www.cstrecords.com

24. Stephanie Britton and Prof. Pat Hoffie (eds), 'Mining: Gouging the Country', *Artlink: Contemporary Art of Australia and the Asia-Pacific*, Vol. 33, No. 4, Artlink Australia, South Australia, 2013.

25. Charmaine Green, 'Breaking my country's heart'in Stephanie Britton and Prof. Pat Hoffie (eds), 'Mining: Gouging the Country', *Artlink: Contemporary*

Art of Australia and the Asia-Pacific, Vol. 33, No. 4, Artlink Australia, South Australia, 2013, pp. 34–35.

26. Daryl Passmore, 'Anti-mining and resources group Generation Alpha threaten Cai Guo-Qiang exhibition at GOMA due to Santos sponsorship', *The Courier Mail*, 12 March 2014.

27. Incite! Women of Color Against Violence (eds), *The Revolution Will Not Be Funded: Beyond the Non-Profit Industrial Complex*, Cambridge, MA: South End Press, 2007, p. 4.

28. Keith Spera, 'Dr. John clarifies his position on Shell, Jazz Fest and Louisiana's wetlands', *The Times-Picayune*, 15 April 2009.

29. Ibid.

30. 'Diaghilev's Groundbreaking Ballets Russes to be Showcased at National Gallery of Art', National Gallery of Art Press Release, 11 January 2013.

31. Mike Boehm, 'LACMA given $25-million gift', *Los Angeles Times*, 6 March 2007.

32. See platformlondon.org for the work of Ben Amunwa, Benjamin Diss, Mel Evans, Anna Galkina, Emma Hughes, James Marriott, Mika Minio-Paluello, Greg Muttitt, Andy Rowell, Sarah Shoraka, Kevin Smith, Lorne Stockman and Jane Trowell.

33. Doreen Massey, *World City*, London: Polity, 2007.

34. 'BP goes green', *BBC News*, 24.7.00; Caroline Davies and Michael Paterson, 'BP attacked over £136m logos petrol prices soar', *The Telegraph*, 25 July 2000.

35. 'BP brand and logo', www.bp.com

36. Chin-tao Wu, *Privatising Culture: Corporate Art Intervention Since the 1980s*, London: Verso, 2002, p. 139.

37. Emma Hughes, *Making a Killing: Oil Companies, Tax Avoidance and Subsidies*, London: Platform, 2013, p. 3.

3. Capital and culture

1. Jennie Lee, quoted in Christopher Frayling, *The Only Trustworthy Book: Art and Public Value*, Arts Council England, 2005, p. 15.

2. Chin-tao Wu, *Privatising Culture: Corporate Art Intervention Since the 1980s*, London: Verso, 2002. p. 143.

3. '1970s and 1980s', History of the Arts Council, www.artscouncil.org.uk (accessed January 2014).

4. Chin-tao Wu, *Privatising Culture: Corporate Art Intervention Since the 1980s*, London: Verso, 2002, p. 65.

5. Andy C. Pratt, 'Mapping the cultural industries; regionalisation; the example of south-east England', in Dominic Power and Allen J. Scott, (eds), *Cultural industries and the production of culture*, London: Routledge, 2004, pp. 19–36.

6. Chin-tao Wu, *Privatising Culture: Corporate Art Intervention Since the 1980s*, London: Verso, 2002, p. 276.

7. Paul Keating, 'Transcript of ALP Cultural Policy Launch', State Theatre, Sydney, 28 February 1993.

8. UK Department for Trade and Industry Our Competitive Future: Building the Knowledge Economy, 1998.

9. François Matarasso, *Use or Ornament?: The social impact of participation in the arts*, Stroud: Comedia, 1997, at www.demandingconversations.org.uk/wp-content/uploads/2010/08/Use-or-Ornament.pdf (accessed 4 December 2014).

10. Bridie Jabour, 'George Brandis threatens Sydney Biennale over Transfield 'blackballing', *The Guardian*, 13 March 2014.

11. Bruce Cheadle, 'Museum of Civilisation Taps Big Oil to help fund Canada's 150th Birthday', *Huffington Post*, 25 November 2013.

12. Hannah Furness, 'Tate Modern announces largest ever sponsorship deal for Turbine Hall', *The Telegraph*, 20 January 2014.

13. 'Protesters foul Tate Britain over BP art sponsorship', *BBC News*, 29 June 2010.

14. Tate Gallery Review 1938–53, p. 9.

15. Tate Annual Report 1984–86, p. 7.

16. Tate Annual Report 1986–88, p. 22.

17. Des Volaris, in 'Meet Des Volaris', *YouTube*, www.youtube.com/watch?v=a6IhxSLzlWg at 1:03 (accessed 4 December 2014).

18. Nicholas Serota, Tate Members' Annual General Meeting, 7 December 2013.

19. Andrew Taylor, 'Arts chiefs warn of the dangers of private money', *Sydney Morning Herald*, 2 December 2013.

20. Chin-tao Wu, *Privatising Culture: Corporate Art Intervention Since the 1980s*, London: Verso, 2002, p. 138.

21. Tate Annual Accounts 2012–13, p. 46.

22. Tate Annual Report 1958–59, p. 2.

23. Chin-tao Wu, *Privatising Culture: Corporate Art Intervention Since the 1980s*, London: Verso, 2002, p. 139.

24. Stephen Wingfield, Financial Review, Tate Members AGM presentation, 6 December 2013.

25. Emma Mahony, interview, September 2013.

26. Terry Macalister, 'Budget 2012: oil and gas industry gets £3bn tax break to encourage drilling', *The Guardian*, 21 March 2012.

27. Naomi Klein, 'The Brand Expands: How the Logo Grabbed Center Stage' in *No Logo: Taking Aim at the Brand Bullies*, London: HarperCollins, 2001, p. 35.

28. John Browne, *Desert Island Discs*, BBC Radio 4, 7 July 2006.

29. Ibid.

30. Patrick Steel, 'Ethical Debate: Sponsorship', Museums Association, www.museumsassociation.org

31. 'Ethical Fundraising Risk Management statement', The National Gallery, June 2012.

32. 'Tate Ethics Policy', Tate, March 2014.

33. Tate Ethics Committee meeting minutes, May 2010.

34. Nick Allen, 'Gulf of Mexico oil slick could increase 12 fold', *The Telegraph*, 6 May 2010.

35. Douglas Brinkley, 'Gulf oil spill threatens wildlife reserve created by Roosevelt', *The Guardian*, 6 May 2010.

36. Suzanne Goldenberg, 'Just 90 companies caused two-thirds of man-made global warming emissions', *The Guardian*, 20 November 2013.

4. *Discrete logos, big spills*

1. 'BP Portrait Award 2014 Competition Opens as BP Shows its Support for 25th Year', BP Press Release, 3 December 2013.

2. 'Trouble on oiled waters', *The Economist*, 20 July 2010.

3. *The Guardian* quoted in 'BP CEO apologises for "thoughtless" oil spill comment', *Reuters*, 2 June 2010.

4. Ibid.

5. Erin Delmore, 'Four years on, animals dying in record numbers from BP spill', *MSNBC*, 9 April 2014.

6. Tony Hayward, in 'BP CEO Tony Hayward (VIDEO): "I'd like my life back"', *Huffington Post*, 1 June 2010.

7. 'BP CEO apologises for "thoughtless" oil spill comment', *Reuters*, 2 June 2010.

8. Tim Webb, 'BP boss Hayward faces Senate grilling live on US TV', *The Observer*, 13 June 2010.

9. Kristina Cooke and Joshua Schneyer, 'New York Fed probes Wall Street exposure to BP', *Reuters,* 28 June 2010.

10. Anonymous asset manager, in interview with Platform.

11. Tony Hayward, quoted in 'Tony Hayward: BP not prepared for fallout, was on financial brink', *CNN*, 9 November 2010.

12. Steven Mufson, 'BP settles criminal charges for $4 billion in spill; supervisors indicted on manslaughter', *The Washington Post*, 15 November 2012.

13. 'BP's record $4bn Deepwater criminal penalties approved', *BBC News*, 29 January 2013.

14. Emily Godsen, 'BP warns Gulf spill costs will exceed $42.4bn as compensation costs rise', *The Telegraph*, 30 July 2013.

15. Ed Crooks, 'BP challenges $18 billion Deepwater Horizon ruling', *Financial Times*, 3 October 2014.

16. Alte Christer Christiansen, 'Beyond Petroleum: Can BP deliver?', Lysaker: Fridtjof Nansens Institutt, FNI Report 6/2002, p. 3.

17. 'Support for BP tar sands resolution', *Ethical Consumer*, 15 April 2010 (accessed 4 December 2014).

18. 'Canada's Toxic Tar Sands: The most destructive project on earth', Toronto, ON: Environmental Defence, February 2008.

19. 'United Nations Declaration on the Rights of Indigenous Peoples', *Indigenous Environmental Network*, 13 September 2007.

20. 'Tar Sands', *Indigenous Environmental Network*, ienearth.org

21. Robert Verkaik, 'BP pays out millions to Colombian farmers', *The Independent*, 22 July 2006.

22. Ibid.

23. Diane Taylor, 'BP faces damages claim over pipeline through Colombian farmland', *The Guardian*, 11 November 2009.

24. 'Colombia', *Leigh Day*, www.leighday.co.uk/International-and-group-claims/Colombia

25. Diane Taylor, 'BP faces damages claim over pipeline through Colombian farmland', *The Guardian*, 11 November 2009.

26. Leigh Day Solicitors, International and Group Claims, Colombia.

27. Claire Hall, 'Brutish Petroleum', *New Internationalist*, 1 July 2010.

28. Ibid.

29. Quote previously on BP.com/Colombia, since removed and re-quoted at http://capacity-training-international.com/2012/03/22/a-security-and-human-rights-legacy-in-colombia/ (Previous address: www.bp.com/en/global/corporate/sustainability/society/case-studies/a-security-and-human-rights-legacy-in-colombia.html – accessed 12 November 2013).

30. 'The Baku Ceyhan Campaign', *Platform*, carbonweb.org

31. Heather Stewart, 'BP failed to act on reports of intimidation along Turkish pipeline', *The Guardian*, 9 March 2011.

32. Terry Macalister and Richard Wachman, 'British oil companies and banks in limbo over Egypt protests', *The Guardian*, 4 February 2011.

33. Terry Macalister, 'Activists accuse Britain of "gas grab" in Algeria despite human rights abuses', *The Guardian*, 9 February 2014.

34. Ed Pilkington, 'Shell pays out $15.5m over Saro-Wiwa killing', *The Guardian*, 9 June 2009.

35. Shell Annual Report, 1996.

36. Tom Henderson and John Williams, 'Shell: managing a corporate reputation', in Barbara DeSanto and Daniel Moss (eds), *Public Relations Cases*, London: Routledge, 2002, p. 12.

37. Ibid., p. 13.

38. Ibid., p. 15.

39. Ibid., p. 19.

40. Ibid., p. 20.

41. Ibid., p. 22.

42. Anna Galkina, *Arctic Anxiety*, Platform, 2011, p. 8.

43. 'UNEP Ogoniland Oil Assessment Reveals Extent of Environmental Contamination and Threats to Human Health', United Nations Environment Programme, 4 August 2011.

44. 'Litigation continues as "deeply disappointing" Nigerian oil spill talks collapse', *Leigh Day*, 13 September 2013.

45. Robert Boutilier, Leeora Black and Ian Thomson, 'From metaphor to management tool – How the social license to operate can stabilise the socio-political environment for business', in *Proceedings International Mine Management 2012*, Melbourne: The Australasian Institute of Mining and Metallurgy, 2012, pp. 227–38.

46. Robert Boutilier and Ian Thomson, *Modelling and Measuring, The Social Licence to Operate: fruits of a dialogue between theory and practice*, Brisbane: Social Licence to Operate Symposium, 2011, p. 2.

47. Ibid., p. 2.

48. Charlotte Higgins, 'Is the Cultural Olympiad a runner?' *The Guardian*, 25 March 2009.

49. Elizabeth Mitchell, 'Olympic ads boost brand perceptions for BP and others', *PRNewser*, 9 August 2012.

50. Robert Boutilier and Ian Thomson, *Modelling and Measuring, The Social Licence to Operate: fruits of a dialogue between theory and practice*, Brisbane: Social Licence to Operate Symposium, 2011, p. 5.

51. Leeora Black, *The Social Licence to Operate: Your Management Framework for Complex Times*, Oxford: Do Sustainability, 2013, p. 60.

52. Ibid.

53. Ibid.

54. Boutilier and Thomson, *Modelling and Measuring*, p. 9.

55. Ibid., p. 17.

56. Ibid., p. 9.

57. Jason Koebler, 'Local protesters are killing big oil and mining projects worldwide', *Motherboard (Vice)*, 12 May 2014.

58. James Marriott, and Mika Minio-Paluello, *The Oil Road: Journeys from the Caspian Sea to the City of London*, London: Verso, 2012, p. 7.

59. Alex Carey, *Taking the Risk out of Democracy: Corporate Propaganda versus Freedom and Liberty*, Champaign, IL: University of Illinois Press, 1997, p. 18.

60. Rena DeSisto, quoted in Peter Aspden, 'Arts Leaders fear cuts in regions', *The Financial Times*, 30 July 2010.

61. Wendy Stephenson, quoted in Farah Nayeri, 'Europe's Corporate Art Sponsors Seek More Bang for Their Bucks', *Bloomberg*, 3 March 2005.

62. Pierre Bourdieu and Hans Haacke, *Free Exchange*, London: Polity Press, 1995, p. 8.

63. Nicholas Serota, quoted in Julia Weiner, 'Interview: Nicholas Serota', *The Jewish Chronicle*, 8 July 2010.

64. Chris Blackhurst, 'Stop putting the boot in BP – we need it to survive', *The Evening Standard*, 3 June 2010.

65. Andreas Whittam Smith, 'BP's success is a national concern', *The Independent*, 4 June 2010.

66. Boris Johnson, quoted in Nicola Boden, 'Cameron at odds with Tories as he refuses to back BP', *The Daily Mail*, 14 June 2010.

67. Chin-tao Wu, *Privatising Culture: Corporate Art Intervention Since the 1980s*, London: Verso, 2002, p. 9.

68. Pierre Bourdieu and Hans Haacke, *Free Exchange*, London: Polity Press, 1995, p. 18.

69. Chin-tao Wu, *Privatising Culture: Corporate Art Intervention Since the 1980s*, London: Verso, 2002, p. 11.

70. bex, 'BP and the oilier side of arts sponsorship', *Greenpeace* blog, 2 July 2010, at: www.greenpeace.org.uk/blog/climate/bp-and-oilier-side-arts-sponsorship-20100702 (accessed 4 December 2014).

71. Chin-tao Wu, *Privatising Culture: Corporate Art Intervention Since the 1980s*, London: Verso, 2002, p. 140.

72. William Hazlitt, quoted in Scott Hess, *William Wordsworth and the Ecology of Authorship: The Roots of Environmentalism in Nineteenth-Century Culture*, Charlottesville, VA: University of Virginia Press, 2012.

73. Brian O'Doherty, *Inside the White Cube: The Ideology of the Gallery Space*, Berkeley, CA: University of California Press, 1999, p. 14.

74. Ibid.

75. 'V&A (Victoria & Albert Museum)', *Art Fund*, artfund.org

76. Colin Tweedy, quoted in Homa Khaleeli, and Emine Saner, 'Crude awakening', *The Guardian*, 30 June 2010.

77. James H. Gilmore, B. Joseph Pine II and Tina Mermiri, *Beyond experience: culture, consumer & brand*, London: Arts & Business: 2009.

78. James Gilmore and Joseph Pine II, *Authenticity: What consumers really want*, Boston, MA: Harvard Business School Press, 2007.

79. James H. Gilmore, B. Joseph Pine II and Tina Mermiri, *Beyond experience, Executive Summary'*, p. 5.
80. James H. Gilmore and B. Joseph Pine II, 'Using art to render authenticity in business', in Tina Mermiri (ed.), *Beyond experience: culture, consumer & brand*, Arts & Business, 2012, p. 6.
81. Tom Henderson and John Williams, 'Shell: managing a corporate reputation', in Barbara DeSanto and Daniel Moss (eds), *Public Relations Cases*, London: Routledge, 2002, p. 19.
82. Tina Mermiri, 'The transformation economy', in *Beyond experience: culture, consumer & brand*, London: Arts & Business, 2009, p. 15.
83. Ibid., p. 14.
84. Ibid., p. 33.
85. James H. Gilmore, B. Joseph Pine II and Tina Mermiri, 'Executive Summary' in *Beyond experience: culture, consumer & brand*, p. 7.
86. Tina Mermiri, 'The transformation economy', in *Beyond experience: culture, consumer & brand*, London: Arts & Business, 2009, p. 13.
87. James H. Gilmore and B. Joseph Pine II, 'Using art to render authenticity in business', in Tina Mermiri (ed.) *Beyond experience: culture, consumer & brand*, London: Arts & Business, 2009, p. 5.
88. Tina Mermiri, 'The transformation economy', in *Beyond experience: culture, consumer & brand*, London: Arts & Business: 2009, p. 15.
89. James H. Gilmore and B. Joseph Pine II, 'Using art to render authenticity in business', Tina Mermiri (ed.) in *Beyond experience: culture, consumer & brand*, London: Arts & Business: 2009, p. 5.
90. Jean Baudrillard, *Simulacra and Simulation*, Ann Arbor, MI: University of Michigan Press, 1994, p. 7.
91. Pierre Bourdieu, *Free Exchange*, London: Polity Press, 1995, p. 54.
92. Jean Baudrillard, *Simulacra and Simulation*, Ann Arbor, MI: University of Michigan Press, 1994, p. 6.
93. Ibid., p. 7.
94. Hans Haacke, *Free Exchange*, London: Polity Press, 1995, p. 37.
95. Mark Fisher, *Capitalist Realism: Is There No Alternative?*, London: O Books, 2009, p. 4.

5. *The impact of BP on Tate: an unhappy context for art*

1. Grayson Perry, quoted in Charlotte Higgins, 'Is the Cultural Olympiad a runner?' *The Guardian,* 25 March 2009.
2. Grayson Perry, quoted in Homa Khaleeli and Emine Saner, 'Crude awakening', *The Guardian*, 30 June 2010.

3. 'The British Museum: Funding Agreement 2008–11', The British Museum.

4. 'The National Gallery: Funding Agreement 2008–11', The National Gallery.

5. DCMS Public Bodies Directory 2010: Information and Statistics.

6. Helen Little, @HelenLittle3, *Twitter*, twitter.com, November 2012.

7. Iwona Blazwick, 'Temple / White Cube / Laboratory', in Paula Marincola (ed.), *What makes a Great Exhibition?*, Chicago, IL: University of Chicago Press, 2007, p. 118.

8. Iwona Blazwick and Francis Morris, 'Showing in the Twentieth Century', in Iwona Blazwick and Simon Wilson, *Tate Modern: the Handbook*, Tate, London, 2006, p. 31.

9. Nicholas Serota, *Experience or Interpretation: the Dilemma of Museums of Modern Art*, London: Thames and Hudson, 1996, p. 42.

10. Ibid., p. 55.

11. Barry Schwabsky, 'Foreword', in Carolee Thea, *Foci: Interviews with ten international curators*, Apexart Curatorial Program, 2001, p. 9.

12. Leon Festinger, *A Theory of Cognitive Dissonance*, Stanford, CA: Stanford University Press, 1957, p. 3.

13. Saabira Chaudhuri, 'Public Eye award singles out mining company Vale, Barclays', *The Guardian*, 27 January 2012.

14. Boff Whalley, 'The Painting, the Tate and the Oil Company', boffwhalley.com, 8 September 2013.

15. Jo Clarke, Mel Evans, Hayley Newman, Kevin Smith and Glen Tarman (eds), *Not if but when: Culture Beyond Oil*, London, Platform and Liberate Tate, 2011.

16. Richard DeDomenici, @DeDomenici, *Twitter*, twitter.com, April 2014.

17. Hans Haacke, *Free Exchange*, London: Polity Press, 1995, pp. 98–99.

18. Iwona Blazwick and Francis Morris, 'Showing in the Twentieth Century', in Iwona Blazwick and Simon Wilson, *Tate Modern: the Handbook*, Tate, London, 2006, p. 35.

19. Ibid.

20. Victoria Walsh, 'Tate Britain: Curating Britishness and Cultural Diversity', *Tate Encounters [E]dition 2*, Tate Publishing, 2008, p. 2.

21. Emily Pringle, 'The Artist, the Gallery, the Art and Learning: Negotiating Theory to Understand Practice', in *Exchange: Artists, Young People and Galleries*, engage, no. 27, London 2011, pp. 50–60.

22. Emma Mahony, interview, September 2013.

23. Mel Evans, 'Canadian museum accepts oil sponsor despite censorship', *Platform*, 2 December 2013.

24. Chris Drury, quoted in Jim Robbins, 'Coal themed sculpture annoys lawmakers', *New York Times*, 21 July 2011.

25. Marion Loomis, quoted in Andrew Michler, 'Chris Drury's "Carbon Sink" art installation strikes nerve of Wyoming Coal Industry', *Wyoming Arts*, 27 July 2011.

26. Jude Kelly, *Conference Report: Taking the Offensive*, by Dany Louise, 2013.

27. Amber Hickey, 'Beyond Reflection: Radical pedagogy and the ethics of art sponsorship', *ArtLeaks Gazette*, May 2013.

28. 'The politics of the social in contemporary art', symposium at Tate Modern, 15 February 2013, tate.org.uk

29. 'Live Culture', exhibition at Tate Modern, Tate Modern: Exhibition, 27–30 March 2003, tate.org.uk

30. Carolee Thea, *Foci: Interviews with ten international curators*, Apexart Curatorial Program, 2001, p. 14.

31. Bird La Bird, 'Presenting Pomp: How did the magnificent PR machine of historic Royal Court portraiture reinforce class structure before the 20th Century?', birdlabird.co.uk, 29 June 2012.

32. 'Tate aims to increase ethnic minority visitors', *Art Newspaper*, July–August 2007, p. 13.

33. 'The Stephen Lawrence Inquiry: Report of an inquiry by Sir William Macpherson of Cluny'. Advised by Tom Cook, the Right Reverend Dr John Sentamu, Dr Richard Stone. Presented to Parliament by the Secretary of State for the Home Department by Command of Her Majesty, February 1999.

34. Viv Golding, *Learning at the Museum Frontiers: Identity, Race and Power*, Farnham: Ashgate, 2009.

35. Ibid., p. 6.

36. Ibid., p. 5.

37. Ibid., p. 4.

38. Ibid., p. 6.

39. Ibid., p. 7.

40. Clayton Thomas Mueller, 'BP Overwhelmed by Criticism at AGM,' UK Tar Sands Network, www.no-tar-sands.org, 15 April 2011.

41. Andrew Dewdney, David Dibosa and Victoria Walsh, *Post-critical Museology: Theory and practice in the art museum*, Abingdon: Routledge, 2013, p. 233.

42. Ibid., p. 81.

43. Ibid., p. 80.

44. 'As a result of BP/CNPC's renegotiations in 2009, the Iraqi government is obliged to pay the companies at the rate they bid, even if OPEC/oil market considerations or infrastructure constraints prevent them actually delivering those levels of production. So from the companies' perspective it doesn't matter whether their target rates are achievable or not; they get paid anyway.' Greg Muttitt, 'From glass box to smoke-filled room', www.fuelonthefire.com, 2 September 2011; 'The fact that throughout 2006 and 2007, tied to the "Surge", the Bush administration was demanding the Iraqis pass a law to let Big Oil take the lion's share.' Greg Muttitt, 'A response to Greg Palast's blood-for-no-oil theory', www.fuelonthefire.com,

2 September 2011; 'As Shell put it in a meeting with the British government in 2006, the Iraqi resource was so large that there was "room for everyone". In other words, they didn't need to compete, as each company could go for a different piece of Iraq.' Greg Muttitt, 'The fourth Iraqi oil auction', www.fuelonthefire.com, 15 April 2011.

45. Greg Muttitt, 'What the Chilcott Inquiry has missed: the role of oil in the war', www.fuelonthefire.com, 3 May 2011.

46. Edward Said, 'Preface (2003)' in *Orientalism*, London: Penguin, 2003, pp. xv–xvi.

47. Andrew Dewdney, David Dibosa, and Victoria Walsh, *Post-critical Museology: Theory and practice in the art museum*, Abingdon: Routledge, 2013, p. 67.

48. 'History of Tate: Sir Henry Tate', Tate website, The National Archives, http://webarchive.nationalarchives.gov.uk/20080910120230/http://www.tate.org.uk/about/theorganisation/history/henry-tate.shtm (accessed 4 December 2014).

49. Catherine Hall, 'Britain's massive debt to slavery', *The Guardian*, 27 February 2013.

50. University College London, 'Legacies of British Slave-ownership', www.ucl.ac.uk/lbs

51. James Marriott, Andy Rowell and Lorne Stockman, *The Next Gulf: London, Washington and Oil Conflict in Nigeria*, London: Constable, 2005, p. 43.

52. Ibid., p. 261.

53. Ibid., pp. 45–56.

54. Andrew Dewdney, David Dibosa and Victoria Walsh, *Post-critical Museology: Theory and practice in the art museum*, Abingdon: Routledge, 2013, p. 24.

55. Frances Spalding, *The Tate: A History*, London: Tate Gallery Publishing, 1998, p. 225.

56. Ibid.

57. Andrew Dewdney, David Dibosa and Victoria Walsh, *Post-critical Museology: Theory and practice in the art museum,* Abingdon: Routledge, 2013, p. 25.

58. Doreen Massey, 'Bankside Local International', in Iwona Blazwick and Simon Wilson (eds), *Tate Modern: The Handbook*, Berkeley, CA: University of California Press with Tate Gallery Publishing Limited, pp. 24–27.

59. Ibid.

6. *Opposition to oil sponsorship and interventions in gallery spaces*

1. Jonathan Jones, 'Slick art sponsorship', *The Guardian*, 19 December 2011.

2. Jon Hendricks and Jean Toche, No. 3, *Guerrilla Art Action Group,* New York, Printed Matter, 2011.

3. Jon Hendricks and Jean Toche, No. 6, *Guerrilla Art Action Group*, New York: Printed Matter, 2011.

4. www.guerrillagirls.com

5. 'Guerilla Girls Bare All: an interview', www.guerrillagirls.com/interview/index.shtml (accessed 4 December 2014).

6. 'Much ado about BP sponsorship as West End play hit by protest', bp-or-not-bp.org, 23 October 2012.

7. Ben Powless, 'Museum's tar sands funding pollutes snow exhibit, says snow person', *Ecology Ottawa*, 6 December 2013.

8. 'Open letter to the Board of the Biennale by participants in the 19th Biennale of Sydney', xborderoperationalmatters.wordpress.com, 19 February 2014.

9. Hans Haacke, *Tate Papers 12*, Tate Publishing, 2009.

10. Ibid.

11. Hans Haacke, *Free Exchange*, London: Polity, 1995, p. 8.

12. Ibid., p. 92.

13. Iwona Blazwick and Francis Morris, 'Showing in the Twentieth Century', in Iwona Blazwick and Simon Wilson, *Tate Modern: the Handbook*, Tate, London, 2006, p. 35.

14. Andrea Fraser, 'What is Institutional Critique?', in John C. Welchman, *Institutional Critique and After*, vol. 2, Southern California Consortium of Art Schools symposia, Zurich 2006, pp. 305–306.

15. Anna Cutler, 'Who Will Sing the Song? Learning Beyond Institutional Critique', *Tate Papers Issue 19*, Tate Publishing, 19 March 2013.

16. Andrea Fraser, 'What is Institutional Critique?', in John C. Welchman, *Institutional Critique and After*, vol. 2, Southern California Consortium of Art Schools symposia, Zurich 2006, p. 123.

17. Andrew Dewdney, 'Editorial', *Tate Encounters [E]dition 4*, October 2008.

18. Emma Mahony, 'Where do they stand? Deviant art institutions and the Liberal Democratic state', *Irish Journal of Arts Management and Cultural Policy*, p. 4.

19. Michel de Certeau, *The Practice of Everyday Life*, Berkeley, CA: University of California Press, 1984, p. xiv.

20. Andy Field, 'Live art: In here or out there?', *Red Pepper*, October 2012.

7. Conclusion

1. Nicholas Serota, quoted in Tate Press Release, 'Anna Cutler Appointed Tate's First Director of Learning', 18 December 2009.

2. Jamie Kelsy-Fry, and Sunniva Taylor, 'Tate, clean up your art!', *New Internationalist*, 6 December 2013.

3. Sonia Shah, *Crude: The Story of Oil*, New York: Seven Stories Press, 2004, p. 173.

4. Desmond Tutu, 'We need an apartheid-style boycott to save the planet', *The Guardian*, 10 April 2014.

5. Chin-tao Wu, *Privatising Culture: Corporate Art Intervention Since the 1980s*, London: Verso, 2002, p. 304.

6. 'History', Whitechapel Gallery, www.whitechapelgallery.org

7. Mark Wallinger and Mary Warnock, *Art for All? Their Policies and Our Culture*, London, PEER, 2000, p. 72.

8. Viv Golding, *Learning at the Museum Frontiers: Identity, Race and Power*, Farnham: Ashgate, 2009, p. 3.

Index